D1247008

GENTLEMEN OF INSTINCT AND BREEDING

INCORPORATED UNDER THE LAWS OF THE STATE OF NEW JERSEY.

NUMBER
3

SHARES
7

The American School of Architecture in Rome

AUTHORIZED CAPITAL, $200,000

THIS IS TO CERTIFY that *Daniel H. Burnham* is the registered holder of *One* Shares of the Capital Stock of this Company transferable only on the books of the Company by the holder hereof in person or by Attorney upon surrender of this Certificate properly endorsed.

Witness, the Seal of the Company, and the signatures of the President and Treasurer, Jersey City, N.J. the _18th_ day of _May_ 1895.

Charles F. McKim
VICE PRESIDENT

TREASURER

Shares $100 Each.

Gentlemen of Instinct and Breeding

ARCHITECTURE
AT THE
AMERICAN ACADEMY IN ROME
1894–1940

Fikret K. Yegül

New York · Oxford Oxford University Press · 1991

THE UNIVERSITY OF TOLEDO LIBRARIES

Oxford University Press

Oxford New York Toronto
Delhi Bombay Calcutta Madras Karachi
Petaling Jaya Singapore Hong Kong Tokyo
Nairobi Dar es Salaam Cape Town
Melbourne Auckland

and associated companies in
Berlin Ibadan

Copyright © 1991 by Oxford University Press, Inc.

Published by Oxford University Press, Inc.,
200 Madison Avenue, New York, New York 10016

Oxford is a registered trademark of Oxford University Press

All rights reserved. No part of this publication may be reproduced,
stored in a retrieval system, or transmitted, in any form or by any means,
electronic, mechanical, photocopying, recording, or otherwise,
without the prior permission of Oxford University Press.

Library of Congress Cataloging-in-Publication Data
Yegül, Fikret K., 1941–
Gentlemen of instinct and breeding : architecture at the American
Academy in Rome, 1894–1940 / Fikret K. Yegül.
p. cm. Includes biographical references
1. American Academy in Rome. 2. Architecture—Study and teaching—Italy—Rome.
3. Art, American—Italy—Rome. 4. Architectural rendering—Italy—Rome. I. Title.
NA2310.I8A448 1991 720'071'145632—dc20 90-32097
ISBN 0-19-506349-X

2 4 6 8 9 7 5 3 1

Printed in the United States of America
on acid-free paper

NA
2310
.I8A448
1991

To Spiro and Diane

81196736 4-2-92 3607

FOREWORD

In this focused volume, Fikret Yegül examines the first fifty years of the architecture program at the American Academy in Rome, from its inception in 1894 until the Second World War. He pays particular attention to the differing definitions of its purpose in comparison with that of the Ecole des Beaux-Arts in Paris, as well as to the views of the trustees and directors about the value of time spent on studying the monuments of ancient Rome and the Renaissance. Yegül discusses the selection process as it evolved, outlines the responsibilities of fellows while at the Academy, and notes the interaction expected between members of the Academy and the American School of Classical Studies after their merger in 1913. The program included collaboration between architects and classicists/archaeologists in recording excavations and preparing drawings of reconstructions of ancient monuments. Yegül's account includes consideration of the educational policy for the school, a policy that focused attention on ancient and Renaissance architecture, appears not to have recognized work from the seventeenth and eighteenth centuries, and completely ignored more recent work.

The heart of Yegül's contribution lies in Chapters VI and VII, in which he presents a series of revealing case studies of the negative reaction of trustees and directors to the work produced by architects both individually and with painters and sculptors in the required annual Collaborative Problem. Quotations from reports by the director, excerpts from minutes of trustee meetings, and letters to the director from the trustees that show a determined attempt by the Academy to ensure adherence to recognized models and standards from antiquity and the Renaissance are used to delineate, in the post–First World War period, a conservative policy that by the end of the 1930s was felt to be reactionary by virtually all fellows and by some contemporaries outside the Academy.

With convincing detail, Yegül chronicles an increasing resistance by fellows to the Collaborative Problem—in the form of ironic designs that mocked requirements—and the mounting frustration of the administration of the Academy. These rich chapters include an account of attempts at reform, suggestions solicited and offered from, among others, Charles Rufus Morey of Princeton University (who was professor of classical studies at the Academy in 1925 and 1926) and Henri Marceau in 1935 (a fellow in architecture in 1925), who was then assistant director of the Philadelphia Museum of Art. Their proposals were virtually dismissed, and it was not until after the Second World War, according to Yegül, that the

Academy, under the direction of Laurance P. Roberts, embraced the modern movement. The sculpture jury, though, held out longer than any other field.

Yegül's incisive study includes a brief examination of parallel concerns within architectural practice and education in the United States and concludes with an assessment of the architecture program at the Academy. He argues that the Academy began to attract the "creative names in architecture" only in the 1950s, when it had learned "to accept talent on its own terms."

The author is a professor of art history at the University of California at Santa Barbara and both an architect and an architectural historian. While still a student in architecture at the Middle East Technical University in Ankara, he worked for one season in 1963 as a draftsman of objects excavated at Sardis. The next season, he returned and, under the direction of George Hanfmann, worked on the Harvard excavations at Sardis annually until the early 1980s. Yegül's volume on the Roman Bath–Gymnasium Complex at Sardis (1986) publishes a portion of the work done there. In 1987, he began a new campaign of work at the site.

Yegül's initial interest in the Academy was generated by a fellow of the Academy, William MacDonald, who was teaching at Yale in 1965 when Yegül was a graduate student at the university. His interest was further stimulated when he studied under Louis Kahn at the University of Pennsylvania in 1966. He learned there of the effect of Kahn's residency at the Academy in 1951, and saw in presentations of the work of Robert Venturi, professor of architecture at Penn and a fellow of the Academy, what he felt to be a reconciliation of contemporary architecture with that of antiquity and the Renaissance.

His interest in the Academy program in architecture intensified, and during his stay at the Academy in the 1983/1984 academic year he began to gather material for this study. He was given access to archival records by the New York office of the Academy and by the Archives of American Art. Yegül's long-standing interest in architectural education, coupled with his concern for the potential relations among architecture, archaeology, and classical studies, was a combination that the Academy valued and was able to foster.

This account of the architecture program, openly critical of the Academy's trustees and administration, will most likely stimulate discussion and encourage further research. Similar studies that position the program of the Academy and the fellows within the academic, intellectual, and artistic history of the United States should be made of each of the fields of the Academy. With this volume, Fikret Yegül has made an initial illuminating contribution of the history of the architecture program at the American Academy in Rome.

Henry A. Millon
Dean
Center of Advanced Study in the Visual Arts
National Gallery of Art
Washington, D.C.

PREFACE

Starting in 1968, when I assisted Frank E. Brown with architectural drawings for Cosa excavations, I had the good fortune to stay at the American Academy in Rome as a visiting scholar on numerous occasions (1975, 1979–1980, 1983–1984, and 1990). Not eligible for a fellowship since I was, until very recently, a foreign national, I admired this institution, which provided a roof under which creative and artistic work existed side by side with graduate and postgraduate studies in the humanities.

As an architect and an art historian of classical antiquity, I was particularly interested in the long history of the Academy's architectural program, which was dedicated to the classical tradition, and the generations of young architects who had enjoyed the privileges of Academy fellowship. I was also curious about the architectural output during the years preceding the Second World War when the fellows were required to follow a rigid program and produce a certain amount of prescribed work every year. This work was represented mainly by measured drawings, archaeological restorations, and the results of an annual design competition in the Beaux-Arts mode known as the Collaborative Problem. It was disappointing to discover that the Academy had retained none of the original drawings and renderings; fortunately, the library kept a full photographic record of the fellows' works between 1915 and 1939. Considerable detective activity disclosed the whereabouts of fifty-five to sixty drawings and watercolor renderings. They had been preserved by some of the older fellows or their families and business associates; some had found their way to museums and architectural-drawing collections. Judged by the photographic reproductions, the great majority of these works are extremely fine in quality and unique in nature because they represent the longest and the richest program of measured drawings and historical studies made by American architects.

This book started its life as a scholarly catalogue to accompany a planned exhibition of architectural drawings from the American Academy between the world wars. The exhibition was to consist primarily of photographic enlargements of drawings and a small number of originals. After the exhibition was postponed indefinitely, the project became a book. I am grateful to the Academy for supporting my initial research, providing me with residence privileges in Rome, and giving me permission to reproduce the photographs of the fellows' works.

Despite the intensity of artistic and scholarly life

among the fellows and residents within each year, the works of the early fellows remain largely unknown. The Academy community lacks a historical awareness. Especially since the mid-1970s, when most of the fellowships were reduced to one year, the sense of continuity appears to be even more difficult to maintain. Knowledge of yesterday sharpens today's focus. I trust that the interest in and discovery of the Academy's past will awaken a deeper understanding of this remarkable American institution dedicated to the arts and humanities.

I am gratified by the enthusiastic reception of the book by Oxford University Press. It was a pleasure to enjoy the cordial support of Joyce Berry, Senior Editor, and her efficient colleagues. During my graduate seminar at UCSB in 1984, my student Gayle Seymour (now an assistant professor at the University of Central Arkansas) helped me ably and effectively with the first organization of the masses of archival material I had brought back from Rome, New York, and Washington, D.C. I benefited from the comments and suggestions of many friends and colleagues who read all or parts of the manu-

script particularly David Van Zanten, William L. MacDonald (FAAR, 1956), Bernard Frischer (FAAR, 1975), Jane Crawford, and Laetitia La Follette (FAAR, 1983). I was coached in the art of saying less and meaning more by Hank Millon (FAAR, 1960), who patiently went over much of the manuscript with me. Discussions with John Pinto (FAAR, 1974) and Meg Pinto about the nature and mission of the Academy, its past, present, and future, helped to clear my historical vision. A former fellow and an occasional visitor at the Academy, John's belief in and unwavering support of the project has had special significance to me. Another special source of encouragement when encouragement was needed came from Stanley Tigerman (Resident in Architecture, 1980), whose close knowledge of today's Academy and sensitive concern for its architectural program substantiate his interest in this study.

It gives me great pleasure to inscribe the names of Spiro Kostof and Diane Favro on the dedication page of this volume. Their support and good opinion of this project and book will continue to be a source of satisfaction and pride independent of and above all other concerns.

Santa Barbara, California F.K.Y.
1990

CONTENTS

GENTLEMEN OF INSTINCT AND BREEDING

Introduction

At the turn of the century, the view was predominant that the classical and Renaissance styles of architecture represented the most refined taste and were the most suitable ones to serve the future needs of America. The primary goal of the American Academy in Rome, which had been conceived by its founders as the final stage in the education of the country's promising young architects, was to contribute to the efforts of professionalization of architecture in the United States through the creation of an elite cadre of exceptional taste and culture. During its first few decades of life, nourished by the heady ideals of the American Renaissance, the American Academy in Rome appeared as an institution reflecting current and even progressive trends in architecture. Between the two world wars, the Academy resisted change, thereby adhering to what had become a conservative view and staying on the side of the conservative and powerful Establishment that largely dominated the architectural profession and architectural education in the United States well into the 1940s. This was not, given the basic premise of any "academy," a surprising position, although it appears that the American Academy, essentially a private institution, tried to uphold the conservative goals and tenets of classicism with greater zeal than did some of the other national schools and academies. Its great admiration for the venerable French Academy in Rome, as model and inspiration, came at a time when, in the words of a modern architectural historian, "academic French art, both in Paris and Rome, was losing its primacy to other modes and sources of inspiration, less formal and less restricting incubators of influence—from the

southern French countryside to the streets of Montmartre."[1] Out of step and out of sympathy with the problems of a changing culture and the surging modernism of the early twentieth century, the Academy declined in importance in the progressive world outside, while inside it suffered from considerable friction between administration and fellows, leading to the unhappiness of both.

After the Second World War, the Academy made a series of fundamental changes in its educational and artistic policies. Giving up the principle of "aesthetic preference," or the requirement that the fellows follow an aesthetic norm, it opened its doors to all creative and original work. It became a true community of artists and scholars pursuing what they believed to be worthwhile and important, including classicism.

A consciousness of history has been playing an increasingly important role in shaping the architecture of the past two decades or so. Beginning in the 1950s and 1960s, the Academy gradually became the center for a revival of interest in a new, broadly interpreted classicism and intellectual historicism. It provided the facilities as well as the inspiration to study historical architecture to a new generation of architects, including Louis I. Kahn, Robert Venturi, Romaldo Giurgula, Michael Graves, Richard Meier, Charles Moore, and Stanley Tigerman. The position of the Academy in maintaining a vital link with the artistic and architectural traditions of the past, and in serving as an intellectual catalyst in acceptance of the past, may need emphasizing and elucidation. Indeed, a review of the policies of the Academy in the postwar years may provide an important starting point for future studies dealing with the architecture of this period.

This book aims to present a history of architectural education at the Academy—and, by extension, an intellectual history of the Academy itself—from 1894 to 1940. Although the scope is restricted to architecture, sculpture and painting are included where they contribute to the re-creation of the artistic and intellectual life of the institution. As major branches of the Academy's School of Fine Arts, the "sister arts," naturally, had the same aesthetic outlook and policies as architecture.

Between 1894, when the American School of Architecture in Rome was founded (it took the title "Academy" officially on June 8, 1897), and 1940, when the Academy closed temporarily because of the Second World War, thirty-one fellows in architecture, and half as many in landscape architecture, produced an impressive volume of drawings. These drawings are both archaeological (travel sketches, measured drawings, and restoration studies) and creative (contemporary architectural assignments and Collaborative Problems).[2] As a group, they make up the largest and most cohesive body of

architectural output of this kind produced by American architects and are comparable in quality and diversity with the best archaeological work of the French Prix de Rome winners of the Ecole des Beaux-Arts. Quite apart from the intrinsic value of and enjoyment to be derived from these drawings, this first historical overview of the Academy's architectural production might serve to illustrate a very significant aspect of the artistic and scholarly life of the Academy itself and shed some light on a somewhat neglected chapter in American architecture. The plates at the end of this book are also the first collective publication of these drawings; many of them have never been published before.

There are many general and historical studies of the American Academy in Rome, many of which were commissioned or encouraged by the Academy with the intention of promoting its interests and informing the public and the cultural world of its objectives. The most substantial study is Lucia Valentine and Alan Valentine's *American Academy in Rome, 1894–1969,* written to commemorate the seventy-fifth anniversary of the Academy's founding. The result of painstaking archival research, the Valentines' book is a general account of the growth and development of the Academy and an affectionate story of the personalities behind it. It is truly "a labor of love," as Rensselaer W. Lee aptly observed in the book's foreword. It is, however, not an educational and intellectual history of this "most venerable and famous American institution on foreign soil devoted to the pursuit of both the fine arts and humanistic scholarship."[3] Nor does it really tell the story of the Academy's fellows, their relationship to the institution to which they belonged, and their changing obligations and privileges over time. The primary purpose of this book is to fulfill that need insofar as the fellows in the architectural program of the Academy are concerned.

The scope of my study is limited to the architectural output of the fellows while in residence in Rome; with a few exceptions, it does not include their subsequent careers in the United States. Hence there is little or no attempt to trace their development as architects (except in a general way and by implication) or to analyze the effects of their Academy experience on their professional lives. I have attempted to place the Academy within the larger cultural context, particularly on the question of Greek and Roman classicism in the 1900s (and the American Renaissance) and in the 1920s and 1930s. But my primary intention has been to stay close to the unique and immediate material provided by the Academy in Rome and its headquarters in New York. To undertake a specialized and detailed study of the larger art-historical and architectural issues of the period would have been to write a different book.

Although the material discussed in this study, covering the period 1894 to

1940, is little known by members of the architectural profession, the intellectual public, and the Academy itself, the issues are still alive and relevant for the historian. Institutions of learning and spirit have an existence outside the individuals who guide them or make the rules by which they are guided. Despite the existence in the past of rules and policies that now appear to many as understandable mistakes, the Academy remains an institution with a remarkably well-conceived basic premise entrenched in humanistic values. It can be proud of its overall achievement, and, over the years, many of its friends have expressed this pride. Nonetheless, the Academy will benefit more from a judicious assessment of its history and a critical airing of past accounts than from a testimonial. Old sins cast long shadows.

I. The American Renaissance and the Founding of the American Academy in Rome

The American Academy in Rome grew out of the pioneering excitement of the artistic new Renaissance in the United States at the end of the nineteenth century. The founders of the Academy and those who shaped its educational and artistic policies were significant participants in this movement and shared its predominant notions and values—its sense of idealism and spirituality, its intensely nationalistic and moralistic bearing, and its belief in the existence of perfect historical models that could serve as a proper source of inspiration for America and foster the creation of an American style of art and architecture.[1]

The fundamental concept of the aesthetic awakening, the collaboration and unification of the arts, had been realized in the Boston Public Library of 1888, designed by the firm of McKim, Mead and White. The building, inspired by and modeled after Italian Renaissance palaces, was decorated by a team of some of the most eminent painters, muralists, and sculptors of the day, including Puvis de Chavannes, John Singer Sargent, Edwin Austin Abbey, Augustus Saint-Gaudens, and Daniel Chester French. Some of these artists reunited around the Chicago architect Daniel Burnham and were joined by others, such as Richard Morris Hunt, John La Farge, and Francis D. Millet, in designing the Columbian Exposition of 1893. As the core group gathered one evening around the roaring fireplace in the log cabin built for the supervisors, Saint-Gaudens exclaimed that theirs was the greatest meeting of artists since the fifteenth century.[2] Both the process and the results of the impressive collaboration in creating the classical "White City" in Chicago

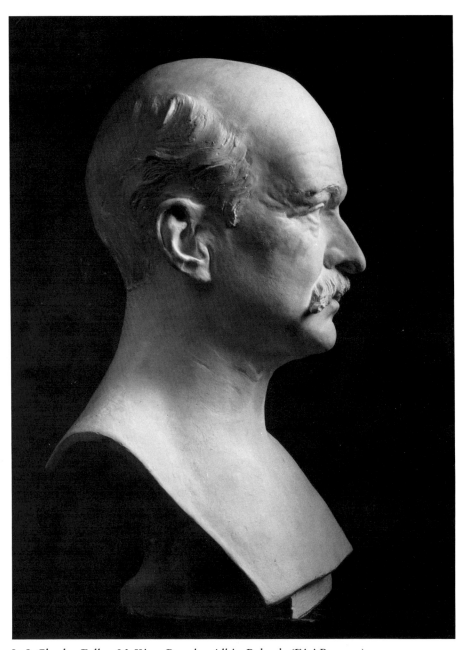

[1] Charles Follen McKim. Bust by Albin Polasek (FAAR, 1939).

was so successful that the idea of establishing an American school in Europe dedicated to the classical tradition and the unification of the arts in the spirit of the Renaissance seemed to be entirely warranted, even if it was based on somewhat heady premises.

The person who most enthusiastically and single-handedly took up the cause of the new school and who made its life his own and determined its policies for the next twelve years was Charles Follen McKim (Fig. 1). He was the true founder of the American Academy in Rome. For the most part, McKim's policies and views were shared by the architects in his firm, his close friends, and a fairly large portion of the architectural profession in general. These views centered around the belief that the classical past could provide America with the best source and model for the development of a national art. The search for a national style suitable for contemporary needs in architecture stemmed from the disappointment felt for the sordid effects of commercialism and urban blight that held American cities in their grip in the last decades of the nineteenth century. A. D. F. Hamlin, noted architectural historian and critic at Columbia University, described the situation:

During the Civil War, and ten years preceding and following it, our architecture was floundering in the lowest depths of tastelessness and artistic poverty. There were few educated architects; the popular standards were almost grotesquely inartistic and really fine architecture was nearly as impossible to execute as unlikely to be appreciated.[3]

The remedy for this situation clearly lay in establishing highly professional programs for architectural education in American colleges and universities, based on the rigorous Beaux-Arts system; in sending talented American students to Paris to study at the Ecole des Beaux-Arts; and in trying to educate public taste in architecture. This was to be done through exhibitions of works in what was considered to be the most refined of all styles, the classical and its direct derivatives, the fifteenth-century Italian and seventeenth-century French Renaissance—styles that had provided the ultimate source for the Beaux-Arts and that had been endorsed by the public at the Columbian Exposition. The original concept for the American Academy can be seen as an item in this remedial package, admittedly a luxury item, but none the less vigorous for that.

The classical bias of the American Renaissance brought a semblance of order to the architectural Establishment, against the background of rapid and often chaotic urbanization and social change in the late nineteenth century.[4] In the eyes of some of McKim's contemporaries, American architecture had

shown no clear and consistent stylistic unity until the highly urbane and "communicable classicism" (meaning an architectural style more familiar to Americans and more adaptable to their needs than other styles) inspired by the Italian Renaissance was adapted in the 1880s by his architectural firm.

In a critical appraisal of the work of McKim, Mead and White written in 1906, twenty-five years after the founding of the firm, historians Henry W. Desmond and Herbert Croly listed among the reasons for the preference of the Renaissance period over others the availability of a great variety of building types of Renaissance architecture, the familiarity of the educated and well-traveled American with this style, and the "modernity" of Renaissance buildings (or at least their ability to be modified to suit modern tastes and needs). In defending the Renaissance against the Romanesque and the Gothic, Desmond and Croly argued that the forms of these medieval styles reflected a peculiar and unique intellectual and social condition extremely difficult or impossible to revive in the modern world:

Indeed, it can almost be said that there is something antagonistic between the state of mind necessary for the successful reproduction of Gothic forms and the intellectually imitative state of mind in which the modern American architect finds himself. Gothic is at the bottom inimitable and special. The architecture of the Renaissance, like so many other creations of the Latin Spirit, is essentially imitable and universal. We cannot and should not break away from it, until we have created for ourselves some sort of national architectural tradition.[5]

The classicism of the late nineteenth century in America, however, was only the reemergence of a theme and tendency that went back to the late seventeenth and the eighteenth centuries and to Thomas Jefferson.[6] Like Jefferson's classicism, the conceptual core of and the artistic justification for the new classicism were based on the belief that this style best expressed the humanistic ideals of democracy and universality embraced by the nation as its rightful, Western spiritual heritage.[7] The new classicism, however, worked on a larger and more cosmopolitan canvas that affected a greater portion of American society than its predecessors had done. During this period, Americans not only truly discovered the meaning of Italian Renaissance, but also created a social and economic framework that closely approximated that of Quattrocento Italy.[8]

The robber barons of the Gilded Age were close counterparts of the benevolent but ruthless merchant princes of the Renaissance. The newly made private fortunes of the New World were lavished on luxurious resi-

dences to glorify the family names, but also were spent unstintingly for furthering the public good, promoting charities, and laying out grandiose urban schemes for the beautification of cities. The large-scale patronage of the arts and artists strove to enhance the relationship among the arts and established the artist as the *arbiter elegantarum* in the world of the wealthy and the fashionable. In matters of taste, Europe, particularly Italy, reigned supreme. Rome and Paris were the fountainheads at which both the educated layman and the professional artist sought to quench their thirst for cultural and aesthetic enlightenment.[9] There was a general and sincere belief in the "sisterhood" of the arts and the attainability of a higher standard of civilization through the collaboration of arts and humanities. The newly created museums, libraries, research centers, and philanthropic organizations, as well as the intellectual and artistic gatherings of the educated circles, recalled the great academies and the ducal courts of the Renaissance that combined art with learning.[10] The American Academy in Rome, in a general way, was created as a manifestation of that belief.

As McKim envisioned it, the Academy was to serve as a finishing and perfecting school for architecture. It would provide advanced education for the "best talent," chosen through competition from among candidates who had successfully completed their studies in one of the approved schools of architecture or "who were equally qualified by private instruction." It was pointed out repeatedly, however, that the education offered by the Academy did not follow a pedagogical program.[11] Those awarded fellowships were expected to be thoroughly equipped with the technical knowledge and the skills of their profession. The three years in Rome were intended to develop the students' taste through contact with and study of selected examples of classical art and its close derivatives.[12] In establishing its goals and program, the American Academy deliberately sought to imitate and *emulate* the centuries-old traditions of the prestigious French Academy in Rome, partly to express true admiration and partly to furnish historical justification for its own existence and activities. No small part of this attempt for justification and support was conveyed through patriotic appeal. France and Spain already had established in Rome their national academies, and Germany its respected Archaeological Institute; it was only fitting that the United States, the youngest of the nations, should not deprive its deserving sons of opportunities enjoyed by the students of other countries.

If the founding of the American Academy in Rome in 1894 can be seen as an idea whose time had come, the future success of the new enterprise was anything but assured and foreseeable. It started in a few rented rooms in the

Palazzo Torlonia in downtown Rome as the American School of Architecture, under the directorship of Austin W. Lord, a young architect in McKim's firm and a former Rotch traveling scholar, later moving to more permanent and spacious headquarters in the Villa Aurora on the Pincian Hill. The fledgling institution would have foundered without the devotion, energy, and often-cited "rodent-like determination" of McKim, who frequently met the expenses of the struggling school from his own pocket and rallied the support of his friends. Among them, the position of Daniel Burnham as an indefatigable fund raiser for the Academy and an unhesitating promoter of its interests and goals needs emphasizing. McKim showed his appreciation in a letter of 1905: "How much the Academy owes you for the great interest you have taken and for all you have done cannot be measured yet."[13] Thomas S. Hines, in his biographical study of Burnham, summarized the sentiments of the eminent Chicago architect toward the American institution he helped to sustain: "The movement to establish the American Academy in Rome was in fact the epitome of Burnham's classical leanings. His love of pomp, ceremony, and architectural magnitude made his interest in Rome and all things Roman quite natural if not inevitable."[14] (See the Appendix for Burnham's letter of 1908 advising Frank J. Forster, a twenty-two-year-old architecture student traveling abroad for the first time, on the important examples of classically inspired landscape architecture in Europe and what to look for in each.)

The first Rome Prize fellows were John Russell Pope in 1895 and William S. Covell in 1897; their fellowships were simply backed by cash donations barely covering one year. Between 1897 and 1909, when Harry Warren of Harvard University won the fellowship, now based, for the first time, on a regular endowment, the Academy hosted the holders of numerous outside fellowships in architecture, but could offer none of its own.[15] Thanks to its devoted friends, the Academy made significant strides during its first decade just the same. In 1897, it assumed its present name and status as the American Academy in Rome, bringing under its aegis painting and sculpture as well as architecture. The first fellowship in landscape architecture was not offered until 1916. On March 3, 1905, the Academy was incorporated by an act of Congress as a national institution. This placed the Academy on the same legal footing in Rome as the other national schools and increased its chances of support at home.

Financial relief came after the incorporation, when Henry Walters, one of the major benefactors of the Academy in its early days, lent the money to purchase the Villa Mirafiori on Via Nomentana. This spacious villa and its

grounds were to be the home of the Academy between 1906 and 1912. At the same time that the national charter was secured, a vigorous campaign was launched to raise an endowment fund by enlisting ten "founders," each subscribing $100,000. Walters and John Pierpont Morgan were the first to pledge; William K. Vanderbilt, Henry C. Frick, Harvard College, and John D. Rockefeller, Jr., had added their names to this roster by 1909. In that year, the Villa Aurelia, a handsome mid-seventeenth-century estate that occupies the highest spot in Rome, on the Janiculum Hill, was bequeathed to the American Academy by Clara Jessup Heyland, an American heiress. The trustees, encouraged by Morgan, accepted the gift in 1910, and a part of the Academy moved to the new property, the first step toward the consolidation of American interests on the celebrated hilltop. McKim did not live to see the move to the Villa Aurelia or the ground breaking for the new Academy building, which was designed after his death by his firm. He died on September 14, 1909, at the age of sixty-two. A plaque with an inscription in Latin set in the right wall of the entrance hall of the Academy building honors his memory.[16]

Morgan, who had taken a slow and cautious interest in Academy affairs, turned out to be an enthusiastic and generous patron during the last years of his life. The acquisition of much of the property owned by the Academy near the Villa Aurelia, including the Villa Chiaraviglio (across the street from the main building) and the Villa Belacci (next to it), is due to him. Already in 1911, he had assured the trustees that he could help raise the money for the new building and had approved the plans, which provided ample living and working space for the fellows and the scholars as well as housing a library and a small museum. There is a vivid account by his biographer Herbert L. Satterlee of his standing dangerously close to an open window of the Villa Aurelia during his last visit to Rome, in 1913: very ill and infirm, he picked himself up in a momentary flush of energy and inspiration and pointed down the hill with his cane, giving instructions about the future growth and development of the Academy.[17] He was, without doubt, impressed by the sight of the large edifice going up below him and felt pride in the image of the American institution occupying the highest hilltop inside the walls of Rome (higher than the French Academy's Villa Medici). He must also have been proud of his position in making this image a secure one. By the time the Academy moved to its new building, in October 1914, the First World War had begun and Morgan had been dead for well over a year (Figs. 2–5).

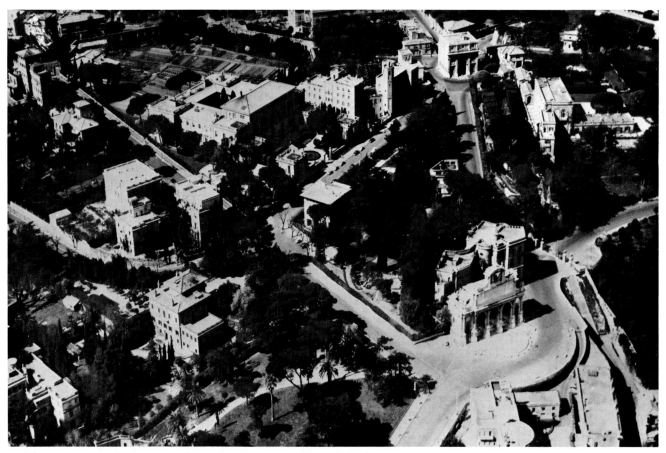

[2] Aerial view of Academy buildings and grounds on the Janiculum Hill.

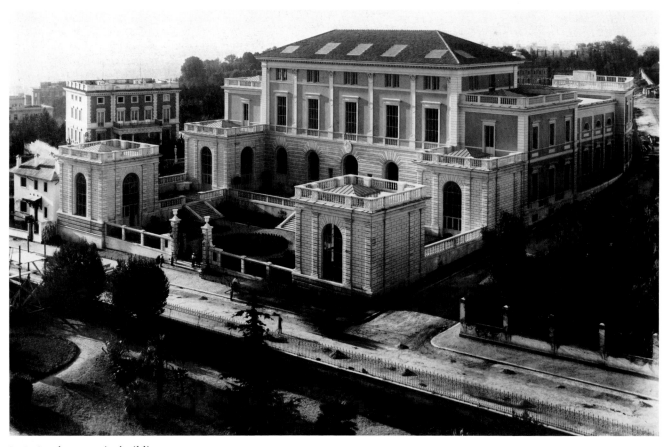

[3] Academy main building, 1915.

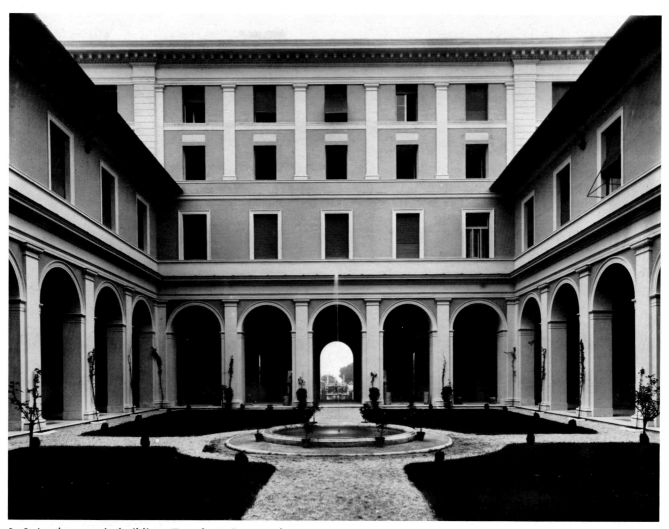

[4] Academy main building. Founders' Courtyard, 1915.

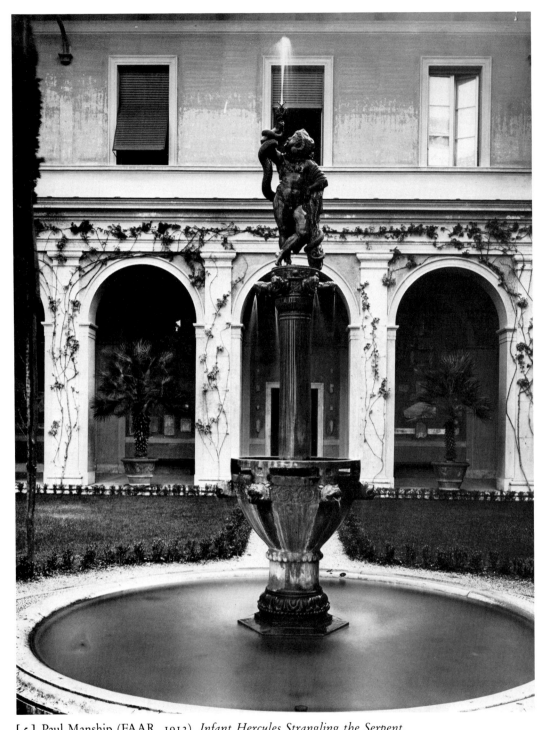

[5] Paul Manship (FAAR, 1912), *Infant Hercules Strangling the Serpent*, 1921. Fountain in Founders' Courtyard.

II. The Unification of
the School of Classical Studies
in Rome and the Academy

John Pierpont Morgan's increasingly influential position in Academy matters during the last years of his life was instrumental in bringing about the official union of the American School of Classical Studies (which had been in existence in Rome since 1894) and the Academy on January 1, 1913. Under the new organization, the Academy, presided over by a director, was composed of two entities, the School of Fine Arts and the School of Classical Studies, each headed by a professor-in-charge.[1] Ideally, the number of fellows in each school was meant to be equal, although such a balance was never maintained. The merging of the two American institutions in Rome was, in the long run, a logical and inevitable step, which had been endorsed and encouraged by Charles McKim all along. However, an earlier attempt at sharing quarters at the Villa Aurora in 1896 had proved unsuccessful. The frictions that had led to the dissolution of this initial partnership were partly residential, a result of the restricted living quarters at the Villa Aurora, but they were caused mainly by the mutual distrust of the practitioners of two essentially very different disciplines. The artists found the scholars "self-important," and the scholars felt that they were treated as second-class citizens.[2] Quite apart from the obvious advantages of consolidating two separate activities under the roof of the spacious new building, there was a noticeable surge of idealism and optimism about the financial future of the Academy, a feeling that provided just the right kind of emotional and intellectual platform for the merger. There is an astonishing volume of writing, much of it quite rhetorical, published by the Academy itself as well as by the

scholarly presses of the day, analyzing the differences between the two disciplines but predicting a happy and inspiring coexistence as opposites united around a common cultural and patriotic purpose.

A short, unsigned article in the *Nation* (1913) recalled the mistaken public view of the artist as a mere temperament and the scholar as a sheer drudge and observed that "to force a community of interest between temperamental charlatans on the one side and unenlightened gradgrinds on the other can result only in academic bankruptcy."[3] But the author was quick to add that nobody could accuse the Academy or the School of Classical Studies of giving shelter to such dreadful characters and praised the wholesomeness and beneficial collaboration already in evidence between one of its architects (Edgar I. Williams) and one of its archaeologists (Esther B. Van Deman) in the reconstruction study of the House of the Vestal Virgins in the Forum Romanum (Pls. 95–99). Charles H. Cheney, a city planner and landscape architect and the partner of Charles Adams Platt from 1910 to 1912, had expressed in 1912 an even broader vision of the collaboration among the Academy's artists and scholars:

Both have their own methods and training—the combination is highly gymnastic and stimulating, and provocative of new ideas and independent effort. It is a great blending of the humanistic impulse with the modern purified revival of ideas in art and classical studies. It is the hope of the Trustees eventually to organize a separate Division of Mediaeval Studies and another of Renaissance Studies.[4]

One of the speakers at the dinner given in honor of the new fellows on September 10, 1913, in New York, was the noted painter and muralist Kenyon Cox, who spoke on the larger interdependence and association of the arts (perhaps with a view toward forestalling any future unpleasantness at the Academy) and also felt obliged to bring the archaeological and scholarly side into this felicitious alliance:

The artist should be able to teach the archaeologists, what the archaeologists sometimes forget, that art is a living thing. . . . And the archaeologists can certainly teach the artist that art is a continuity, that to know it one must know its past as well as its present, and that an educated artist is something more than an artist up to date.[5]

The same sensible and idealistic view was given official recognition in the Academy's Annual Report of 1913: "For the artist, history gives life to what he sees in the past; for the student [of classics or archaeology], art is the blood that flowed in the veins of those whose works he studies."[6] The Report

continued, however, with exaggerated phrasing characteristic of many official publications of the period:

The bringing together, in close communion and under enlightened guidance, of the flower of our young men in callings which we nourish, is destined to exert an influence upon our refinement and accomplishment which we are not far-seeing enough fully to estimate. We can say though that it should mean a long step towards the renewing what our life of today has so sadly lost, the influence of that element for which no better name has ever been found than "The Humanities."

Humanities aside, the actual union of the two schools that formed the Academy was successful, and their fellows were able to maintain an everyday working relationship even if they may not have been aware of an "enlarged understanding" of their respective disciplines based on "bonds of cordial harmony." There must have been some informal exchanges of ideas and information, but the collaboration of the artists and the scholars seems to have been largely restricted to straightforward field projects—no less valuable for that—such as the teaming, in 1921, of Victor L. S. Hafner, a fellow in architecture, and Ernestine P. Franklin, a classicist, in studying the Basilica of Maxentius (Fig. 6). That collaboration, at least, seems to have been fully in the spirit of the stimulating gymnastics promised by Cheney in his 1912 article, as it required working on a twelve-meter ladder composed of seven individual sections in order to measure one of the colossal columns of the basilica. George Mason Whicher, the professor-in-charge of the School of Classical Studies, described this endeavor: "The sight of a young woman engaged in such pursuits, standing 30 feet above the pavement on the pedestal of the column, attracted such throngs that the police authorities finally gave orders that she must desist and descend!"

The position of women at the American Academy had indeed become a difficult and awkward issue with the merging of the two schools. The School of Classical Studies, from the outset, admitted women as fellows; the Academy, as represented by the School of Fine Arts, was opposed to the idea. When the new building was planned, no accommodations for women scholars had even been considered. The few women scholars associated with the Classical School were housed in separate apartments in the Villa Aurelia or had to find lodgings outside. They were admitted into only the library in the Academy building. They could not take their meals with men in the main dining hall. A small dining room was set aside for women who were fellows of the School of Classical Studies or who were married to fellows of either school (at present, this room is being used as a bar). Even though the exclu-

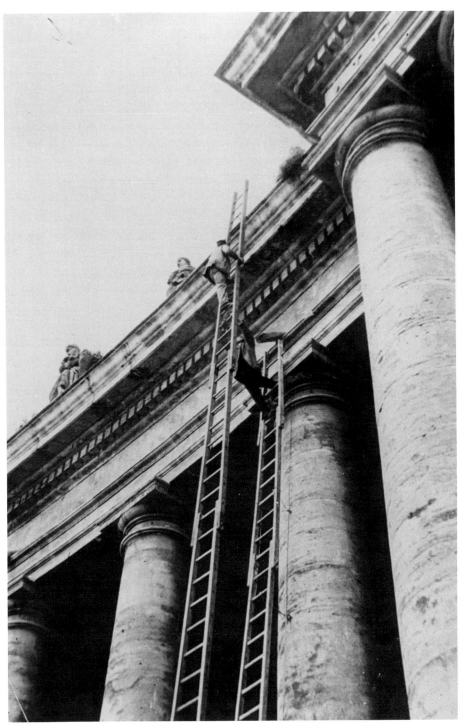

[6] W. J. H. Hough (FAAR, 1915–1917) measuring St. Peter's colonnade in Rome, 1917.

sion of women from men's company in similar learned and artistic institutions and clubs was quite common in those days, that does not mean that some women did not feel unfairly treated and unwanted. And, as far as the School of Fine Arts was concerned, they *were* unwanted. We know that the question of women at the Academy had become controversial because there was serious concern on the part of the women's colleges and coeducational universities (which supported the classics program at the Academy) that the program of admitting women into the Classical School might not be continued after the merger. Albert W. Van Buren, a classicist and the Academy librarian, attempted to mollify the scholarly circles:

Women play a large and important role in the educational and scholarly life of America, and the American Academy in Rome . . . recognizes this fact and its own obligation to conform to it. The Academy is for the present obliged to limit its dormitory accommodations to the men Fellows. . . . It is not that the women are less fortunate than before, but the men are more fortunate.[7]

Indeed, there was no indication on the part of the trustees to justify Van Buren's optimism. Occasional attempts by the directors of the Academy, Jesse Benedict Carter (1913–1917) and Gorham Phillips Stevens (1917–1932), supported by the representatives of some women's colleges, to bring pressure on the president and the trustees to consider a women's dormitory building elicited either complete silence or comments like "It is much better to consolidate our present activities . . . than branch out . . . into women's accommodations. These will come but can wait—and, then, let women come forward and provide the means."[8] Women, indeed, did wait. Although there was an attempt to adapt the mezzanine floor of the main building and the so-called mezzanine apartments (which have a separate entrance from the outside) for the use of women in the 1930s, women's full acceptance as resident fellows of the Academy (that is, enjoying the same living and dining privileges in the main building as men) did not occur before the late 1940s and early 1950s. Only in 1963 were the first fellowships in the School of Fine Arts awarded to women.[9]

The conservatism of the American Academy reflected the reigning attitudes of the profession at home and harked back to earlier decades.[10] On the issue of women, the positions of the French Academy and the British School in Rome were only a little more tolerant. The former had been favorably compared with the American Academy in 1920 by Charles H. Meltzer:

The French are much more liberal than they used to be in their ideas as to the rules of their art schools. It is quite likely that, in the not distant future, they will abolish the

old order which is still supposed to bar married *pensionnaires* out of the Villa Medici. If I were indiscreet, indeed, I could a tale unfold—but after all, it is of private interest.[11]

The thinking that so stiffly maintained the exclusion of women from the School of Fine Arts until not so long ago is intriguing. The belief was officially expressed that women would distract the men fellows, who should devote themselves to the serious and divine calling of their art. This historical but misconceived notion of the nature of art, and of women, at least had an idealistic ring to it.[12] In a letter dated January 1911, written by Daniel Burnham to Francis Millet and discussing the wife of a candidate considered for the Academy directorship, one catches a glimpse of the unofficial, and perhaps more candid, feelings of the founders about the place of women at the Academy:

The other point you urge in favor of . . . is that his [the candidate's] wife has knowledge of Roman society and skill in playing the game. Dear Frank, that is the very thing you *don't* want. We have had mistresses in the Academy in Rome, and what has come of it? When I visited the Academy a cold chill ran down my back because I was received in a drawingroom by a woman. No man knows what this means better than you. It has not worked, and it can not be made to. Imagine a woman presiding at the Villa Medici! Would any French artist stand it? There should be no women in the Mirafiori. The students there are not boys. They do not need "the influence and refinements of a home" and they do need entire freedom to work each according to his own nature, following his own moods. Any restrictions upon him will vex and interfere, and any set of formality about him frets his life. No woman can live there without making a nest for herself in the Villa, and will this nest be hidden and so used as to be negligible in summing up the spirit of the School? You know it can not be. No woman ever lived could subordinate herself.[13]

III. Rome and the Academy

In the early days of the Academy, a lively debate existed between those who maintained that Paris would have been a more suitable center for the interests of artists and architects and those who defended Rome. Why was Rome chosen as the set of an advanced school in the arts and architecture?

The essay that prefaced the first publication of the Academy, the *Catalogue for the Annual Exhibition of 1896,* attempted to give one of the answers to this question by quoting the eminent French composer Charles Gounod, the winner of the Prix de Rome in 1839. After commenting on the richness, majesty, and serenity of Rome as a cultural environment, Gounod pointed out that Rome's "past as well as its present, its present as well as its destiny, makes it the capital of not merely a country, but humanity." Gounod's message, adapted by the Academy, represented the historical view of Rome as both the source and the repository of Western art and civilization. This view cropped up quite frequently in publications connected with the Academy,[1] but never with as much flamboyance and poetic relish as in the history of the Academy written by C. Grant La Farge, the secretary to the Academy board from 1912 until his death in 1938. This much-admired promotional essay, which opens with the memorable line "America owns a great possession . . . in the Eternal City," was published on many occasions, first in 1915, and then in 1917, 1920, and 1927 (the editions of 1915 and 1920 commemorate the twentieth and the twenty-fifth anniversaries of the institution). In the last section of the essay, La Farge asked the question "Why Rome?" and proceeded to take the reader on a bird's-eye tour of the city, a

long and nostalgic flight of fancy into the past, studded with clichés and classical quotations in which metaphor and fact, history and myth, "cedared Lebanon" and "silken Samarkand" mixed indiscriminately. The final paragraph echoed Gounod's theme of universality in searching for an answer to the original question:

Why Rome? . . . Because all this uncounted wealth, this endless store heaped up by hands, the passions and the minds of all that long procession of generations; this still undiminished fountain men call Italy—all this belongs to no one people, to no group nor class nor nation. It is yours and mine; it is there for all who would seek. But it will not, may not, come to us; it must be sought, sought in the land of its making . . . and the land, focus and heart is Rome.[2]

On the question of Rome, Charles McKim had expressed himself with greater clarity and directness. In a letter written in 1894 to Edwards J. Gale, one of the younger architects in his firm, who was traveling in Europe, he said: "As between Rome and all other Italian cities, give me Rome. . . . Rome contains for the architect the greatest number of typical examples."[3] The same view was officially spelled out in a report prepared by the School of Fine Arts in 1919:

Rome was chosen as the seat of the American Academy because her vast collection of antiquities, her classic monuments, her public buildings, her palaces and churches, present so complete a panorama of the development of art and history of civilization, and in order that the Fellows of the Academy might live in the midst of that atmosphere of ennobling influences from which so many generations have drawn their inspiration.[4]

The only other city that effectively challenged Rome's supremacy as the artistic center of the Old World was Paris, "the hothouse . . . of *fin-de siècle* ideas untrammeled by convention or tradition [and] the hub about which the wheel of art revolves."[5] To a certain extent, many of the Academy's founders who had received their professional training in Paris, including McKim, were in sympathy with this point of view. McKim, although proud of his École des Beaux-Arts background, consistently refused to use French nineteenth-century architectural mannerisms in his own work.[6] Consequently, even during the formative years of the Academy, the choice of Rome as America's artistic base in Europe was widely criticized, leading to a temporary withdrawal of support from the Society of Beaux-Arts Architects.[7] But the fact remained that even the Ecole sent its best talent, the winners of the Prix de Rome, the

most-coveted artistic crown, to Rome, to study Roman and Renaissance art at its best and purest.[8] Thomas Hastings, representing the Paris side of the debate, but arguing from a rational angle, believed that American architects should go where they could find the masters in architecture, just as the French had gone to Italy and the Romans to Greece. "If anyone thinks," he wrote,

that today he can find the best living architects in Italy or at the North Pole, let him go thither, but don't let him go to Italy to study and measure the great buildings of the Renaissance unless in his youth he has all that can be taught to him so far as technical education is concerned.[9]

Spokespersons for the Academy, such as Senator James McMillan in 1902, Austin W. Lord in 1903, and Charles H. Cheney in 1912, did not take the same point of view as Hastings on the issue of seeking the "best living architects," but agreed that a sound technical training was the irreplaceable basis of all advanced work in architecture. Lord, the first director of the Academy, argued "in the strongest possible terms against the idea of sending forth untrained men to Rome."[10] Technique and culture were two aspects of higher education in the arts and architecture: Paris, with its atelier tradition, provided the technique; Rome, with its monuments, the culture. In a sense, these corresponded to the two components of architectural design: plan and façade, utility and beauty. Paris offered the best training in the former; Paris-trained architects were admired for their skill in "practical planning and directness of solution of the problem in hand. But the great inspiration of beauty in facade was not appreciated and demanded until McKim, Mead and White awakened everyone to what might be done." And this is exactly where Rome and the American Academy entered the picture: "The secret of the subtle refinement of the Renaissance or of Greece can only be grasped by living some time [in Rome], analyzing, sketching, measuring—not to learn to copy what it inspired, but to put the same culture and grace into new things at home."[11]

This sensible and moderate view, which accepted Paris and Rome at different stages in the education of an artist or an architect and attempted to draw from the peculiar strengths of each, should be evaluated against the strong pro-Rome argument of some of the founders of the Academy. According to Edwin H. Blashfield, a prominent muralist and one of the most influential trustees in determining the fine-arts policies of the Academy until the mid-1930s, the lesson of Rome and Italy was more useful than that of Paris because it was broader in scope and less tumultuous:

Instead of emphasizing sharply one phase of thought it offers the development of a chain of thought; above all . . . it enables the pupil to realize that the present is not the ultimate thing which it seemed to him . . . not the art which dazzles, but the art which shines enduringly, is to be sought.

And the prime objective of the Academy, which lay at the very core of its educational policy, was the "sequestration" of its pupils "from the ephemeral and from all which has not proved its title to endure."[12] Although Blashfield's ideas were directed toward the training of a painter, as an educational policy they applied to architecture as well, and were meant to cover all the fine arts.

To Blashfield and many other academic artists and critics like him, Paris at the turn of the century represented all that was unproved, experimental, and faddish in art, which could be potentially dangerous for a young, impressionable mind. Paris, like Rome, had a splendid background of art and architecture of all periods, but its background was "confused" by the foreground. In Paris, when "a great personality makes itself felt, perhaps suddenly," wrote Blashfield, "it is not sufficiently removed from us that we view it undisturbed and as a fixed luminary; it dazzles us but not warms us, and the hundreds of young men who are swept into its sequence are but the tail of a comet."[13]

The argument for the sequestration of the fellows of the Academy from the undesirable currents of "unproved and experimental art"—which probably implied all nonacademic contemporary and modern art—and the belief that France, with its permissive artistic tendencies, did not set a good example to follow appear with considerable vehemence in the writings of Francis Millet, an academic painter who was no less influential than Blashfield in shaping the artistic and educational policies of the Academy in its early days. Millet carried the Rome versus Paris debate straight into the enemy camp: "From [France] came also the adoration of originality, of novelty in technique, the indifference to idea and ideals. The results have been in France, that art has confessedly degenerated." Consequently, Americans who studied art in Paris and showed brilliance there were often unsuccessful and seemed to have "lost their grip, shortly after they returned home." According to Millet, the founders of the American Academy in Rome, artists all, recognized the *fons et origo* of the problem: the young American artists needed to learn abroad more than just technical skills. They had to discover the great principles that govern all art. These the Academy could be trusted to teach:

What [it] proposes to do is to provide the opportunity for an artist to cultivate himself—to give him the advantages of cloistration [*sic*] for a period long enough for

him to absorb the ideals of the great art of the past, and to stimulate his imagination . . . by diligent study and by close acquaintance with the masterpieces with which Rome abounds.[14]

For the great majority of the leading artists of the period, such as John La Farge, Augustus Saint-Gaudens, Daniel Chester French, Henry Siddons Mowbray, and Kenyon Cox, all among the founders of the Academy, the aesthetic ideal was acquired by a selective and intellectual process through which the young artist could learn from the best and most authoritative examples of the past.[15]

Austin Lord, the first Rotch scholar in architecture (1888) and McKim's choice as the first director of the American School of Architecture in Rome (1894–1895), expressed the peculiar advantages of Rome over Greece as the seat of the Academy in contemporary and, to a certain extent, functional terms. Although Roman work never reached the high standards of Greek, Lord observed, it developed a far greater number of architectural types, which were more readily applicable to modern requirements. It was easily imitable. Therefore, Rome, rather than Greece, must be the source of inspiration and supply the realistic models for the contemporary world. Lord perceived, however, some danger in the modern tendency to place undue emphasis on scientific and logical ingenuity in design. He advised the students of architecture to return to an understanding of architecture as a fine art, without totally sacrificing functionalism. The architect "may come into intimate touch with the pictorial and sentimental side of his art, and draw his inspiration from the same archaeological sources that have inspired the leaders of successive architectural periods for hundreds of years."[16]

Lord maintained that the future leaders of American architecture must learn to distinguish between the essential qualities of classical architecture, which give it its simplicity, grandeur, repose, and refinement, and its nonessential details. Ruins, in various stages of preservation, he emphasized, were particularly useful in demonstrating the relationship between detail and mass, parts and whole: "What we call scale, the adequate expression of the bigness of things, is a quality inherent in the proper proportioning of the masses, and has an existence entirely independent of the details and accessories which are too frequently employed in modern buildings." Once the student, through the correct exposure to and study of the classical tradition, has mastered the skill of recognizing and appreciating simplicity as the first principle of architecture, he is then free to make a mature judgment about all periods and styles he had before him, "a standard by which he can decide with authority . . . [the] logical developments necessary and proper for the application of

classic forms to modern requirements, and which of all the changes that have been wrought in the classic forms . . . are worthy of preservation and further development." The acquisition of this standard and the fundamental skills of aesthetic judgment (some would have called it "taste"), Lord believed, was the most important lesson of Rome.

Lord's thinking on the use of archaeological and classical models for architects was fresh and progressive. Emphasizing the principles of design rather than style, the underlying structure rather than surface appearance, it echoed the best teachings of the Beaux-Arts and represented a more flexible and creative use of historical precedent than views held by most of his contemporaries, including McKim. His association with the Academy was, unfortunately, extremely short. Although he had been a director and a charter member, he was never made a trustee of the Academy or asked to serve on its architectural juries.[18]

Distinct from the intellectual and artistic reasons for choosing Rome were purely human and nonacademic considerations—those that claimed almost magical benefits from experiencing the liberating atmosphere of the Eternal City. This was the view expressed by Royal Cortissoz, the well-known art critic for the New York *Tribune*, who was invited to deliver one of the three addresses at the annual dinner in 1913. According to Cortissoz, the money contributed to the Academy was never better spent than "when it is enabling a student of painting, sculpture, architecture or archaeology to take long purposeless rambles through the streets, or sit idly under Tasso's oak on the Janiculum, looking with dreamy eyes over the panorama of the city." Cortissoz recommended that the new fellow also "adventure like a man among masterpieces" and stay away from too much book learning so that the spiritual message of Rome could soak through his pores. "You have got to stay human and simple," he advised.

It is a good thing to explore St. Peter's with a critical eye. It's a good thing also to sit down for your dinner at one of the little open-air tables before the restaurant across the vast square, and, as you dine, to absorb the grandeur and the beauty of that heroic space held within the lines of Bernini's stupendous colonnade. . . . You just get unconsciously saturated in it. With your Chianti you drink in an inspiration that will last you all your life.[19]

This delightfully uncomplicated view of Rome and the Academy appears not to have been shared by the Academy officers. Following McKim's death in 1909 and corresponding, more or less, with the consolidation of the Academy property on the Janiculum, a highly emotional and more complex tone

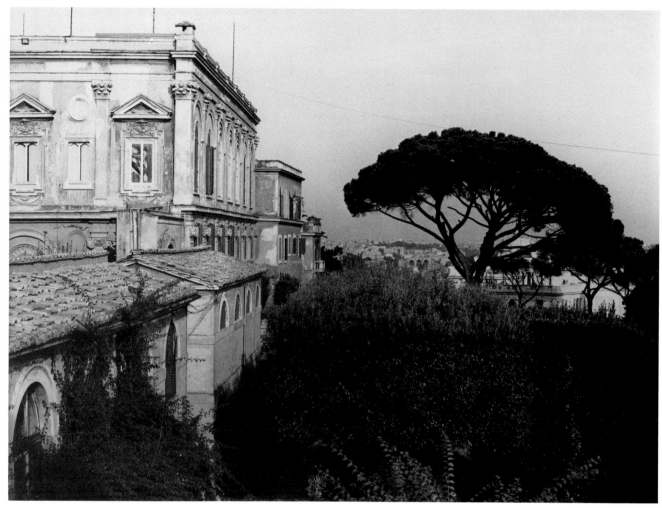

[7] Villa Aurelia and general view of Rome.

became noticeable in the Academy's estimation of the city and its own position in it. The overpowering historicity of Rome seems to have assumed almost a totemic significance as the Academy sought to invent its own creation legend and strove to lace its destiny with that of the city.

Nowhere is this tendency more pronounced than in the symbolic exploitation of the Academy's eminent position on the highest hilltop in Rome, the desire to link that position and the Academy, as though through a surveyor's sight line, with the web of historical and topographical landmarks of Rome spreading immediately below the Janiculum as well as with the distant countryside stretching from the Alban Hills to the Mediterranean (Fig. 7). The Annual Report of 1913 quoted a long essay by the English historian George M. Trevelyan. Charged with poetic allusions to the past and describing the

sentiments raised by the famous view, the essay honored Rome, "in all its mellow tints of white and red and brown, broken here and there by masses of dark green pine and cypress, and by shining cupolas raised to the sun," as the "heart of Europe and the living chronicle of man's long march to civilization."[20]

Trevelyan's essay was followed by an equally colorful commentary on the association of the spot with recent Italian history and, particularly, on the significance of the ownership of the Villa Aurelia to the Academy and to American ideals of youth and liberty. The Villa Aurelia (then the Villa Savorelli) had served as Garibaldi's headquarters. During the siege of Rome, in 1849, it was around the villa that

the fiercest struggle for Italian liberty had reached the zenith of its fury and heroism. Battered into a gaping ruin by that wild storm of shot and shell; rebuilt then for a habitation, it now as our Administration Building, reaches, let us hope, the end of its vicissitudes. From here, where "the battle was ordered," will henceforth be ordered the peaceful striving of our chosen men.

And the essayist added: "Surely there is something of fitness in the lodging here of an American institution, born of the resolve to give freedom of opportunity for advancement in the Fine Arts and Classical Studies to the youth of our country."[21]

Even Albert W. Van Buren, who could, in all other subjects, be trusted to maintain a sober point of view, became expansive when Rome and the site of the Academy came up for discussion in his article of 1913. Van Buren recounted the enthusiasm of the scholarly visitors he had had the pleasure of escorting to the belvedere of the Villa Aurelia, "who felt the sudden apparition of all Rome and most of Latium . . . bathed in the rich colors of a Roman afternoon, framed in by the noble outline." He reported having seen those scholars actually "speechless with emotion when confronted with what to the student of western civilization is the most momentous landscape in existence and to the soul with an eye for beauty certainly one of the most inspiring." And as for describing and praising the position of the Academy on the Janiculum (to the reader acquainted with classical literature, there was a hint of Statius's eulogy of Domitian's Palace on the Palatine), Van Buren admitted his own literary shortcomings, modestly calling himself the "Pedestrian Muse," and opted to recall "the measures in which Horace immortalized Soracte, or in which Martial sang [of the Seven Hills]."[22]

These superlatives are tall orders for any earthly spot to satisfy, but they were uttered sincerely, albeit in the language of erudite affectations. And it is

also true that the location of the Academy is superb—enough to make anyone who feels a part of the establishment proud and expansive. The influence of the city of Rome and its history seems to have kept a whole generation of Academy spokesmen spellbound. As late as 1924, in a paper that aimed to rally support for the American School of Classical Studies in Athens and the American Academy in Rome, delivered at the annual meeting of the American Classical League, Walton Brooks McDaniel, a professor of classics at the University of Pennsylvania, could not resist making an unfettered display of sentimentality on a subject that might have benefited from firmer handling:

It is our task, I take it, to see Greece and Italy receive our very ablest youth. Let us make the competition for these fellowships the fiercest in the world. Let the best eyes of America gaze on the treasures of art and archaeology in those lands. Only our best trained hands deserve to paint an Italian landscape or model the fair daughters or handsome sons of Italy. Give them our warmest hearts, the sort that will thrill at the song of the nightingale in an Athenian garden or of the thrush in the trees at the Villa Aurelia.[23]

For a decade or more following the First World War, the Academy's assessment of Rome and its own image in the artistic and historical atmosphere of the city was emotional and confused. It is almost hopeless to seek a glimpse of level-headed appraisal of the relationship between the American institution and its panoply of Old World values. The record left by the Academy during this period, from official memoranda to promotional pamphlets and private letters, bristles with impassioned rhetoric and patriotic clichés about "the spirit of the times," "the fountain of art," and "the great purpose of our founders," while the names of Renaissance artists like Michelangelo, Bramante, and Raphael are dropped in like peas into a bowl.[24] In reports and announcements signed by William R. Mead, C. Grant La Farge, Jesse B. Carter, and Gorham P. Stevens, nostalgic memories of Rome alternate with spirited outbursts of prophesy for the future of classical and Renaissance art in America—and the proud and singular position allotted to the Academy in shaping that future.[25] The sense of sincere pioneering idealism and missionary spirit that characterized much of the intellectual and artistic climate of the era explains, perhaps, why even those occupying responsible positions could act like the priests of a mystery cult whose high altar lay in front of the Villa Aurelia.[26]

IV. The Fellowship:
Its Rules, Requirements,
and Responsibilities

The Academy fellowships in architecture were open to unmarried men, citizens of the United States, selected in a competition by a jury. The applicants had to be graduates of one of the approved architecture schools, colleges, or universities or to have certificates of at least two years of study at these approved schools.[1] They were required to have at least one year of experience in an architect's office. Also eligible were Americans who were pupils of the first class of the Ecole des Beaux-Arts in Paris and who had obtained at least three values in that class, provided that they had satisfied the committee about their general educational fitness.

The competitions were essentially simplified versions of the French Prix de Rome competitions, with two instead of three trials. For the first trial, the competitors were required to develop within ten days an architectural scheme based on an initial idea recorded by a sketch (*esquisse*) filed with the jury. Ten competitors were admitted into the final competition, which was held in New York. They were allowed five weeks to develop a new architectural problem also based on a sketch. The final drawings were rendered in ink and watercolor.[2]

For the benefit of the American students at the Ecole des Beaux-Arts, the Academy also held competitions in Paris in 1913 and 1914. The procedure of these competitions, recorded in the correspondence between C. Grant La Farge and Edward P. Mellon (an architect and a nephew of Andrew Mellon), who was the Academy's representative in Paris, gives an insight into the actual mechanics of these competitions in general. The Academy and the Ecole had a

guarded respect and admiration for each other. In 1913, the Academy was pleased to be able to hold its competitions at the Ecole's facilities. Mellon, in a letter to La Farge dated March 15, 1913 (on board the S.S. *France*), reported that the officers of the Ecole "did all in their power to favor us and make matters agreeable, convenient and comfortable" and suggested that the trustees send a letter of thanks to the French authorities. This was a request that La Farge and the trustees took up enthusiastically:

We thought here that the courtesy of Beaux-Arts ought to be rather formally and prettily recognized . . . [so] I wrote a somewhat pompous and elaborate letter to the American Ambassador, requesting him to convey to the proper authorities in Paris our thanks and appreciation. This evidently "hit the bull's eye," . . . because I received in reply an equally pompous and florid epistle from [the ambassador] explaining that it had given him much pleasure to convey the matter to the Minister of Foreign Affairs. So, you see, I think we have done it in real style.[3]

Unfortunately, all this courteous exchange came to nought. The following year, the New York office slipped and the "problem" did not arrive in Paris in time. Mellon was compelled to cancel the engagement of the "lodges" that had been scheduled with great difficulty for the use of the American Academy, as a new, delayed reservation conflicted with Grand Prix season. The French authorities were upset and, as Mellon had predicted, did not repeat their offer to the Academy of the use of their facilities. A variety of factors, including this contretemps and the generally cumbersome process of administering competitions overseas, caused the cancellation of this experiment after two trials.

The trustees were aware that fellowship competitions could reveal only the technical and professional abilities of the candidates, not their personalities and general levels of culture. And they were unhappy about this shortcoming. A special committee formed in 1919, with the intention of reviewing competition procedures, strongly recommended that the Academy insist on a high level of liberal education from its candidates if, as fellows, they were expected to understand the great works of art of the past and the development of art and architectural styles. The committee also suggested that the Academy seek its candidates for the fellowship

among those only who will be recognized as gentlemen by instinct and breeding and whose educational and personal qualities of leadership and high character give promise of the development we desire. . . . We must devise a method by which those who are charged with the appointment of the Fellows in Architecture, Painting and Sculp-

ture, may reach a more intelligent decision than it is possible under our present system of open competitions.[4]

The first step taken to attain this goal was the suggestion that the candidates for the fellowships be carefully interviewed by the juries.

The determination of character and background could, of course, be ticklish, as can be seen from the character sketches Mellon had provided ("I thought a word from me might be of aid to the jury") in reporting the Paris competition of 1913:

I think the strongest men are: Polhemus–Robertson–White–Chandler–Atherton–Brown and Shepley. This information gleaned from outsiders and not my own judgment. Polhemus, as you probably know, came out second in last year's competitions in America. [Lawrence Grant] White's reputation and standing you know. . . . [Frank W.] Chandler is in Paris on a scholarship of Mrs. Phoebe Hearst of San Francisco and has the reputation of being one of the most earnest and hardworking men in the school. [Walter] Atherton [the candidate selected in Paris] is also a hard worker but unfortunately handicapped by great timidity. [Henry Richardson] Shepley is a close friend and companion of White's [Fig. 8]. . . . All of these men are gentlemen and would fit well with the men already at the Academy. . . . Nauheim, one of the four remaining tried last year and is a Jew.[5]

As this sort of information was obviously appreciated by the New York office, Mellon included a more detailed account and a personal rating of the four competitors in 1914, making sure to point out that his rating was *not* based on the architectural and professional qualities of the candidates' performance at the competition. The two top men for 1914 were Frank Chandler and Marion S. Wyeth, whose good family in New York and "leading medical specialist" father were favorably commented on. Chandler (who had also tried in 1913) was widely known and liked and was the favorite. Besides being supported by Phoebe Hearst, he had among his friends

some of the leading men of California, such as Mr. [Charles Henry] Crocker, Mr. [Frank Lyon] Polk, Mr. Arthur Brown, and the Hon. Truxtun Beale . . . and as it would be a good thing for the Academy here to have a popular man win . . . I, too, would be glad to see him win.

Bringing up the end of the list and betrayed not so much by his work as by his background and looks was one luckless George E. Mitchell: "I am not sure, but I think Mitchell is a Jew—at least his looks and actions indicate it, and he is generally thought to be one."[6]

3. Name the colleges, art schools or universities which you have attended and state the length of your residence at each, the degrees and honors, if any, which you have received, and the course of study which you have pursued.

3 years residence and degree of AB from Harvard

18 months in the Ecole des Beaux Arts and four values in the first Class.

4. ~~State whether you are~~ *I am* able to read :

French,
~~German,~~
~~Italian,~~
~~Latin,~~
~~Greek,~~

5. State what evidence of special fitness for advanced work you submit in support of your application. (Give a full list of all documents submitted.)

None.

6. Give an itemized list of the letters of recommendation submitted in support of your application.

Letter from M. Victor Laloux.

7. Do you declare it to be your intention to pursue your work under the direction of the Academy for the full term of any Fellowship which may be awarded to you and to abide by all the regulations of the Academy ?

I do.

Signature.

Henry R Shepley

[8] Henry R. Shepley's application for an Academy fellowship in 1913 while a student of architecture at the Ecole des Beaux-Arts in Paris.

As it turned out, none of the contestants from Paris made the final trial in New York; it appears that there was a more delicate pattern of concern about these competitions that Mellon did not fully comprehend. The New York office, especially Samuel B. Trowbridge (who was the chairman of the three-man jury), was unsympathetic to the prospect of having a large proportion of the finalists from Paris. The Fine Arts Committee was also against the idea of an Ecole-trained winner. This was partly because they did not want to create the impression in the United States that it was necessary to study in Paris in order to have a good chance to be appointed a fellow of the Academy, but also because underlying feelings of reserve existed between the Academy and the Ecole.[7] Even though the Academy respected the venerable tradition behind the 300-year-old French institution, the Academy and the Ecole were rivals in the current architectural debate over Rome versus Paris.

It would be unrealistic to think that the Academy juries during the period covered by this study were entirely fair and objective, but it would also be unfair to assume that they were very different from any other juries or admission committees. Quite apart from their demonstrable bias on matters of ethnic origin and social background, the juries were open to subjectivity and prejudice because of their composition. The membership of the juries hardly ever changed, except as the result of the death of a member. During the twenty-five years from 1912 to 1937, William M. Kendall (the principal designer from the office of McKim, Mead and White, and a founder and trustee of the Academy) was on all twenty-five architectural juries. John Russell Pope (FAAR, 1895) served on twenty-one; Louis Ayres, on sixteen; Charles Platt, on thirteen; Samuel Trowbridge, on twelve; Henry Bacon, on eleven. The situation was quite similar for the painting and sculpture juries.[8]

Undoubtedly, these men were among the most prominent practitioners of historical and academic architecture in the United States during the first few decades of the twentieth century, and many worked on important federal projects into the late 1940s. Almost all were also Academy trustees, and some were former fellows. They belonged to an inner circle whose center was McKim's office at 101 Park Avenue and the Century Club of New York. These men voted for one another and had similar conservative views on matters of art and architecture; they shared an inflexible image of the "gentlemen by instinct and breeding" who would fit the Academy. Not that all gentlemen could fit the Academy; Allyn Cox, for example, turned out to be a regular rebel and, according to Stevens's diary, gave the director much cause to worry while he was a fellow in Rome from 1917 to 1920. Cox was chosen a fellow in painting in 1916; his father, Kenyon Cox, was a member of the four-man jury.

The regulations governing the recipients of Academy fellowships remained more or less the same during the period between the wars. The fellows were to report in Rome on October 1, following their appointment. During the first year, they were obliged to remain in Rome and central Italy. During the second and third years, they were expected to visit sites in mainland Italy, Sicily, Greece, and "other countries where classic and Renaissance remains exist." After 1919, they were allowed to spend their second summer of the fellowship in America. All travel had to be authorized by the director on the condition that the fellow's prescribed work was completed. The residency records of the fellows were kept diligently by the director and were included in tabulated form in the Annual Report of the Academy each year until the mid-1930s. According to the rules, a fellow who married during his fellowship forfeited all the privileges and emoluments of his fellowship, but in practice this rule was never implemented rigidly. Married fellows, however, were required to find housing outside the main building.

The architecture of ancient Rome was the chief subject of study for the first-year fellows. They were required to measure, draw, and render several examples of classical detail of monuments chosen by them but approved by the director. By the end of the first year, rendered restoration studies of the classical buildings were expected. The Academy assisted in obtaining the permission necessary for the study and measurement of these buildings and provided funds for the rental of ladders or the construction of technical equipment needed for the measurements. Minor excavations were often undertaken in connection with these restoration projects, but published archaeological reports, for the most part, were limited to short descriptions in the *Memoirs of the American Academy in Rome*. Fellows were forbidden to copy from published drawings of these buildings, but considering the size and scope of some of the restoration projects attempted, such as the Thermae of Caracalla, Hadrian's Villa in Tivoli, or the Sanctuary of Apollo in Delphi, it would be naïve to think that they did not (Pls. 47–100).

Early in the history of the Academy, Austin Lord had asserted that the approach of an architect to a restoration problem should be more "creative" than that of an archaeologist or scholar, and should be directed primarily toward the discovery of the "principles" that govern historical models rather than their outward appearance: "In his more advanced studies concerning the restoration of the plan and elevation, [the architect's] imagination may be allowed free play, as the ultimate object of the restoration is not necessarily to reproduce the exact monument, but to develop a logical superstructure from the plan and fragments that exist." The important point, Lord emphasized, was searching out the solution to a problem from the standpoint of the

ancient architect, who was not burdened by the ideas of style and arrived at solutions in the simplest way. "Thus, through the medium of restoration work, the student is brought in closer relation with the ideas of the earlier artists, and interest in his work is enhanced by the feeling that he is put in a position to discover new and better methods of solving varied problems in architecture."[9] Lord's views on archaeological restoration and the use of historical models were based largely on the ideas of the mid-nineteenth-century architect and theoretician Eugène Viollet-le-Duc, and they explain why the great majority of the fellows' restoration drawings, although profuse in output and beautiful in appearance, are not very helpful for strictly scholarly purposes.[10]

Starting with the initial prize winner, John Russell Pope, the architectural fellows of the Academy (and some students from various American schools who had won architectural scholarships to travel in Europe and who stayed and worked at the Academy) were among the first group of Americans to adopt the venerable European tradition of making measured drawings (*relevés*) of historical buildings—a method that occupied an important position in the education of French architects. Even the Ecole-trained American architects of an earlier generation, such as Richard Morris Hunt, Henry H. Richardson, and Stanford White, had restricted their historical studies to travel sketches. Pioneering efforts were almost exclusively archaeological in nature, such as the fine drawings by Francis H. Bacon in Assos (1881–1882, 1902–1921) and Howard Crosby Butler in Syria (1899–1909) and Sardis (1911–1914).[11] The rich photographic record showing the fellows measuring and sketching classical details at dizzying heights atop improbable-looking ladders reveals the degree of seriousness with which they applied themselves to these exercises (Fig. 6). The study of measured details was the fundamental method for understanding the essence of classical architecture.

The second-year fellows in architecture were required to do a set of rendered drawings from actual measurements and notes of a building of the Renaissance. Again, the subject had to be approved by the director or the professor-in-charge of the School of Fine Arts. During the third year, fellows had to do rendered drawings based on measurements for the restoration of (1) an antique building or group of buildings (until 1919, this had to be from a classical site in Sicily or Greece), (2) a city square or a group of buildings in Italy of the medieval or Renaissance period, or (3) a Renaissance villa. The drawings had to be executed in color and show the existing state of the building as well as a proposed restoration. All these studies were to be supplemented by a short historical and descriptive essay.

But the project that was considered to be more important than any other

and critical in demonstrating the original goals and ideals of the Academy was the Collaborative Problem, an annual four-week competition among teams composed of an architect, a landscape architect (after 1921), a sculptor, and a painter (Pls. 1–46). The Academy underlined the nature and importance of the Collaborative Problem for its educational policy:

The question of collaborative work is of vital consequence. It is in the realm of architecture that this country must, as have all countries before it, find its completest material expression; architecture in all its manifold forms; of landscape setting, town planning, groups of buildings, as well as individual structures; architecture enriched and vivified by the sister arts of painting and sculpture. What every serious person who contemplates the works of bygone splendid days must realize, is that who produced those works did so in unison; the architect did not design a building *in vacuo*, with spaces left which some bewildered painter of easel pictures would weaken and fail to decorate, or on which the sculptor, untrained in architectural form, would stick his figures like jugs on a mantelpiece. Far from it, they were all, in a sense, architects; frequently they were actually so. . . . We are almost as far from this today as though it had never been, and we must have it back again. . . . We shall get it by throwing the chosen men themselves together, for sufficient lengths of time, in close personal association during their formative period, and in constant, richest atmosphere of such masterpieces as will tell them the story over and over again.[12]

The theory of the alliance of the arts, and the fostering of a sympathetic feeling and understanding among them, is as engaging and valid now as it was then. But by conducting this alliance solely along the lines of Renaissance sensibilities (and retaining the Renaissance as the primary model for artistic collaboration), the Academy found itself, over the years, opposing the sensibilities of its own time and neglecting certain practical considerations. For these reasons mainly, the Collaborative Problem became extremely controversial and caused considerable friction between the fellows and their supervisors and unhappiness among the trustees. It was discontinued after the Second World War.

In the beginning, the Collaborative Problem was unstructured and informal. The subjects were issued and the results were judged by the director in Rome. After the First World War, acting on the suggestion of Harold Van Buren Magonigle, who had been a Rotch scholar in architecture at the Academy in 1894 to 1895, the American Institute of Architects offered a prize for the winner. This established the Collaborative Problem on a more serious footing. The problem was prepared and judged by a committee in New York composed mainly of the trustees of the Academy (ordinarily, by the special committee of the School of Fine Arts). The members of the jury made their

criticisms and comments for the contestants in a separate report after the judgment.

During the 1920s and early 1930s, the design of the winning team was published in one of the major architectural journals, such as the *Journal of the American Institute of Architects, Pencil Points,* or the *Architectural Record.* The project lost much of its original luster and seriousness for both the fellows and the trustees of the Academy after the mid-1930s and became merely a requirement, a chore, to be satisfied as quickly and painlessly as possible. After much vexation in New York and Rome, the trustees decided to take a less active role in the project; once again, the problems were issued and judged by the director in Rome, and perfunctory reports were sent to New York, assuring everyone of the smooth operation of the system.

Occasionally, disagreements arose between the director and a fellow on the issue of required work. Frictions were also caused by complaints about the general conditions of life at the Academy: the poor quality and insufficient quantity of food, inferior service, inadequate heat, insufficient money. According to the entry for April 18, 1917, in Director Gorham Stevens's diary, Allyn Cox, a first-year fellow in painting, telephoned from Florence and informed Stevens that he was not coming to Rome for the Collaborative Problem and refused to work under the sponsorship of the Academy any longer. The next day, Stevens wrote a letter urging him to return. Evidently, Cox did return and worked on the Collaborative. But there are numerous entries in the diary concerning Cox's "insulting" the Italian servants and associates of the Academy, "complaining about food for an hour," and, on November 4, 1917, insulting even Stevens himself: "Telling me I was working for a decoration" (that is, neglecting his duties as the director of the Academy and spending too much time with the Red Cross; Stevens was a Red Cross captain during the war years). Subsequently, Cox became a resident painter at the Academy, served on the painting jury five times, and was generally a staunch and conservative supporter of the Academy ways he had once rebelled against.

The indolence of Edward Lawson, the first fellow in landscape architecture (1916–1919, 1921), caused much discomfort to the director and dissatisfaction to Frederick Law Olmsted, Jr., and James S. Pray, his sponsors at the American Society of Landscape Architects. Many letters were exchanged between Rome and New York on the "Lawson Case," Lawson himself writing to Pray in frantic self-defense: "Ever since I have returned to the Academy, I have been trying to make every minute count and to this aim I never see bed until the morning hours"[13] (Fig. 9). Stevens's own view of the young man was less than enthusiastic. Writing to Olmsted on May 10, 1920, he suggested

[9] Edward Lawson (FAAR, 1916–1919, 1921) in his studio in 1920: "Ever since I have returned to the Academy, I have been trying to make every minute count and to this aim I never see bed until the morning hours" (E. Lawson to J. S. Pray, 12 December 1919).

that "in the future, the personality of the candidate be carefully taken into consideration before he is appointed. Lawson is a very agreeable and pleasant young man but he lacks gumption and he is far from a hustler. His general education is also limited." Contrary to Stevens's expectations, Lawson did achieve success, by waiting without hustling: he returned to the Academy as a professor of landscape architecture in 1928, and was very much honored by Stevens, who was still the director. In fact, Lawson, in his capacity as a resident professor, had an opportunity to offer advice on a case in landscape architecture similar to his own.

Richard Webel, a fellow in landscape architecture (1926–1929), was also criticized severely for neglecting his work and traveling too much. Webel wrote a charming ten-page letter to Ferruccio Vitale, who was his sponsor in landscape architecture in New York and a trustee. He explained his case, assured Vitale of his "full cooperation with the officials," and ended by asking for extra money in order to make a color movie on Italian villas.[14] In a letter dated April 25, 1927, Vitale cautioned Webel "against too great an exuberance" in his traveling, advised him that he should not take it upon himself to conduct tours of Italian gardens for every American traveler, "not even for the members of the Garden Club of America, who have established your fellowship," and instructed him to abandon the film venture.

Exuberant and outgoing as ever, Webel continued his travels undaunted ("Spain . . . a short trip to Paris . . . a tour of the Chateaux country . . . vacation at the Black Forest with mother . . . a course of treatment at Heidelberg") and continued to charm the visiting members of the Garden Club. But he wrote more frequently and enthusiastically to Vitale and reported how much he enjoyed the Academy during his short stays there:

Though the spirit last year was good, this year (1927) it is superb. The elimination of the visiting students as an integral part of the Academy . . . has had a salutary effect in many ways. . . . We have a splendid Fellow in Rapuano, and I am delighted to share Landscape honors with him. . . . We have decided to cooperate closely in our work and visits. . . . We certainly have a corking group of men. Everyone of them is a prince. . . . Rome is full of sun and roses. Rapuano and I have been playing in the tennis tournament with the British Academy.[15]

Vitale's worries about Webel's future also proved entirely groundless: Webel succeeded in becoming a professor at the Harvard School of Design from 1929 to 1939 and was the resident in landscape architecture at the Academy in 1963, while his friend and colleague Michael Rapuano was its president.[16]

Despite this kind of evidence, which suggests that some of the fellows found required work wearisome, the overall production of architectural drawings, sketches, and rendered restoration studies by the fellows of the Academy is impressive in volume and is generally high in quality. Starting in 1904, annual exhibitions in Rome of the works of architects, painters, and sculptors became a tradition that is still preserved (Figs. 10, 11). Along with those of other national schools, these exhibitions were something of an event in the cultural calendar of the city and were often attended by the king and queen of Italy and the American ambassador (Fig. 12). In the spring of 1930, the Academy participated, with sixty-five photographic enlargements of architectural drawings, in an important exhibition of Italian villas. The exhibi-

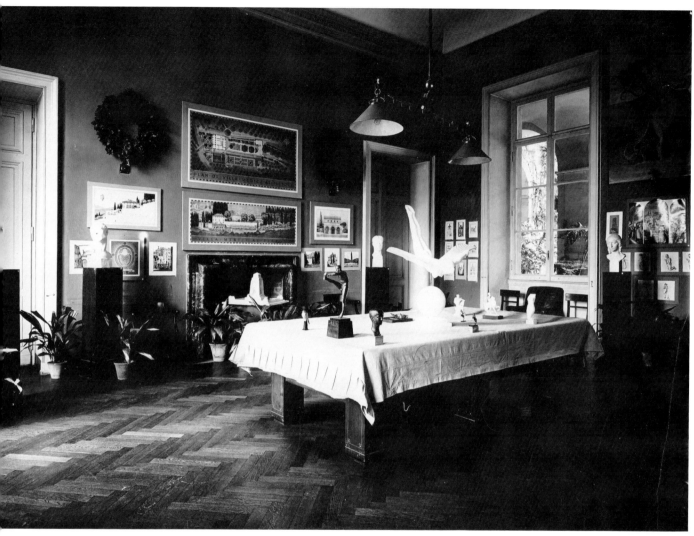

[10] Annual exhibition at the American Academy in Rome, 1925.

tion was held at the Palazzo Vecchio in Florence. According to the director's report of that year, the exhibition catalogue described the American architect's drawings as the most accurate of all those displayed.

The first exhibition in the United States of the fellows' works took place in New York in 1896. In subsequent years, Academy exhibitions of a semi-official nature were held in several galleries and clubs, such as the Grand Central Galleries and the Century Club. Between 1910 and 1930, the American Academy in Rome was regularly included in the prestigious annual exhi-

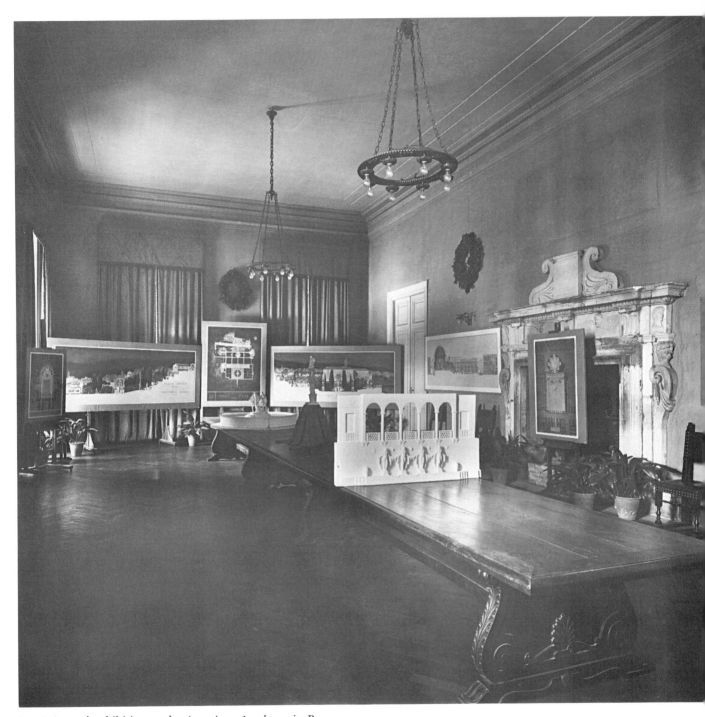

[11] Annual exhibition at the American Academy in Rome, 1929.

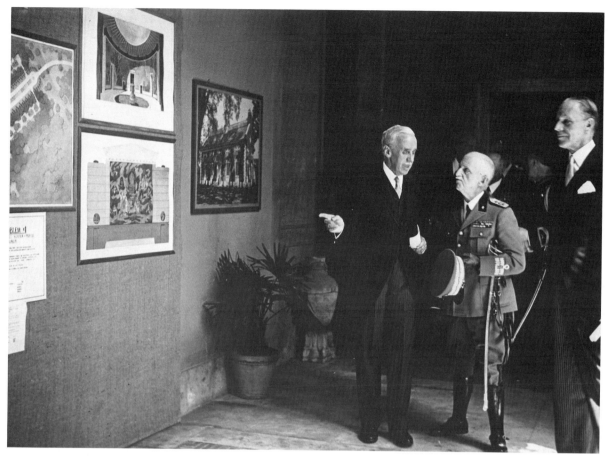

[12] King Victor Emmanuel II of Italy, Director Chester A. Aldrich, and Ambassador William Phillips at the opening of the annual exhibition, 1939. Aldrich commented on the back of the photograph: "Trying to explain what is meant by a 'Collaborative' (without much success)!"

bition of the Architectural League of New York, and the works were published in the League's Yearbook. Apart from these semiofficial events, fellows' works were often solicited by various schools and institutions of architecture throughout the country.[17] At the New York World's Fair of 1939 and the San Francisco Golden Gate Exposition of the same year, the Academy was represented by the works of thirty-three of its fellows and published a special booklet illustrating some of their works (Figs. 13, 14).

In addition to their appearance in the Annual Reports of the Academy and in occasional promotional pamphlets, the measured drawings and the restoration studies by the fellows were published in some of the early issues

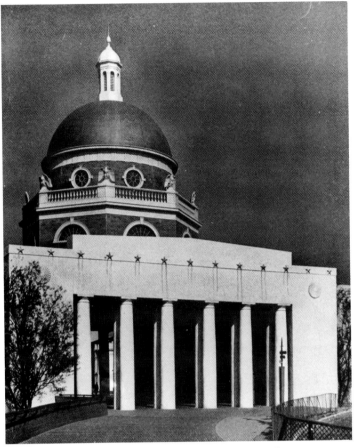

[13] James Kellum Smith (FAAR, 1923), Court of States, 1939. Golden Gate Exposition, San Francisco.

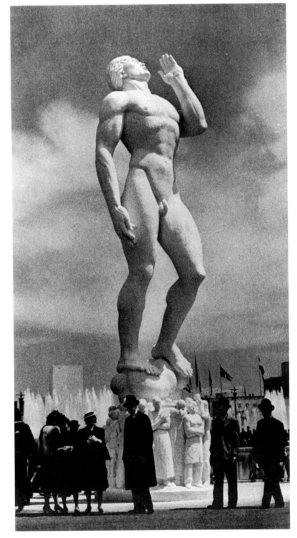

[14] Leo Friedlander (FAAR, 1916), statue group at the Court of Peace, 1939. Golden Gate Exposition, San Francisco.

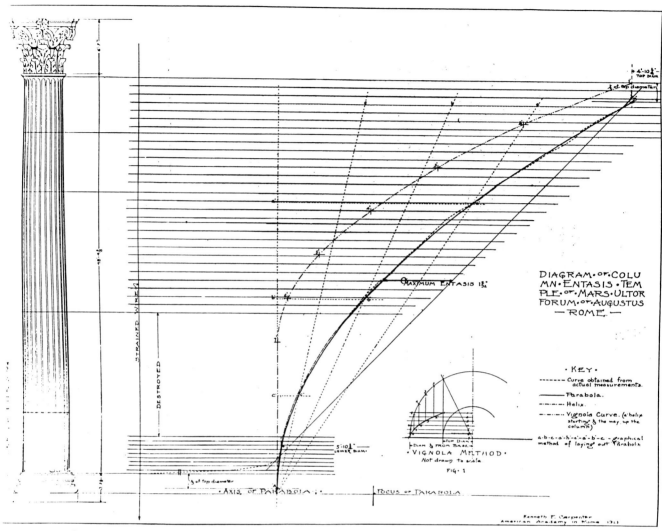

[15] Kenneth E. Carpenter (FAAR, 1913), study of the entasis of the columns of the Temple of Mars Ultor, Rome.

of the *Journal of the American Institute of Architects* (1913–1914). Appearing under the title "Rome Letter," these drawings were accompanied by short descriptive essays[18] (Fig. 15). More extensive coverage of the restoration studies and slightly longer articles are found in the Academy's *Memoirs*.[19] A few of the fellows in landscape architecture published lists of or small guides to Italian villas and English gardens. Some of these "publications" were privately printed or simply typewritten and were bound in homemade folders; they are not likely to be found anywhere except the Academy li-

brary.[20] No single publication collected the impressive output of the fellows' measured drawings and archaeological restorations or their Collaborative Problems.[21]

Of particular interest is Eric Gugler's fine study for improving the approach to St. Peter's Basilica, presented to Pope Benedict XV in 1915. Gugler, a McKim fellow in architecture from Columbia University, proposed a straight tree-lined avenue with sets of reflecting pools in the middle, terminating at a circular piazza on the side of Ponte San Angelo. Gugler's design anticipated the present scheme (1936–1950) by decades, but it was a more sensitive solution[22] (Fig. 16).

In 1923, the Academy again established a working contact with the top level at the Vatican when Franz Cardinal Ehrle obtained permission for the second-year fellow in architecture, Victor L. S. Hafner, to study the dome of St. Peter's (Fig. 17). Hafner's careful structural study led to the discovery of cracks in the dome and in the buttresses, which caused some alarm. These cracks were probably harmless, but Hafner took the damage seriously and even sought to engage a concrete expert from New York to advise on the right cement compound for filling in the cracks. There is some indication that the

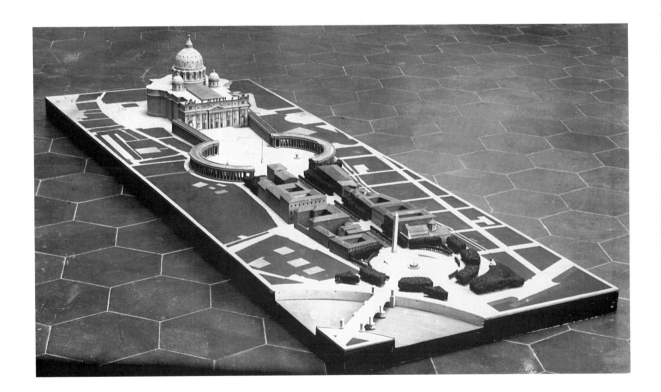

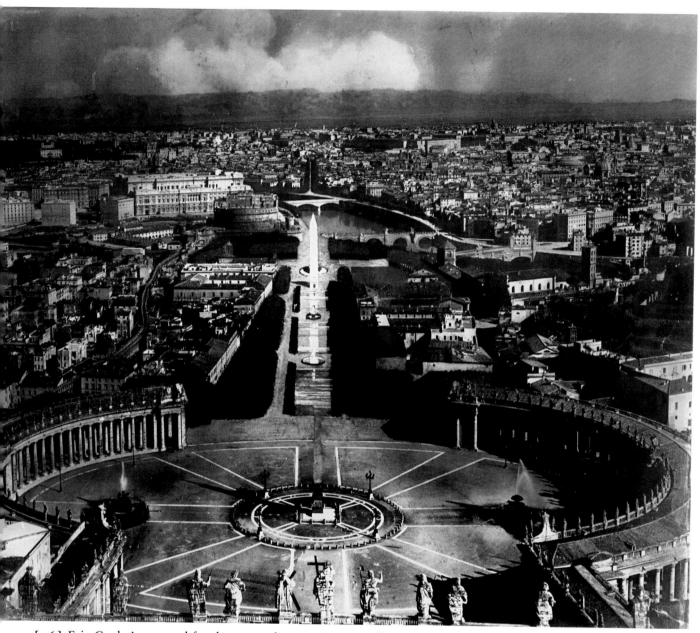

[16] Eric Gugler's proposal for the approach to St. Peter's Basilica,
presented to Pope Benedict XV in 1915. Model (*left*) and photo-montage
study (*above*) of the mall and the reflecting pool.

[17] Victor L. S. Hafner (FAAR, 1922), structural study of the dome of St. Peter's Basilica, 1923.

Vatican did not appreciate the concern and publicity, and no remedial action was taken to restore the dome. Hafner's energy was diverted to build a replica of Michelangelo's famous model of the dome, and his attempts in this direction were more enthusiastically received. The gigantic model (over 20 feet high) was the sensation of the annual exhibition of 1924 and was subsequently bought by the University of Cincinnati[23] (Fig. 18).

[18] Model of the dome of St. Peter's built by Hafner and shown at the annual exhibition of 1924. It is a replica of Michelangelo's model. (Shown in the entrance hall of the Academy main building.)

V. The Educational Policy
of the Academy and the
Concern for Classicism

The course of instruction at the Academy was never clearly and permanently established, and it continued to be an issue of debate into the 1940s. Charles F. McKim believe in a strictly traditional "menu" that controlled and restricted the students' choice of architectural monuments and required of them a certain amount of work to be produced by the end of each year. As early as 1894, a committee on the plan of study had been organized. It was composed mainly of McKim's friends and the core group of the Academy founders, but it also included, by invitation, the heads of the fine-arts and architecture departments of several eminent universities.

McKim's "plan of study" met with unexpected opposition from the outside committee members, but primarily from William R. Ware, the head of the Architecture School at Columbia University and a pioneering educator who, in 1868, had organized the first school of architecture in the United States at the Massachusetts Institute of Technology. McKim was alarmed at Ware's progressive and lenient policy, which would have allowed students to travel in Europe without supervision and choose their own examples of architecture to study.[1] This policy, he believed, would lead to laxity among the students and turn the Academy into "a kind of architectural club where the Secretary would be the dragoman to speak to tourists in architecture." The enthusiasm of the influential group behind McKim, augmented by the persuasive power of $15,000 that they had been able to raise ("sufficient to defray the expenses for three years"), prevailed. Yet during the years preceding the First World War, when neither the course of study nor regular fel-

lowships had been firmly established, the students, indeed, enjoyed a fair degree of flexibility in choosing examples in styles outside the sanction of the Academy. Besides pure classical exercises, such as the measured detail drawings of the Erechtheion in Athens and the Theater of Marcellus in Rome, John Russell Pope left a fine watercolor study of the polychromatic Gothic vaulting of Orvieto Cathedral, and Harold Van Buren Magonigle "succumbed to the charms of Doge's Palace" in Venice (Figs. 19, 20). Even during the war years, Philip Trammel Shutze's (FAAR, 1917) interests embraced the decorative and Manneristic motifs of sixteenth- and seventeenth-century Italian architecture, although he presented them in subdued and harmonious compositions. As observed by Mary N. Woods, "McKim could not completely curb the American penchant for the decorative and picturesque."[2]

Ironically, the educational policy of the French Academy in Rome, which had been an early source of inspiration and a sort of model for the fledgling American institution, appears to have been somewhat more lenient during the first few decades of the twentieth century. In an essay written in 1921 that compared the two academies, Charles H. Meltzer observed that the French *pensionnaires,* unlike their American colleagues, were not considered "students," but were full-fledged artists and architects: "They are not nailed down by rules of art conventions. They are expected to turn their shares of work. Aside from that, they do just as they please. . . . No one dictates [to] them or tries to shape the courses they may have chosen for their art." Meltzer noted that there was a genuine desire to advance the cause of art at the American Academy, "though not exactly on the free, broad lines in favor at the French Academy."[3] He questioned, in particular, the principles of the Collaborative Problem, on the grounds that it might discourage individualism and force the students into a stiff mold, although the French Academy, during those decades, did not produce any artist of note. He was told by Frank P. Fairbanks, the professor-in-charge of the School of Fine Arts, that the primary concern of the American Academy was not to encourage individuality among the fellows, but to inculcate the theory of the interdependence of the arts and to develop general taste. Fairbanks defended the American position vis-à-vis the French:

We have been charged with thinking more of education than of accomplishment. We have been told that we are "academic." And so, but not in an offensive sense, maybe we are. And, none the less, the school may do much good. It must be good for the students who come here to enjoy the companionship of others who love art, to exchange ideas about their respective interests, and learn how true it is that no one art can stand alone.[4]

[19] John Russell Pope, "Full Scale Drawings" of column-base details, Theater of Marcellus, Rome, 1895 (unpublished).

[20] John Russell Pope, watercolor study of Orvieto Cathedral, 1896.
(*Pencil Points*, December 1974)

It has been pointed out that McKim, in setting forth the educational policies of the Academy, had acted with the best possible intentions. He was unaware that, unlike his own experience as a student of architecture in Paris, the fellows of the Academy, mature young professionals in their mid- or late twenties, did not need the kind of close guidance and the regimen needed by a

young and inexperienced American student at the Ecole.[5] Taken as a whole, the administrators and the trustees displayed a tendency, almost a desire, to see the fellows dependent on their experience and knowledge of the world. The older men wished to guide, protect, and, if necessary, discipline the younger men on their path to maturity and success—sentiments that offer a parallel to the heroic ideal of male friendship of the ancient Greeks. One might detect a glimpse of the subtle psychological depths that may have existed in the trustee–fellow, old man–young man relationships in some of the documents of the period, such as a letter written by Jesse Benedict Carter, the first director of the Academy after the merging of the two schools. The letter is addressed to William R. Mead, the president of the Academy, and is dated January 28, 1913:

We are working for the humanities in their relation to the future of America and the most important element in our work is not the attitude of the society or the approval or disapproval of the world at large, but rather the attitude of our young men themselves—the members of the student body, who are after all our only object. We keep them in check; we curtail them here and there; sometimes we discipline and punish them and we guard any feelings of excessive importance on their part, and yet, after everything is said and done, they are the most important, the only element in our institution. For them we labor; for them we do what we are doing, and for their advantage we are raising this institution, knowing that if they are the sort of men we think them to be, our efforts will not be in vain and they will return to America to give it the beauty and light, the strength and sweetness which we need.[6]

Of the two basic obligations of a fellow in architecture, the first, completing a prescribed amount of work by the end of each year, calls for no great justification and, with the exception of the Collaborative Problem, caused no problems. To do rendered drawings and to measure, record, and restore historical monuments were part of the normal training in architecture, which the fellows had been quite used to in their previous schooling; and such projects were in the tradition of other national academies in Rome. These exercises also gave the fellows their first chance for exhibition and recognition. Besides, the amount of work required in a year was not very much and left considerable time for traveling, sketching, and pursuing personal interests. However, the requirement that the archaeological studies, as well as the Collaborative Problem, be in a historical style approved by the Academy restricted individual choice and judgment, and became the major cause of dissension in the educational policy of the Academy. The wisdom of this doctrinaire policy, untenable now, was seriously questioned then by many

outside artists, educators, critics, and art historians, and by many of the fellows themselves.

McKim and the founders of the Academy believed that the classical and Italian Renaissance styles in architecture represented the most refined taste and were the most suitable mode to serve the future architectural needs of America. The enthusiastic approval of classicism by the profession and the public at the 1893 Columbian Exposition, and the fine models set by buildings like the Boston Public Library gave strength to their belief. Furthermore, classicism had been given preeminence over other historical styles by the United States government. In an article of 1902 supporting the establishment of the American Academy in Rome and the classical tradition it served, Senator James McMillan, the sponsor of the Senate Parks Commission Plan for Washington, D.C., observed:

There is universal agreement in Washington that, in the great revival of building about to begin at the national capital, the universal or the classical type of architecture shall prevail. It is, therefore necessary that opportunity be offered to American students to study in detail the architecture of Greece and Rome.[7]

For many, the adoption of classicism as the new, desirable style for the nation also meant the rejection of all others, particularly the modern. Francis Millet, representing the trustees and the executives of the Academy, was one of the most ardent of the supporters of classicism as the only style worthy of studying. He wrote in 1905:

The project [the Academy] originated in the revival of the forgotten belief in the sound lessons of antique art, which was the most valuable result of the Chicago exhibition; in the revival, after a period of worship of ignorant originality and the perverted spirit of invention in modern art, of a sane and healthful respect and veneration for the masterpieces which have stood the test of time and have remained for centuries superior to caprice and fashion.[8]

McKim himself, although disarmingly spontaneous, was no more moderate than Millet in his distaste for modern and functionalist tendencies in architecture and in his determination to protect the Academy against such dangers. Writing to Daniel Burnham about the candidates to be sent to the Rome Prize competition by the Chicago Architectural Club, he insisted that "all designs be classic in character. . . . [Otherwise] you will be likely to get all kinds of Yahoo and Hotentot creations which prevail in the East and still occasionally crop up in the West."[9]

McKim's and Millet's views on the importance of classicism as a model for American architecture echoed the views of many of the participants in the Columbian Exposition expressed in the 1890s. Henry Van Brunt observed in 1892 that the classical style of the opulent buildings gathered around the Court of Honor would serve as an "object lesson . . . of the practical value of architectural scholarship . . . [and] serve as a timely corrective to the national tendency to experiment in design." Van Brunt hoped that the education of architects in pure classical models "will prove such a revelation that they will learn at last that architecture cannot be based on undisciplined invention, illiterate originality, or indeed, upon any audacity of ignorance."[10]

Kenyon Cox, a noted muralist, one of the founders of the Academy, and an occasional jury member in painting, presented the case for traditional classicism in a more mellow and defensive tone in 1911. Cox was relieved to find that the American people were by nature conservative, particularly in matters of art. He admired the classicism of the architecture of his day and hoped for the emergence of a national style in the classic mode in due time: "If we strive for originality now," he cautioned, "there is little hope of anything better than the architectural chaos we have heard so much of."[11] The idea was echoed by Charles H. Cheney, writing for the Academy's interests in 1912, one year before the Armory Show in New York: "A thorough knowledge of the classic forms is a proper steadying influence to the strong modern tendency to originality, which untutored, generally has ended only in the bizarre."[12] The safeguarding of the fellows against the unwanted influences and styles had already been spelled out firmly in the 1896 catalogue of the Academy: "The founders believe it to be of the utmost importance for an architect . . . to study on the spot the typical monuments of Antiquity and such works of the Italian Renaissance as are worthy of being considered their successors."

The restricted architectural menu, consisting of courses in Greek, Roman Imperial, and Italian Renaissance architecture, was to be prepared either by the Academy's own officers in New York or by one of its associates in Rome, who according to McKim should be "a qualified pilot who has been over the ground and who will see that they [the fellows] spend their prize money *on the greatest examples* and are not allowed to foolishly spend their prize money on their immediate selections."[13] In fact, the "qualified pilot" was the director in Rome, the head of the School of Fine Arts, or an experienced resident whose views on architecture could be trusted to agree with those of the board. Although there was a general consensus that monuments with Manneristic and baroque tendencies were not "worthy successors of Antiquity," some ambiguity exited in deciding what exactly these unapproved

monuments were and how far an architect of the past could be allowed to transgress the restraining qualities of unity, harmony, and balance before his work could be considered decadent. Michelangelo, particularly, gave the pilots much trouble. There was no getting around the towering artistic stature of the man. Yet he did display just those unwanted qualities of inventiveness. And he did deliberately violate the canons of classical design. In a letter to Edwin H. Blashfield written in 1899, discussing a list of Renaissance architects recommendable to the fellows, McKim suggested

that the names of Vignola and San Gallo be coupled with that of Bramante in the reference to churches; and that Michaelangelo belongs to this category rather than among the creators of palaces; the half a dozen first and most typical examples being, say, the Cancelleria and Giraud by Bramante, the Massimi and the Farnesina by Peruzzi and the Farnese by San Gallo, and finally St. Peter's, for which Michaelangelo deserves only curses for his brutal interference, the cornice attributed to him having really been carried out by Vignola (see Le Tarouilly). This is only a suggestion intended to give Michaelangelo the credit for his conversion of the Baths of Diocletian into the Church of Santa Maria deghl' Angeli, and especially for the dome of St. Peter's. With these exceptions, is it not true that he has left but little which is entitled to be considered amongst the masterpieces of the Renaissance in Rome?[14]

The dislike for baroque architecture was not a sentiment restricted to McKim and his Academy associates. Well into the twentieth century, it was the common opinion of those professionally connected with art and architecture that there was little to learn from and much to avoid in Italian architecture of the seventeenth century—generally considered to be a period of decadence characterized by bizarre and irresponsible experimentation with the classical orders, of an almost "hystrical scramble for novelty." This disparaging appraisal of Mannerism and the baroque had its roots in the art criticism of Jacques François Blondel and the nationalist—or rather, anti-Italian—currents in French architecture in the mid-seventeenth century connected with the redesign of the Louvre and the founding of the Academie Royale d'Architecture. Although during subsequent centuries architectural practice in France exhibited much of the freer tendencies of the seventeenth century and gave birth to styles based on the creative synthesis of French and Italian sensibilities (predominantly through the influence of Michelangelo and Palladio), the academic and theoretical point of view remained essentially antibaroque.[15] This was, at the turn of the century, the historical and intellectual crucible in which the aesthetic judgment of generations of Beaux-Arts–trained architects—almost all of the names behind the American Academy—was formed. And this was the image represented in the great majority of

architectural-history books found on the shelves of the architectural library of the Academy.

Given these convictions, one might question why the Academy was founded in Rome, the cradle and home of seventeenth-century baroque architecture, rather than, say, Florence. But the Academy saw in Rome's architecture what it wanted to see, and some of the buildings and their details, which we would describe today as Mannerist or even early baroque (such as the Villa Giulia by Vignola, Vasari, and Ammannati; the Palazzo Massimi by Peruzzi; and Santa Maria della Pace by Pietro da Cortona), it saw strictly as a part of the Roman Renaissance. Some of the architectural aberrations even had some educational value, as Director Gorham Stevens saw it: "The very fact that Rome possessed the noblest conceptions of art side by side with the most bizarre, permitted the student to rectify his judgment by immediate comparison and to form his taste along pure and simple lines."[16] Still, the assessment of an artist like Bernini must have been problematic to the Academy's board because it would require criticism of his dynamic sculpture but admiration for the sublimity of his Piazza San Pietro. His Scala Regia might have been dismissed as a childish architectural joke.

There were a few architects of the seventeenth century, however, who the Academy and architectural critics in general could, unequivocally and without fear of challenge, ostracize. Foremost among these untouchables, who were never assigned for study (and whose works were repudiated in all historical source books available to the fellows at the Academy), were architects like Guarino Guarini and Filippo Juvarra from northern Italy and, most vehemently, Francesco Borromini of Rome. For Borromini, there was no forgiveness. His name had become the symbol for all that was regrettable in seventeenth-century architecture, an artistic Lucifer who even the most moderate and charitable historians felt obligated to condemn in the name of good taste and decency. "The absence of any logic, the hatred for simplicity, . . . a marked tendency towards complexity and willful originality, above all else an insatiable desire to surprise"[17]—this is how some of the sins of Borromini's architectural genius were listed in the much-thumbed copy of Georges Gromort's *Italian Renaissance Architecture* in the Academy library. And the guardians of taste at the Academy saw eye to eye with him. The works of these baroque masters, represented by not a single sketch or drawing among the thousands produced by the fellows between 1895 and 1940, became a kind of spiritual and visual touchstone for the fellows and the residents in the 1960s and continues to be so.

VI. Conformity and Dissent at the Academy During the 1920s and 1930s: The Collaborative Problem and Accepting Traditional Modernism

The educational and architectural policy on which the Academy was founded was an extension of architectural thinking and development in the United States during the second half of the nineteenth century. It was also a reflection as well as an application of the beliefs and experiences of the Academy's principal founders, whose professional and artistic lives were rooted in the past. Yet profound changes in art and architecture were in progress, especially in Europe, by the end of this period. Into a new century alive with the spirit of search, experiment, and creativity, bristling with new intellectual and artistic currents, the Academy was ushered as an anachronistic institution entrusted, ironically, with the mission of shaping the future of architecture. How untenable the themes and ideals supported by the Academy were becoming vis-à-vis the developing sensibilities of the day can be best understood by studying the documentary evidence that illuminates its internal history. Although this material is incomplete, the candid nature of what has been preserved allows clear, if somewhat disconnected, views of the relationship between the fellows and their supervisors and of the artistic and educational program the fellows were expected to follow. It also offers a valuable insight into the fellows' reaction to this program, and their approval or rejection of it or the ideology behind it.

General supervision and direction of the students, which had never been very strict in the early days, became more rigid soon after the First World War, corresponding roughly to the completion of the new building and the organization of the Academy into two schools: Fine Arts and Classical Stud-

ies. On December 12, 1917, Gorham Stevens, then the acting director, did not have enough student projects to send to the New York Architectural League exhibition, and he expressed his disappointment in a letter to C. Grant La Farge, the secretary of the board:

Davidson [George Davidson, FAAR 1916, painting] is now in his fifth year, and he has nothing which he considers sufficiently finished to exhibit. Nebel [Berthold Nebel, FAAR 1917, sculpture] has just finished his three years and has nothing to cast which he can exhibit. Stickroth [Harry I. Stickroth, FAAR 1917, painting] will end his three years this month: at the moment he has nothing finished. . . . I realize that these young men here are struggling to find themselves, but I don't think that they should struggle for three years without finishing at least some small things, if they have got to be able to finish big things in after life.[1]

As a remedy to this frustrating situation, Stevens proposed that in the future the work of the fellows be sent to New York at the end of each year to be approved by the trustees: "If a student's work is bad, he is not reappointed for the next year; the student whose work is exceptionally good receives a money prize." And he made the reasons for this suggestion perfectly logical and clear, explaining that it was much easier for the board to exercise that sort of control over a fellow than it was for the director of the Academy as an individual, "especially when that individual must live on intimate and cordial terms with the men."

One has to take into account that these were hectic war years, and the fellows often had to take time to do Red Cross work. After all, Nebel did manage to cast his piece, which was shown in New York in 1920, but the expressionistic and dynamic style of the work, showing two wrestlers, did not meet with the approval of the trustees (Fig. 21). In a letter to Stevens dated October 16, 1918, concerning the projected trip to Rome of Charles Adams Platt (a successful New York architect who subsequently became a trustee, the vice president, and the president of the Academy), William Mead took time to express his views about the piece:

I want to say quite frankly and confidentially, that the photograph of Nebel's "Group of Wrestlers" was a great disappointment to me. I do not say that it is not fine in its own way, but I must say, from my point of view, it does not in any way represent the type of work our Academy students should do while at Rome. . . . It is anything but Rome or Greece, and would never have been done if Rodin had not set the pace. It certainly is not academic and compares very unfavorably with the work done by Manship, Polasek or Sherry Fry [Fig. 22]. . . . Do they do that sort of thing at the French Academy?[2]

[21] Berthold Nebel (FAAR, 1917), *Wrestlers*. Shown at the New York Architectural League exhibition in 1920, it was a great disappointment to President William R. Mead, who wrote to Director Stevens: "It does not in any way represent the type of work which our Academy students should do while at Rome."

[22] Paul Manship's much admired *Duck Girl*, 1914. The type of work encouraged at the Academy.

He added in a postscript: "When Platt saw the photograph . . . he was as shocked as I was. He said, 'You don't want to send a man to Rome for that sort of thing, you ought to send him to Germany.'"

It seems that Rodin, whose work had already received universal acclaim, was posing somewhat of a threat to the Academy. In a paper defending the American Academy and academic training in art, read in 1911, Augustus Saint-Gaudens himself had paid tribute to Rodin as "one of the leaders of the movement against academic training . . . [who has an] extreme power of expression," but was quick to emphasize the beneficial effects of Rodin's own thorough academic training during his early career. Apparently, the great sculptor had visited the Academy on February 9, 1915, two years before his death. "Rodin called on us," Stevens recorded in his diary in his fine laconic style. One would have much liked to know more about this event (as the Valentines point out), but it appears that the occasion was accorded no greater significance than teas with the Princess Torlonia or tennis games at Parioli. Stevens always took the trouble of noting in his diary whenever he introduced an outside artist to the fellows or took him up to their studios. Rodin must have been thought the perfect example of that "foreground interference" from which Edwin Blashfield wanted the fellows sequestered. On that account, however, Stevens had nothing to worry about—yet. In 1919, Samuel B. Trowbridge of the Executive Committee visited Rome in order to ascertain "whether the American Academy was organized and conducted in a manner to fulfill the purpose of the Founders." His report was encouraging: "There is no taint of that sordid Bohemianism which so often invades artistic communities"[3] (Fig. 23).

Soon after the war, the peaceful state of affairs was disturbed by tendencies more deeply disconcerting than mere "sordid Bohemianism." Young landscape architect Edward Lawson's visits, during his travels in 1921, to villas "belonging to a decadent period of the Renaissance" had not gone unnoticed. During the same year, Frank Fairbanks (FAAR 1912, painting), the newly appointed professor-in-charge of the School of Fine Arts, took the fellows on an excursion to two "monumental examples of Barocco decoration" (unfortunately, we do not know which). While the technical proficiency of these works was admired, the primary intention of the outing was to show "the colossal misuse of technical abilities to perpetuate such overwrought flamboyancy."[4] Despite the salutary effects expected from such exercises, general student interest in the baroque seems to have reached a hazard level that induced Fairbanks to include a paragraph of reckless enthusiasm in his first Annual Report sent to the board of trustees:

[23] The fellows at dinner. Academy main building dining hall, 1917–1919.

That the 17th century flurry that has of recent years held in thrawl [*sic*] a number of our men, is in its final stage seems certain at this writing. We haven't the slightest doubt that it will again display a brazen countenance at an inadvertent moment but we expect to have ready for it a large and effective club so beautiful and alluring to the unsuspecting eye and mind that its recipient will never know what has hit him when he receives it.[5]

This passage was omitted in the final publication of the report.

The continuing interest of the fellows in the periods outside the sanction of the Academy, particularly modern art and architecture, is nowhere better illustrated than in their attitudes toward the Collaborative Problem. The Problem was the only project that placed them in an active position in design

and forced them to come to terms with their own leanings toward originality against the traditionalism of the institution they belonged to. Not surprisingly, it is on this subject that the greatest renitence occurred, pushing the students into alternate patterns of conformity and dissent as the Academy relaxed or tightened its conservative stance.

Many of the earlier fellows (from 1911 to 1913 and from 1915 to 1921) adopted formalistic and Beaux-Arts solutions to the Collaborative Problem (Pls. 1–3). These solutions did not give any cause for alarm even when they seemed to be quite closely derived from recently completed works in the United States, as was the winning design for the Problem of 1915, "Tomb of a Famous Painter" (Fig. 24). The design by Walter L. Ward, fellow in architecture, and his team—Eugene Savage (painter) and Berthold Nebel (sculptor)—displays a possible awareness of H. A. MacNeil's *Soldiers' and Sailors' Monument* in Albany, New York, which was shown at the annual exhibition of the Architectural League of New York in 1913 and published in the League's Yearbook (Fig. 25).

Philip Trammel Shutze's much admired Collaborative Problem for 1920, "A Villa for the American Ambassador in Rome," is one of the finest examples of the creative eclecticism tolerated, even encouraged, by the Academy

[24] Collaborative Problem, 1915: "Tomb of a Famous Painter" (Walter L. Ward [FAAR, 1914–1916], architect).

(Fig. 26). The broad, harmonious façade, expanded by private gardens and service wings on the entrance side, is dominated by a boldly projecting central unit. The design of the bottom half of this unit—with its two-story arcaded loggia and rusticated order, blind arches of the end bays, and battered corner buttresses—derives from the principal façade of the Villa Santa Colombo, a stately sixteenth- to seventeenth-century structure outside Siena (Fig. 27). The top half of Shutze's design has different sources. The prominent attic on the entrance side and the great semicircular *risalto*, flanked by sweeping curves and volutes that crown the garden side, reveal Shutze's preference for the motifs of the eighteenth-century Tuscan villa tradition, such as the Villa La Tana, south of Florence (Fig. 28), or the garden façade of the Villa Gori, near Siena.[6] The side units of Shutze's design—with their simple pilasters, framed panels, and oval windows—echo the sober elegance of the Villa Spada on the Janiculum, a stone's throw from the Academy. Shutze had measured and drawn this villa during the previous year (Fig. 29). He applied this mixture of Italianate ideas on a more modest scale in a

[25] H. A. MacNeil, *Soldiers' and Sailors' Monument*, Albany, New York. Published in 1913, the design seems to have influenced Ward's project for the 1915 Collaborative Problem.

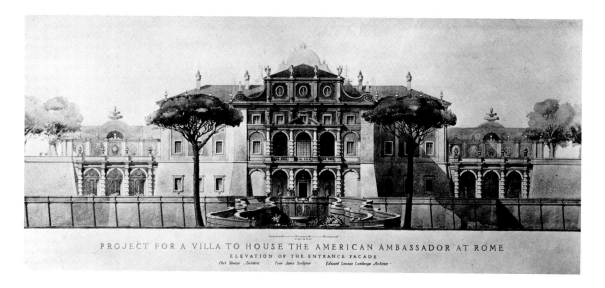

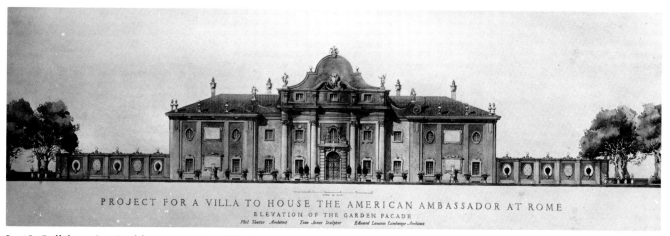

[26] Collaborative Problem, 1920: "A Villa for the American
Ambassador in Rome" (Philip Trammel Shutze [FAAR, 1916–1920],
architect). Entrance façade (*top*) and garden façade (*bottom*).

building that was actually built, the Calhoun-Thornwell House in Atlanta,
Georgia (Fig. 30). Shutze designed this house for his employers, Hentz, Reid
and Adler, in 1921 to 1922, soon after he returned to the United States after
the completion of his fellowship at Rome (Fig. 31). The mural paintings and
the stucco decorations of the Calhoun-Thornwell House were done by Allyn
Cox, the fellow in painting with whom Shutze had collaborated in Rome on
"A Monument to a Great General," in 1920, and who was to become a close,

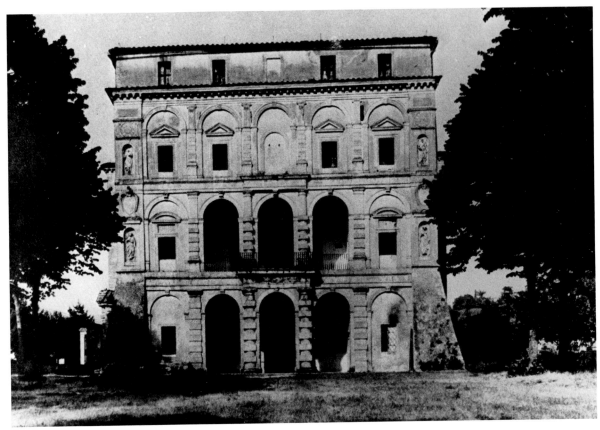

[**27**] Villa Santa Colombo, Siena. Main façade.

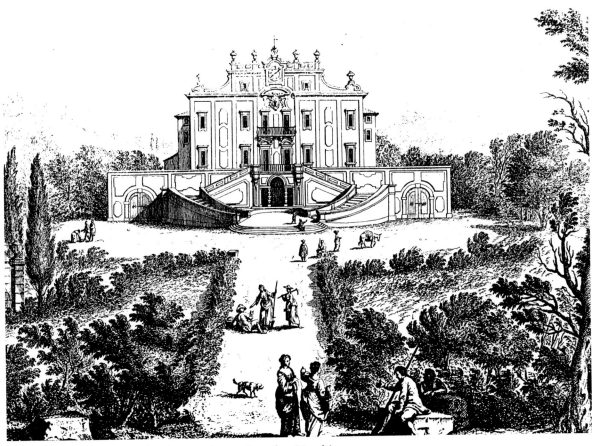

[**28**] Villa La Tana, outside Florence (engraving after Zocchi).

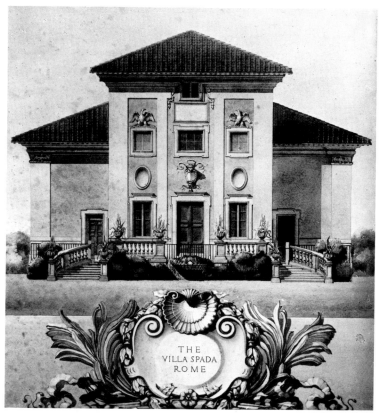

[29] Villa Spada, Rome. Measured and drawn by Shutze in 1919.

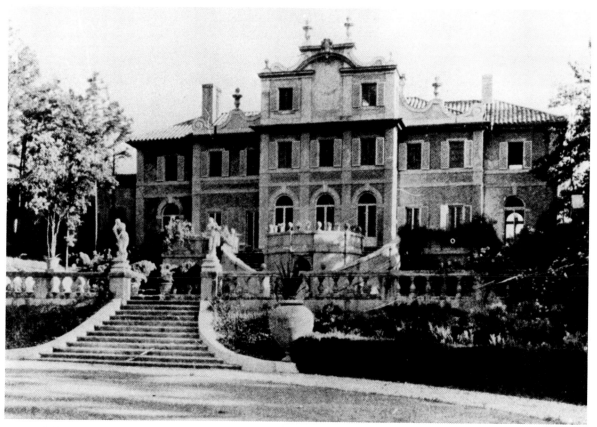

[30] Philip Trammel Shutze, Calhoun-Thornwell House, Atlanta,
Georgia, 1919–1922. Shutze designed the house during the year he spent at
home on leave from his fellowship.

[31] Shutze in his studio at the Academy, 1920. (Seen against the wall are the drawings for the "Circular Pavilion in Hadrian's Villa in Tivoli" and the Villa Spada in Rome.)

lifelong friend (Fig. 32). The Italianate classicism and the villa tradition remained two of the primary sources of inspiration in Shutze's architectural work in Georgia in the 1920s.[7]

The first serious discord over the Collaborative Problem arose in 1923. None of the three teams that competed on that year's Problem, "A Bridge for Children in a Zoological Garden," was worthy of a prize (Pls. 4–7). The design submitted by the team composed of Victor L. S. Hafner (architect), Alfred E. Floegel (painter), and Gaetano Cecere (sculptor) was nothing short of a scandal: a bold Chinese roof carried by four hefty wooden pillars

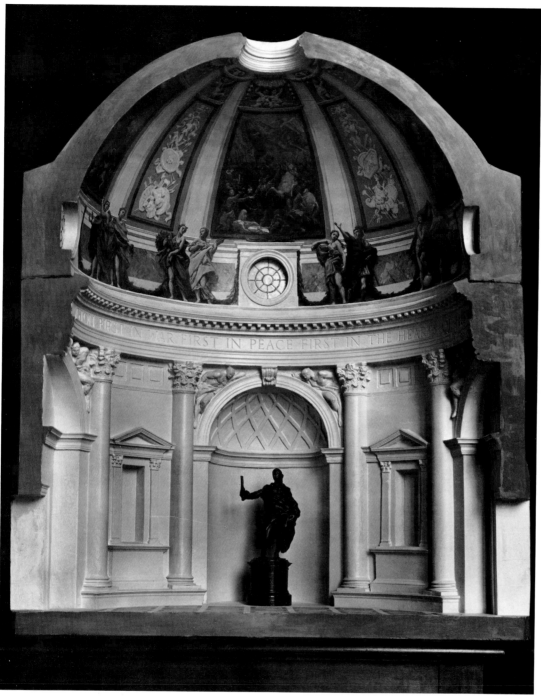

[32] Collaborative Problem, 1920: "A Monument to a Great General."
The plaster model of the project on which Shutze collaborated with Allyn
Cox, fellow in painting.

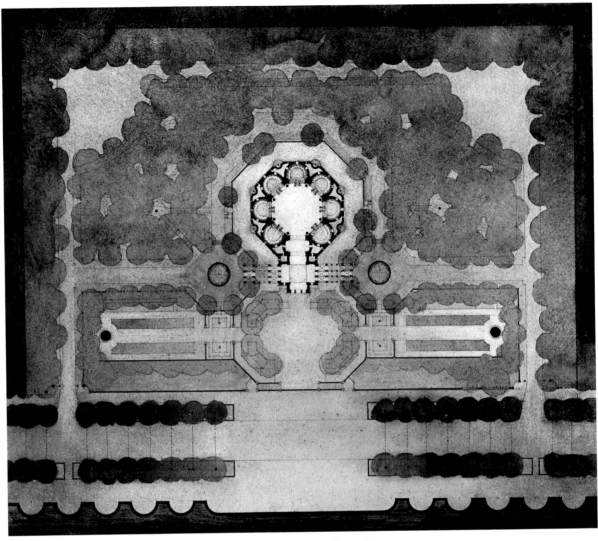

[33] Collaborative Problem, 1924: "A Casino at a Summer Resort"
(Henri G. Marceau [FAAR, 1924], architect).

hovered arrogantly over the sloping parapet of an arched bridge (Pl. 4). The lofty ceiling displayed a decoration vigorous and inventive in its storybook allusions (Pl. 5). The parapet repeated the Oriental motifs. The whole ensemble was an eclectic and handsome fantasy, which might not be displeasing to the modern eye. The shocked jury, however, considered it a flagrant refutation of the Academy's principles; it not only was in a style "so divergent from classic traditions as that of the Saracenic and those of the Far East," but also was not even in the correct traditions of China and Japan. The report of the Fine Arts Committee took pains to point out that "the main object of the Academy in sending young men to study in classical lands is to become

familiar with the culture of those lands, their best traditions in the arts, and to base thereupon all subsequent professional work." Hafner's project was remembered for many years to come. Any future project, however bad, at least "could not be as bad as Hafner's Chinese Bridge."[8]

The Collaborative Problem for 1924 was the first to allow the senior member of each team to choose a program among alternatives as well as to allow the students to choose their own teammates—concessions gained after much pleading and bickering. Promptly, each of the three teams of that year chose a different program: "A Casino at a Summer Resort," "A Scheme for a Garden Motif," and "An Entrance to a Stadium." The winning design, the "Casino," submitted by the team led by Henri Marceau, was a domed octagon whose sides were developed into deep, semicircular niches (Fig. 33; Pls. 8, 9). It was praised by the jury "as being conceived and carried out upon the principles which the Academy desires to see respected and followed, and because the collaborators, without cramping their fancy, have avoided eccentricity."[9] The architecture, which was considered "distinctly classical and in good taste and scale," was clearly based on late antique multilobed, centralized schemes, such as the so-called Temple of Minerva Medica in Rome or San Vitale in Ravenna (Fig. 34). The interior, lavishly decorated in a free interpretation of the Pompeian third style, with its characteristic reds, blacks, and yellows, was described by the artists themselves as "dignified in character

[34] Temple of Minerva Medica, Rome. (Restored plan by F. K. Yegül)

and yet playful in color in keeping with the festive associations of a Casino." The jury expressed some reservations about this combination of reds and yellows. It admitted that classical precedents "evidently greatly favored in Roman antiquity" had been followed, but ruled that such violent combinations "went with the ostentatiousness that was by no means a high quality in Roman art." Mosaics of Ravenna and Early Christian Rome were suggested as alternatives because of their quieter and richer effects, "which would probably be better liked by our contemporaries in the United States."

As for the "Entrance to a Stadium," submitted by a team under Hafner's leadership, the committee viewed it as "unworthy of serious consideration"—not because the design was bad, but because its architecture "followed no style" (Fig. 35). Indeed, Hafner's "Stadium Entrance" was a lampoon of styles. It was a brazen pastiche in which Assyrian, Egyptian, Etruscan, and Roman elements were heaped together over a brutish structure with elephantine pylons that framed an arch complete with a baroque keystone.

In his statement, Hafner described the project as a "modern stadium" and explained that his team, interpreting the athletic qualities of strength, vigor, and robustness, tried to keep the entrance simple, massive, and solid:

The team decided early in the work to eliminate unessential drawings made for exhibition purposes and to get right at the problem by studying it in the clay model. This gave us an opportunity to study it in three dimensions from all angles and under all practical conditions of light and shade. . . . One not only saw the relation of parts from a single point of view, but from every angle and aspect.[10]

A rather crude model in clay was, indeed, all New York received from Hafner's team. It should also be noted that although the Academy expected the fellows to construct partial models showing the interiors of the projects, studying and designing a building with the help of models was alien to the Beaux-Arts tradition and was seldom required from students of architecture in the 1920s and 1930s.[11] Hafner admitted that since he was the senior member of his team, architecture would play a much more important part in the collaboration than painting and sculpture. The statement ended by informing the committee that the stadium was to be built of concrete. In one brief page, Hafner had managed to defy most of the principles of the Academy: use of a classical prototype, collaborative effort, traditional materials of construction, and preliminary and other rendered drawings.

It is hard to imagine exactly how the committee took all this—certainly not as a joke. If the agitated scribblings that fill the bottom and the margins of Hafner's statement are an indication, the jury members apparently were

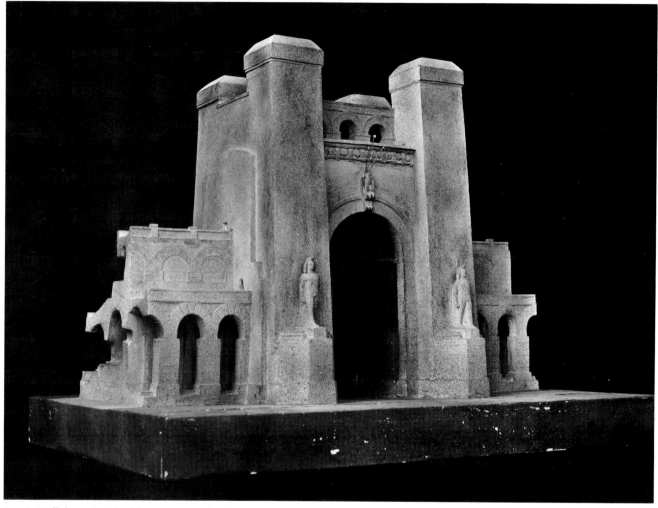

[35] Collaborative Problem, 1924: "An Entrance to a Stadium" (Victor
L. S. Hafner [FAAR, 1922], architect).

utterly disgusted and shocked: "Architecture: rotten. Sculpture: rotten. Shall
diploma be withheld"[12] (Fig. 36)? The committee added a long note in a more
formal language in its report to the board of trustees that Hafner,

in spite of a very severe warning last year in connection with his submission of a
Chinese design for the Collaborative Problem, has again departed from the traditions
and ideals of the Academy in an apparent defiance of the wishes of the Trustees, [and
has] submitted a design which is not in accordance with the principles to which he
has subscribed.

An Entrance to a Stadium

The team who developed this subject was composed of Mr.
Victor L. S. Hafner, senior architect, Mr. Lawrence T. Stevens,
second year sculptor, and Mr. Francis Bradford, first year painter.

This group decided as a subject for this problem, an entrance
to a modern stadium, and as the architect was the senior member of
the team it was considered an excellent architectural problem in
which the painting and sculpture played a less important part.

The scale was set for 3/8" = 1'-0".

The team decided early in the work to eliminate unessential
drawings made for exhibition purposes and to get right at the
problem by studying it in the clay model. This gave us an
opportunity to study it in three-demensions from all angles and
under all practical conditions of light and shade. The results,
as far as the profit in study was concerned, were excellent. One
not only saw the relation of parts from a single point of view, but
from every angle and aspect.

The team has tried to keep the entrance simple, massive, and
solid, interpreting the athletic qualities, viz., strength, vigor
and robustness.

The location of the entrance is in the center of a screen which
connects the ends of a horse-shoe stadium (see sketch). The portion
on either side of the entrance merely connects with the pylons which
terminate the ends of the horse shoe. This screen serves to enclose
the field and also gives additional seating capacity. Circulation
to the seats of this portion is from the pylons on the ends which
contain staircases. No entrance for spectators has been provided
in this detail in order to avoid any interference of the circulation
for athletes and performers in and out of the stadium.

The material of which the stadium is built is concrete.

 Victor L. S. Hafner.

[36] Hafner's statement for his "Entrance to a Stadium" and the
scribblings of the members of the Committee of Fine Arts in the margins.
Samuel B. Trowbridge was the chairman of the committee that judged the
projects of this Collaborative Problem.

There was no forgiveness for desecrating the altar twice, once with a Chinese bridge and again with a Mesopotamian gate: Hafner's diploma was withheld, and he became the only fellow in Academy history to suffer the severe penalty of *damnatio memoriae*. To this day, Hafner's name is not included in the official lists of former Academy fellows.

Why did Hafner, a graduate of Harvard who was quite capable of working in the best classical style and Beaux-Arts tradition (he had proved this in his Rome Prize competition and in the 1922 Collaborative Problem) and had been doing excellent archaeological exercises for his prescribed work, turn himself into a rebel and martyr (Pls. 67, 68)? My guess is that Hafner and his team had worked very hard and dutifully on the "Chinese Bridge" of 1923. Despite its unusual style, the project was well designed and had all the characteristics of a Beaux-Arts composition. The drawings were done with care and effort, not as a joke or in defiance of the Academy's principles. Hafner was not expecting the condescending and harsh treatment he got from the jury; I suspect he was shocked and embittered. The next year, he made sure that the jury was presented with as horrid and incongruous a concoction of architectural parts as he could imagine, a genuine architectural abomination on which the jury members could properly feast their eyes.

This *was* an act of planned defiance, and perhaps not a very mature one, for Hafner's deliberate attempt to create an architectural aberration did not stem from intelligent reasons expressing why he should rebel against the regimen of the Academy. Nor did it, in a constructive and cogent way, show that Hafner was capable of, or even interested in, understanding the institutions of his time and expressing them through design.

The committee found fault with the director in Rome for allowing such a situation to develop and proposed that the trustees, through the secretary, remind the director of his duties, the importance of the Collaborative Problem, and the aims of the Academy.[12] If Director Stevens and Fairbanks, professor-in-charge of the School of Fine Arts, felt taken down a peg because of the stiff reprimand they received and the new, tightened rules imposed by the headquarters, their correspondence with New York in 1924 and 1925 shows only their eagerness to cooperate with the trustees, and their activities in Rome demonstrate their keenness to propagate the point of view desired by the board.

It cannot be totally accidental that at a time when the meaning and success of the Collaborative Problem were very much a concern of the Academy officers and needed every kind of intellectual stimulus that could be mustered, an important lecture, "On the Unity of the Arts," was delivered at the Academy by Felix E. Schelling. A professor of English literature at the Uni-

versity of Pennsylvania, Schelling promoted a very conservative view un-evenly disguised in an attitude of liberal thinking. The lecture, delivered on January 28, 1924, must have considered of critical importance because it was published in the same year by the Academy.[14] It has very little to do with what its title implies, and, indeed, its contents are ambiguous, as if Schelling, in the role of an emissary, was not quite convinced about the message he had undertaken to communicate to his young audience.

Up to a certain point, the fellows were encouraged to be innovators in art, but they were also to avoid temporary and trivial movements, revolts, and eccentricities. Much of modern art and most modern artists were trivial and eccentric by the standards of Schelling's taste, but particularly the Cubist, "who only in painting of strange, geometric figures can convey his image to an obtuse and incredulous world." The lecturer disarmingly and paradoxially sanctioned experimentation in art and displayed an aloof acceptance of con-temporary developments in science. Nevertheless, the "newfangled people, the practical, scientific sort" were playfully slurred. The fellows were gently advised to "tell them 'my art will outlast your science.'" One could easily endorse Schelling's observation elsewhere in the lecture that "all the free verse in the world will not put Homer, Sophocles, Virgil, and Horace out of fashion." But the implications of his next statement—that "all the jazzery that ever came out of the jungles of Africa will not take the place of Bach or Beethoven"—uttered as it was in the 1920s, the preeminent decade for Amer-ican black jazz, reveal the limits of the genteel professor's generosity and make one doubt the appropriateness of his selection as a mentor for the young.[15]

The main consequence of the trustees' reaction to the crisis of 1923 to 1924 took the form of a strong restatement of the Academy's principles drawn up by La Farge, the board's favorite penman. This document was later referred to as the "Credo," or sometimes the "Bible." There was really nothing new in this unfortunate manifesto, which opened with the words "The American Academy in Rome is founded upon a settled belief" and expanded into the description of that belief as the unquestionable acceptance of the supremacy of the arts of classical antiquity and the Italian Renaissance, to the exclusion of all other styles and periods. It stiffly obligated the fellows to restrict their studies to these periods while at the Academy. In the last paragraph, the Academy showed its muscle by stating: "It is the duty of every Fellow to become fully aware of the policy and to accept it as a govern-ing law and without question. Guidance will be given to them, and that guidance must be accepted wholeheartedly."[16]

The impact of the "Credo" on the daily architectural and educational

program and life of the Academy was almost immediate, since Stevens and Fairbanks meant to implement it to the letter. But on certain delicate matters of style, this was easier intended than done. The style in question for the 1925 Collaborative Problem, "A Chapel in a National Garden," was Romanesque. One of the competing teams, headed by Henri Marceau, the senior architect (who had been studying the Romanesque of northern Italy), wanted to know if a chapel inspired by the Italian Romanesque could be interpreted to be "in the spirit exemplified in the monuments of Classical and Renaissance art." Stevens was not taking any chances. On November 7, 1924, he wrote to Samuel B. Trowbridge, the chairman of the Fine Arts Committee, for a precise ruling as he cautiously offered his own view:

If he [Marceau] did a church inspired by the basilica churches of Rome, I would consider that his design came within the letter of the law, but if his design is based upon examples of Romanesque work in northern Italy, there are other influences to be found in them in addition to classical influences and that, if the other influences predominate, his design would probably not be considered by the Committee.[17]

New York took this disputation on stylistic matters with due gravity. The Fine Arts Committee, presided over by President Mead himself, met to discuss the matter of Marceau's Romanesque chapel. The committee first instructed Stevens to consult the "Credo" in the future for any "precise ruling" he might want, and told him that on this issue the members agreed entirely with his interpretation. Then it added in a postscript, with baffling inconsistency: "Mr. [William M.] Kendall suggests that San Ambrogio in Milan will furnish a good type of architecture which would be acceptable and upon which you can form your basis of judgement."[18] What was not made clear was whether the committee considered the twelfth-century San Ambrogio to be inspired by the basilica churches of Rome or whether "other influences" of Lombardic northern Italy (such as the ribbed groin vaulting of San Ambrogio) were not judged sufficiently strong to mar the classical purity of the building's style.

If these rulings, settled beliefs, and aesthetic judgments of the Academy concerning historical architectural styles appear naïve, there are good reasons. First, architectural education in the United States in the 1920s almost universally required students to abide by Beaux-Arts–determined rules of design and a set of sanctioned styles. Second, and more significant, most of the important names behind the Academy from its first days—the trustees in fine arts and high-placed officers who were artists or architects—were not trained art historians who could pass professional judgment on problematic

and complex issues in art history and archaeology. Most were recognized as leading artists and architects, and almost all were successful in their fields, but they were not scholars. Their ideas on the history of architecture were formed and guided by well-known pictorial handbooks and manuals ("documents"), such as P.-M. Letarouilly's *Les Edifices de Rome moderne* (1840–1857).[19] And their knowledge of historical precedents, which they so freely talked about and in which they proposed to guide their younger colleagues, was never based on hard, analytical studies of architecture, but on romantic, impressionistic, and generalizing views formed during their student days in Paris or Rome or during their European travels in later years.[20]

For the most part, they were quite wise to keep silent about slippery stylistic and theoretical problems, such as the formal and structural inconsistencies within an "approved" period or in the works of "approved" artists; the baroque component of Roman Imperial architecture or Bernini's architectural work can be cited as examples. If explanations were necessary, they often called on the useful theory of "decadence," a temporary period of infatuation or a passing phase of impurity, to be distinguished from the more permanent decadences, such as the seventeenth-century baroque—although none the less regrettable for that. More complex and paradoxical issues that could not be readily explained by the theory of temporary decadence—in this case, the question of the continuity of the classical tradition in northern Italian Romanesque architecture—not surprisingly confused them.

A string of events connected with the Collaborative Problem and the "Credo" in 1926 became the first serious and authoritative questioning of the Academy's policy and ideology. The man who did the questioning was an eminent scholar and historian of Early Christian and medieval art, Charles Rufus Morey of Princeton University, who was staying at the Academy in 1925 and 1926 as professor of classical studies.[21] Apparently (as described in Fairbanks's letter to Mead, dated February 11, 1926), Morey had seen and praised the Collaborative Problem of one of the competing teams that year. The subject chosen by all three teams was "A Monumental Staircase for the United States Navy Department," and all three designs were strikingly similar in composition—essentially, a watered-down Beaux-Arts in character (Pls. 10–12). Although the project that Morey saw and admired was not specified, it was almost certainly the design by the team of William Douglas (architect), Francis S. Bradford (painter), and Walker K. Hancock (sculptor). Theirs was the one scheme disapproved of by Fairbanks for using a few architectural motifs that could be vaguely interpreted as medieval or Gothic, including an arched entrance, gilded mosaic decoration, and Gothic lettering to frame the mural painting (Pl. 12). It appears that Morey and Fairbanks had

a discussion on February 3 about the Collaborative Problem and the goals of the American Academy in general. Baffled and disturbed by Morey's commendation of the "Gothic" project, Fairbanks placed a copy of the Academy's "Credo" in Morey's mailbox the next day, with a note requesting the scholar to tell him what he thought of these principles.

One would like to know Morey's initial reaction to this strongly worded manifesto, which pontificated on broad issues of culture and art in such a high-handed manner. Whatever he may have thought of it, the scholar's letter to Fairbanks was polite and clear-headed. Morey went straight to the heart of the problem by questioning the premise presented in the second paragraph, stating the belief on which the Academy was founded: "that in the arts of classic antiquity and their derivatives, down to and including the major Renaissance period, are contained the fundamental principles upon which all great art so far known and proven is based."

Morey proposed that besides the classical, which represented an intellectual and ideal mode of expression in art, there was, in the European tradition, the intuitive and realistic mode of the medieval or the Gothic, entirely ignored by the Academy. "The belief on which the Academy is founded," he argued, "assumes that Gothic architecture is not great art, nor the painting of the Dutch, nor what is most vital in the Italian fifteenth century." And he added, "The historians of art would, I think, also hold it to be true that what is vital in modern art is derived rather from the realistic mode [medieval and Gothic] than from the classic." Morey's assessment of the Academy was devastating, but fair: "If the Academy is conceived as a school of discipline, and not as a milieu provided for the free play of creative instinct, I think that its single-minded adherence to the classic ideal is a position well-taken." As long as the Academy remained a private foundation, Morey observed, it has "the right to take any aesthetic position it pleases"; and, judging by the second paragraph of the "Credo," the Academy deliberately chose to classify its position in the public eye as an institution of aesthetic preference and propaganda.[22]

This time it was Fairbanks's turn to be shocked. He reported the crisis immediately to President Mead, enclosing a copy of Morey's letter (with the professor's consent): "Prof. Morey's commendation was so utterly at variance with the ideals of the Trustees as I know them that the occasion demanded all the enlightenment that I could give it." And he offered his opinion:

My purpose in sending this letter to you is to express my amazement that our statement of principles seems so educationally cramping to a man of Prof. Morey's

obvious intelligence and broad education. I admit that it is also a little disturbing to realize that if we cannot "get over" our ideas and aims to a man of mature mind, we can hardly be sanguine in reaching to the indeveloped mentality of the prospective student, at least with any great degree of assurance.[23]

Of course, Fairbanks was being unfair to Morey, who appeared to have understood the aims and ideals of the Academy all too well but would not allow himself to be influenced by them.

It might not be far-fetched to suggest that Morey's year of residence at the Academy, and particularly the issues brought up in connection with the dispute over the "Credo," provided the inspiration and the intellectual raw material for his article "The Academic Point of View," published the following year in the *Arts.* The article, erudite and generalizing at the same time, is essentially an elaboration of the ideas about the idealistic-classical versus realistic-medieval modes that Morey had formulated in his letter to Fairbanks. According to Morey, the academic point of view assumed "an absolute standard of beauty which has no relation to experience" and divorces beauty from truth. In a sense, Morey implied a parallel between the dogma of monarchic or religious absolutism and the credo of the modern academies of art, which were governed by an "ideal of absolute perfection, intellectually conceived, to which every human behavior and thought must be made to fit."[24] Yet while his avowed position as a scholar of primarily the medieval period precluded him from accepting the Academy's unyielding insistence on the supremacy of the classical mode, Morey was no more a supporter of the contemporary movements in art and architecture than were the luminaries of the Academy with whom he had, inadvertently, crossed swords. He even saw in academic training a kind of haven against the bewildering confusion of contemporary life, brought about by modern science and its unqualified factual orientation.[25]

Back in Rome, the crisis was superficially explained as an infringement on the affairs of the artists and architects of the School of Fine Arts by scholars and classicists. On March 20, 1926, Stevens wrote to President Mead and clarified Morey's position as a "Professor of History of Art," rather than a "Professor of Art," and reassured his superior in a combat spirit worthy of his club-wielding colleague in charge of the School of Fine Arts that "the School of Classical Studies will have to pass over our dead bodies before the ideas and the traditions of the original founders will be departed from!"

Mead and the trustees were quite upset by these developments. It was one thing to deal with a straying young fellow, but quite another to face the highly intellectual opposition of an eminent professor of international repute. How-

ever, it was unlikely that the board members could appreciate the significance of Morey's observations, since to accept them would have left very little of the old Academy, *their* Academy, McKim's Academy, to salvage. Perhaps they could not conceive that a new Academy based on a realistic and open policy could still be McKim's Academy, or they did not wish it. And perhaps they could not see that if institutions are to live, they have to be able to change and go beyond the boundaries of their founders' visions—that would be the greatest vision a founder could have. Instead, they hardened their untenable position and dug their heels deeper into a tradition that they did not even properly understand.

In his monograph on the Philadelphia architect George Howe, Robert Stern discusses the deep sense of emptiness and dissatisfaction that permeated American culture in the 1920s ("beneath the surface glitter of the twenties, a core of sickness and fear corroded American life") and chooses to isolate 1927 as the year when the "fulcrum on which the balance between the old [nineteenth century] and the new [twentieth century] tipped with irrevocable finality in favor of the latter," and "special spirit of 'modernity' . . . suddenly came to form". However, none of the intellectual and artistic neuroses or the mounting sense of crisis and decision—Spenglerian or not—had yet affected the Academy, although gradually it would.[26] Over the next three or four years, there were signs of restlessness among the fellows and a number of minor infractions of the rules, which greatly vexed Fairbanks, as a letter he sent to the trustees in 1928 clearly shows:

One man came to Rome so tainted with the puerile aspects of Modernism that he could not be approached by anyone. He was suspicious of the faculty and the Fellows were ruthless in harassing him. It necessitated over two years of utmost patience from us for this man finally accept assistance we wished to offer him.[27]

One would like to know how Fairbanks's patience with the recalcitrant student worked, but it seems unlikely that it had been long-lasting and gentle if judged by his letter to La Farge written a year later, on July 13, 1929. This time, Fairbanks complained to the secretary about the first-year sculptor David K. Rubins:

Rubins has struck a snag with his first year figure, a standing girl (Eve, I think, he calls it). He is trying to experiment with it, but, unfortunately, not in the traditional styles of which there are so many good examples at his hand. . . . This is an old story. We have had men before who have tried to dodge their obligations to the Academy. Simple and obvious logic, sometimes latitude, avails, but when they fail we ought to learn to drop this type of student in the interests of our well-known credo.

The next paragraph of Fairbanks's letter gives one an insight into what he, and some of the former fellows as visiting alumni, thought of Rubins or others like him who sympathized with modern art and did not want blindly to follow artistic doctrines:

Albin Polasek [FAAR 1913, sculpture] and Tom Jones [FAAR 1922, sculpture] have been spending a few days in Rome. They have been over the Academy and whipped themselves into a fine fury over the first-year sculptor [David K. Rubins]. Perhaps I am influenced by them, but I think not. They incline to the belief that he is the type that develops into a first class Bolschevic [*sic*] when he returns to New York, and knocks, preferably, those who are trying to help him, but whose help he doesn't want.[28]

There was, nonetheless, a sense of rapport concerning the Collaborative Problem during the next years, 1927 to 1930. The results of the competitions were generally approved by the Academy, and cooperation among the teams seems to have been revived. For one thing, the headquarters in New York returned to the practice of specifying the subject of the Problem as well as the members of the teams. Rome's input into the choice and treatment of the subject, site, and style was restricted or eliminated altogether: "The style shall be that of classical antiquity . . . or the major Renaissance" read the brief, official rules for the Problems, and that was that. These measures effectively prevented any foolishness on the part of the fellows in the way of introducing eccentricities or exoticism into their designs. Once again, they were engaged in typical Beaux-Arts subjects: "A War Memorial for a Large American City," 1927 (Pls. 13–17); "A Memorial Loggia for a Temple of Festivals of Chamber Music," 1928 (Pls. 18–21); "A Casino and Bathing Pool for a Rich Gentleman's Country Estate," 1929 (Pls. 22–30).

The improbable sounding "Temple of Festivals of Chamber Music" of 1928 made visible, for the first time at the Academy, the cautious steps taken in the direction of Art Deco aesthetics: Art Deco had been enjoying a favorable reception in the wider professional circles in the United States since the opening of the Exposition Internationale des Arts Décoratifs et Industriels Modernes in Paris in 1925. The jury's opinion was favorable. The slender, untapered square columns with Ionic fluting and the reduced, inventive capitals of the elegant modernistic loggia, designed by the team of Homer F. Pfeiffer (architect), Walker K. Hancock (sculptor), and Deane Keller (painter), were commended for making "a most interesting and successful modification of the Greek orders" (Pl. 21). In the second typing of the jury's report, the word "interesting" was crossed out and replaced by "original."

The semicircular colonnade of the loggia proposed by C. Dale Badgeley (architect), George H. Snowden (sculptor), and Michael Mueller (painter) appeared deceptively more conservative (Pls. 18–20). The stately columns, with their attenuated beaded fluting, resting on simple torus bases, display all the spare and linear elegance of an archaic Ionic temple—perhaps, a cross between the Heraion at Samos and the Artemesion at Ephesus. An Egyptianizing touch via Hellenistic Alexandria was introduced by the acanthus and palmette capitals, with their unusually elongated palmettes (Pl. 19). The scheme was, of course, an archaeological impossibility—in its own way as eccentric and "incorrect" as Hafner's Chinese bridge—but it had an air of probability, was well designed, and, above all, breathed quiet good taste consonant with the idea of the "classic" in the minds of the jurors in New York. Badgeley's temple, "striking in effect," was the winner of the competition.[29]

Badgeley, in collaboration with David Rubins (sculptor) and Dunbar D. Beck (painter), also won the competition in 1929: "A Casino and Bathing Pool."[30] All three teams that year utilized the abundant supply of water at the top of the hill on the given site as suggested by the program and produced fairly similar designs (Pls. 22–30). In all three, the opening of a long vista by the use of a sloping waterway, cascades, and waterfalls makes evident the inspiration from well-visited sites, such as Caprarola, the Villa Lante, and even perhaps the eighteenth-century Bourbon palace at Caserta. Badgeley's scheme demonstrates his close adherence to general Beaux-Arts principles better than those of the other two teams (Pls. 25–27). The jury praised his solution not only for its unobstructed vista, strong axiality and symmetry, and unity of plan, but also for its architectural details, which "are not only very good, but in a discreet way original, and original in the proper way—that is—new and yet not discarding entirely the traditional forms."[31]

Badgeley's architectural ornament and details in his last Collaborative Problem in Rome had fully embraced Art Deco forms and sensibilities. His thin, fluted pilasters even reveal some influence from the fluted, square piers of Pfeiffer's porch from the previous year, which had received the Academy's sanction (Pls. 21, 26). Pfeiffer's "Casino," however, did not do so well. The jury felt that the plan was defective and lacked unity because of the position of the pool (Pls. 28–30). The thin arcaded screen flanked by square-headed openings he designed as a backdrop (which was criticized by the jury because it lacked a cornice and created a visual ambiguity) could find favor today in postmodern aesthetics—and may even be improved by a broken pediment.

The Collaborative Problem for 1930, "A Monument to Mechanical Progress in an Exhibition," appears to have been a forced attempt to take notice of

modernity (Pls. 31–38). It was also a nod toward the highly successful Machine-Age Exposition, which took place in New York in 1927.[32] The style, the character, and the height of the design were left to the competitors. For an institution that occupied an awkward position in the face of an era of technological and mechanical progress and whose feelings about modern architecture were mixed, the subject of the problem spelled trouble from the beginning. The scope of the project was larger than that of any previous ones assigned by the Academy. And the subject was almost impossible to express in terms of classical or Italian Renaissance motifs.

All three teams produced futuristic designs of leviathan proportions—powerful geometric masses with funerary connotations. Pyramids, towers, and cylinders looking like oversize thermos bottles and pressure cookers shot forth vertical shafts of light into darkened skies. Large as they were, the monuments themselves appeared minute in the great mosaic of the exposition master plan, isolated motifs in the vast lacework of avenues, malls, and basins that would have dwarfed Versailles. Concrete was the favored material for two of the teams, who declared that their primary concern lay in "presenting as straightforward a solution as we can: one simple plan and a monument designed for formed concrete—the more practical the solution, the more it is in character with the dignity of mechanics."

It is not difficult to see that all three teams turned for inspiration to the typical competition projects of the Ecole des Beaux-Arts or to the singular Piranesian vision of Désiré Despradelle's great classic, the design for the monumental tower called the "Beacon of Progress" (1893–1900)—a tour de force of historical fantasy and architectural rendering illustrating a kindred theme[33] (Fig. 37). Vast and generalizing geometric configurations and inventive forms engendered by annual competitions for the Paris Prize sponsored by the Beaux-Arts Institute of Design may have been the kind of material readily available for study (Figs. 38–40). A particularly close visual and thematic source for the "Monument to Mechanical Progress" appears to have been the winning designs for the Paris Competition of 1929, "A Memorial to the Spirit of the West," published in the September issue of the Institute's *Bulletin*[34] (Fig. 41).

Ordinarily, the character of the designs produced by the Academy's Collaborative Problems was distinctly different from the results of the typical Grand Prix projects of the Ecole. Although accepting the basic Beaux-Arts precepts of design and composition, the American Academy always emphasized a subtler, quieter, and purer classicism, which the supervisors liked to identify with Rome and Italy, as opposed to the vast flamboyant schemes and the overwrought mosaic, the "Beaux-arts baroque," preferred by an earlier

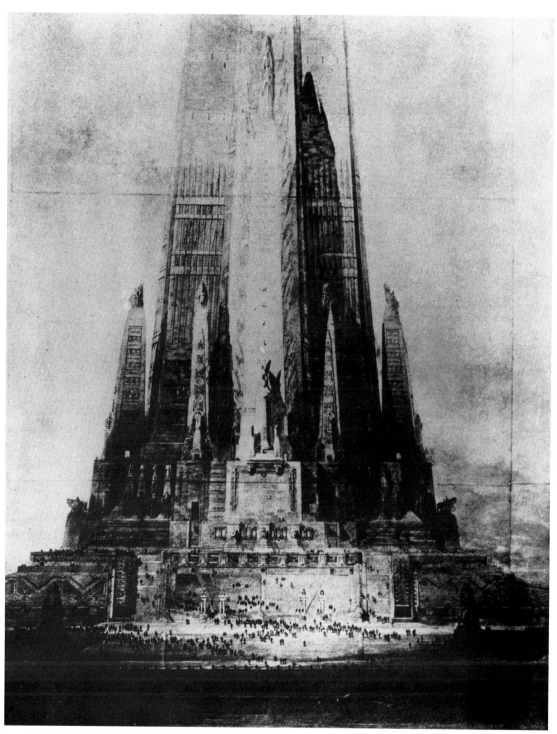

[37] Désiré Despradelle, "Beacon of Progress," 1893–1900.

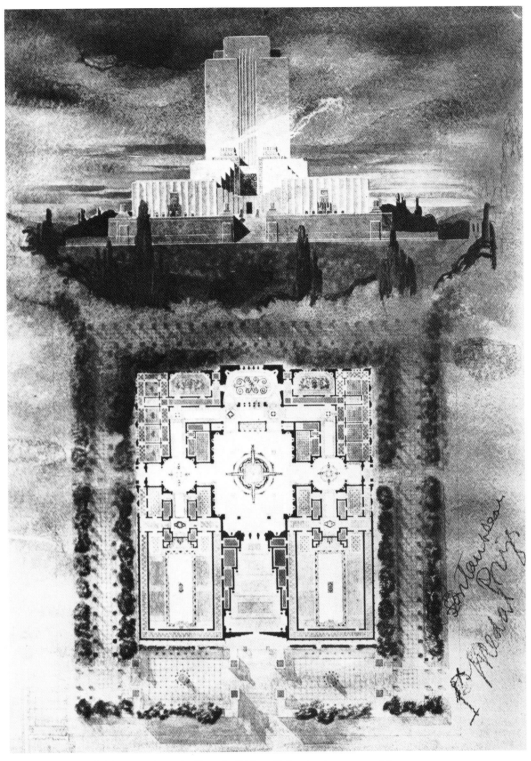

[38] K. J. Heidrich, "A Masonic Temple." First Prize in the competition sponsored by the Fontainbleau School of Fine Arts, 1929.

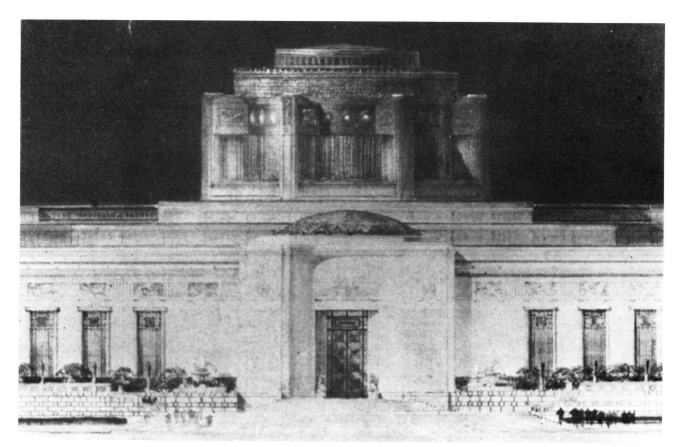

[39] D. S. Nelson, "A Radio Broadcasting Station." Paris Prize, First
Medal, 1927.

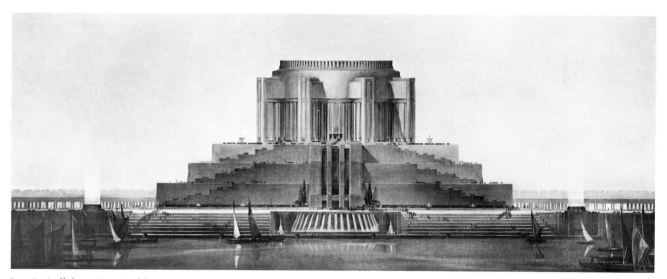

[40] Collaborative Problem, 1930: "A Monument to Mechanical Progress
in an Exhibition"(Cecil C. Briggs [FAAR, 1931], architect).

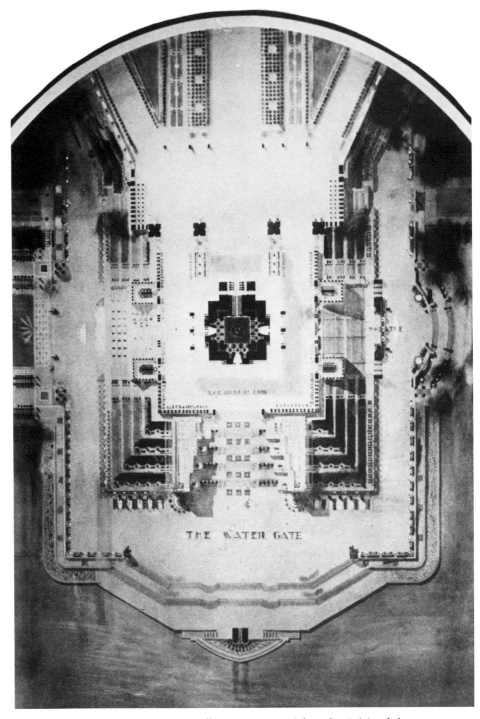

THEATRE

THE HOUSE OF FAME

THE WATER GATE

[41] I. W. Silverman and J. J. Haffner, "A Memorial to the Spirit of the West." Paris Prize, First Medal, 1929. Plan (*above*) and elevation (*right*). (Bulletin of the Beaux-Arts Institute of Design [September 1929]: 8–11)

generation of American architects who imitated the French system.[35] At least once in their history, the fellows in Rome must have felt proud to show that given the right kind of project, and given their head, they could equal some of the most credible Beaux-Arts extravaganzas.

Functionally defective and aesthetically derivative as these new forms were, they were nevertheless an attempt to break away from the more visible aspects of classicism and move in the direction of what the fellows conceived of as modernism. It seemed that the great year of reckoning, proposed as 1927 by Stern for the larger architectural profession in America, had come, with a three-year delay, to the Academy.

Their seniors in New York were not impressed, however. The jury regarded the results of the 1930 Collaborative Problem was a blatant defiance of its policies, and no awards were made. The verdict was clear: "No design appears to be the result of closely knit collaborative effort. The preoccupation of the collaborators with modernistic functional thought almost to the exclusion of fundamental artistic consideration is apparent." The jury also deprecated the "effort to invent new forms": "The monument should first of all be a thing of beauty and the results in this case, ignoring the classical tenets of proportion and good taste, seems to the Jury to lack logic, common sense, and distinction."[36]

Following the unwelcome results of the 1930 Collaborative, Fairbanks wrote on December 1, 1930, to Roscoe Guernsey, the executive secretary in the New York office, that some of the dissenters, who were "breaking out most flagrantly against academic traditions," expected the Academy to respond to their ideas and that they thoughtlessly used the Academy "for gestures that are a frank refutation of our basic ideals." He noted that among the fellows there was "an irritation that there is not outlet for original (God help the term!) work." Fairbanks proposed to Guernsey one of two things: the New York office should either do everything possible to inform the candidates for the Rome Prize of what was expected of them, or

find a method that could act in the nature of a safety valve (the Collaborative Problem, preferably) that would avoid the continued atmosphere of suppression that our policy fosters. It is possible that one single recognized outlet for their originality (Ho! Hum!) would meet the needs of the problem and foster stimulation in a legitimate manner.[37]

Guernsey's prompt reply of January 2, 1931, assured Fairbanks that the Academy would be more careful in the future in seeing that the newly appointed fellows were properly "instructed" by an architect trustee—to start it off right, by none other than Charles Adams Platt, the president of the Academy since 1928, who had decided on "a more thorough job in this line" and did not think it was sufficient "to hand the men a copy of our 'Bible or *Credo*' and expect satisfactory results." Guernsey did not touch on Fairbanks's inquiry about the "recognized outlet for . . . originality," but told him that he would be very glad to receive any names—if Fairbanks could give them, and in total confidentiality, of course—of the fellows "who seem to show the need of having received a more thorough advance information about the work of the Academy before they went to Rome." In polite commonplace, Guernsey was anxious to find out if the Academy's weakness

appeared in any particular branch or field. Translated into plain English, what he and his supervisors wanted to know was who the troublemakers were and what institutions they came from.

New York's decision to tighten the reins once more and make the goals of the Academy as clear as possible to all fellows was reflected in the 1931 Collaborative Problem, "A Small Museum on a Private Estate." The tone and the unusually detailed description of the Problem left little doubt about the Academy's continuing sponsorship of the classical mode:

A wealthy art collector has a fine old estate . . . [with] an extensive house or villa with outbuildings, etc. . . . The gentleman has acquired a celebrated collection of Classical and Renaissance sculpture and he proposes to build a small museum in which to house these works of art. This building is to be placed on the west end of the formal garden which will be on axis of his existing house. . . . The entrance to the museum is through a portico or loggia, and in relation to this loggia on the axis from the house is to be a fountain. The collaborative problem consists of three elements: the loggia, the painted decoration of the wall of the loggia, and the fountain in perfect relation, one to the other, and to the garden.[38]

So much for the "outlet for . . . originality" Fairbanks had requested!

The fellows could clearly see what was wanted of them. It would be naïve to assume that a group of young architects and artists, however strict their training in academic art had been, would be comfortable with a program that left nothing for them to do except draw up the prescribed axes of the composition and fill in the intaglio of the loggia arcade. Yet they appear to have gotten their revenge by doing just that—making it very obvious who the joke was on if anybody bothered to ask. All three schemes came out looking more or less alike, very neatly and properly like a small Renaissance garden casino with a triple-bay plan and an arcaded loggia—reminiscent of the Freer Gallery of Art in Washington, D.C., designed by President Platt in 1923. And this was clearly not a question of shirking hard work because all the drawings were beautifully rendered (Pls. 39–41).

The jury was somewhat at a loss. It praised the beauty of the drawings, admired the effort, but "regretted that a too close study of the existing examples had perhaps thwarted the purposes of the various teams in deriving something more imaginative and spontaneous." The solution presented by the third-year architect Cecil C. Briggs (Fig. 42), an extraordinarily hard-working and prolific fellow, was such a flagrant copy of the upper level of the garden casino of the Villa Farnese at Caprarola that the jury could not help noting that it "could hardly be judged as an original design" (Pls. 40, 41). It

would, indeed, have been very difficult in those days for a fellow in architecture to know what the jury would consider "original." Quite apart from Platt's Freer Gallery of Art, much in McKim's own work was based on specific Italian Renaissance models: the Art Gallery at Youngstown, Ohio, designed by his firm in 1917 (Fig. 43), was directly inspired by the same source, and there is every reason to believe that Briggs knew that building. But Briggs's scheme was not merely inspired by precedent—that would have been submitting to the program. By making a deliberate *imitation*, Briggs intellectually dissociated himself from his own design, refusing to credit it as architecture. He also left a record of his quick mind in the form of a joke

[42] Cecil C. Briggs in his studio in Rome.

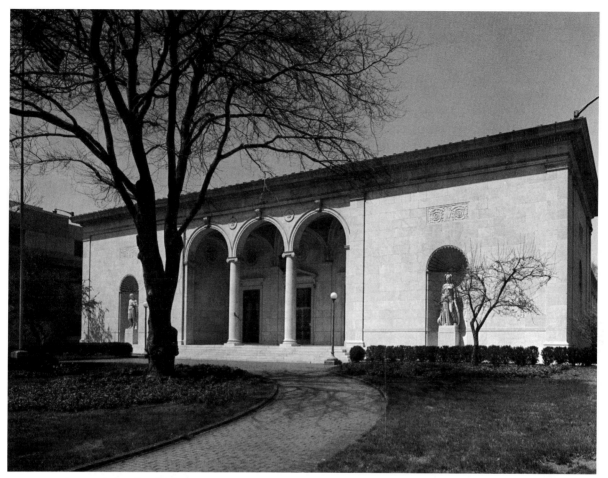

[43] McKim, Mead and White, Butler Institute of American Art
(formerly the Art Gallery), Youngstown, Ohio, 1917.

inserted into one of his drawings. A superbly rendered sheet of details carries
the pointed title "Collaborative Drawing" and includes a view of an inscrip-
tion plaque affixed to one of the end walls of the loggia. The inscription
begins, "This drawing is not for exhibition nor publication as far as architec-
ture is concerned. . . . It is nothing," and continues lightly in pencil, "to
write home about" (Pl. 41).

VII. Attempts to Reform the Educational Policy in the 1930s and 1940s

The cumulative effect of these small frictions and disagreements between the fellows and the officers of the Academy during the 1920s and early 1930s, occasionally reaching a critical level, had done much to erode Gorham Stevens's position as director. He was aware of the absence of spirit in Rome and was unhappy about it. The trustees felt that these increasingly frequent lapses into questioning the classical tradition, and particularly the overall laxity about the Collaborative Problem, could have been avoided by firmer leadership in Rome. They also knew of Stevens's archaeological interests, and many did not approve of them. They believed that these interests made Stevens more of a scholar than an artist and distanced him from the School of Fine Arts.[1] The desire to start a firmer new policy with a new director was in the air. Ironically, the trustees could not have found more cooperative agents and defenders of their ideas and beliefs than Stevens and Frank Fairbanks, whose willingness to serve and to please literally jumps out of every line of correspondence they had with New York.

In 1928, the trustees had considered replacing Fairbanks in his capacity as professor-in-charge of the School of Fine Arts with temporary appointments of "eminent artists." Fairbanks, who had shown considerable promise as a fellow in painting from 1909 to 1912, had failed to develop into an eminent artist. Rather, he had become a perfect bureaucrat and had produced nothing to inspire the students after eight years in Rome (except starting the excellent tradition of making portraits of the fellows in the School of Fine Arts, some two dozen of which adorn the back wall of the bar at the Academy).[2] Fur-

thermore, some of the students had complained that Fairbanks was not functioning well. Alarmed and insulted, Fairbanks wrote a long letter to the trustees on March 18, 1928, defending himself and his position at the Academy as the permanent head of the School of Fine Arts and asking the trustees not to overrate eminence in the arts. He argued that first-rate artists on short-term professorships at the Academy could exert unfavorable influence on the fellows:

There is needed something much more subtle, much more sympathetic, with much more understanding for the effectual operation of developing the creative impulses of our men, so that minimum disturbance is brought to bear on their artistic ego; an ego which, once shattered or lost, may permanently injure the career of a Fellow in Rome.[3]

He then represented himself as the subtle and gentle traditionalist the Academy needed. The plea, supported by Director Stevens, worked and Fairbanks was kept—for a time.

The Collaborative Problem for 1932, "A Restaurant and a Ballroom in a Hotel," failed to raise much interest among the three competing teams. Flat-roofed buildings in a fairly noncommitted style, with plain wall surfaces and arched windows, a lean sort of classicism, resulted. Again, no team was found worthy of a prize (Pl. 42). Stevens offered a lame excuse: "A Collaborative Problem is the most difficult of all problems, especially in the case of our artists, when men cannot themselves select their team-mates."[4] Both he and Fairbanks retired from office at the end of the year.

Fairbanks's parting shot in the Annual Report of 1932 was bolder, more perceptive, and perhaps more remarkable than anything he had allowed himself to say while he was in office or hoped to stay there: "All of these men have shown an exemplary attitude of appreciation for their opportunities. If they do not display, in all respects, the attainment that we so much desire of them, the fault is not in the environment abroad, but rather, in the lack of it in America."[5]

Conservative, polite, and hopelessly short-sighted to the end, Stevens wished success for the Academy and for the "new policy to be inaugurated" (the very one that required his elimination) in the same report. Somewhat out of place, he also added his belief in the benefits of state sponsorship of the arts and predicted that the United States government would occupy in the near future an important place in the great artistic and intellectual movements in America.[6]

In his love for and belief in the institution he had served loyally for twenty years (seventeen years as director, longer than any other director of the

Academy to this day; he was fifty-six years old when he left the Academy), Gorham Phillips Stevens had been like many of the old friends and associates of the Academy in occasionally allowing his excitement to take control of his sense of reality.[7] His long career in Rome was full of practical successes on behalf of the Academy (especially in enlarging and consolidating its properties and real estate), but it also suffered from a number of misjudgments and disappointments. He lived a generation too late for the proper appreciation of his remarkable talents and sentiments as an architect. In 1956, at the age of eighty, Stevens published in *Memoirs* a report of his invention of a machine for drawing the volute of an Ionic capital "for any column between twenty and sixty feet in height." He ended the short technical article with the terse observation: "The Ionic order is out of date today. In modern architecture, even in buildings which are expected to last for centuries, there is little, if any, demands for Ionic columns." He added with nostalgia:

But architectural styles are forever in a state of flux. The present article is written in the hope that some day architects will revert to the use of classical orders, particularly in the design of public buildings. It is with that hope that the writer wishes to record in this article how an exceedingly beautiful Ionic capital can be quickly drawn.[8]

Stevens lived to see the complete triumph of the modern architecture he detested, but not long enough to witness the return of some modern architects to the "use of the classical orders." He died in 1963, only three years before another fellow in architecture, Robert Venturi (FAAR, 1954–1956), laid down the tenets of postmodern architecture with the publication of *Complexity and Contradiction in Architecture.* It was, perhaps, better that Stevens did not see the new wave of classicism and intellectual historicism in America. He was too much of a purist to appreciate and approve of it. I suspect that few of today's postmodern architects would show much interest in a machine for drawing a perfect Ionic volute; it would be too "correct" for their taste and lacking in esprit.

The architectural environment in the United States in the 1930s was certainly not very encouraging for Renaissance villas and palaces, even though the modern movement was far from being accepted. As far as the Academy was concerned, however, there was really nothing new in the "new policy." A final attempt was launched to return to the monumental classical manner and to make the Collaborative Problem work during the short term of the new director, James Monroe Hewlett. Although Hewlett reported in 1933 that the "Collaborative is back on its feet" and Roscoe Guernsey informed the board of trustees in the same year that "this growing interest in the

Collaborative is gratifying, as it is in complete harmony with the primary aims of the Founders of the Academy," this was simply wishful thinking.[9] The project for 1933, "Property Development for the American Academy in Rome" (for the Via Angelo Masina lot, across from the main building), did not bring notable results. There was no Collaborative Problem in 1934 and 1935.

In 1934, Hewlett began his Annual Report for Fine Arts by giving an assessment of the "influence of a movement summarized generally under the term 'modernism' and highly destructive of students' appreciation of classic precedent and classic examples." He observed in the works of the current fellows (again with wishful thinking) "a gradual awakening of this enthusiasm for tradition marked by a tendency to appreciate more highly the more archaic productions of the classic spirit in architecture, painting, and sculpture."[10] What Hewlett might have meant by "more archaic productions of the classic spirit" is intriguing; I suspect this was a kind of formula devised by him to explain—and excuse—the fact that the fellows' works no longer looked properly "classical." Archaic Greek art was not among the sanctioned styles included in the official Academy list, but the venerable authority of that style, its simplicity and severity—superior to that of the classical—was quite unassailable. Therefore, it was a safe outlet for creativity as well as a title or designation that could conveniently be appended to describe any reasonable deviation from the pure classical mode, as Paul Manship, the notable fellow in sculpture, had discovered in the 1910s. Indeed, the use of the term "archaic" and the reawakening of interest in the style may have been inspired by Manship himself, who had been visiting the Academy in 1934.[11]

After 1936, the "classic" style as McKim and the founders of the Academy knew it, which was expressed primarily by the use of the orders, returned to the Academy no more except in archaeological work. The subjects of the Collaborative Problem issued between 1936 and 1939 included more and more public buildings of contemporary interest, such as "A Hydroplane Airport with a Memorial Beacon," 1936 (Pl. 43); "A Marine Museum and Aquarium," 1937 (Pl. 44); and "A Natatorium in a Public Park," 1938 (Pl. 45). The results reflected the kind of simplified and "columnless" classicism that was quite in the current idiom for public and government buildings in America and widely represented in architectural journals of the 1930s. The plans, however, were still very much in a late and watered-down Beaux-Arts style. They displayed good, generous layouts, a clear articulation of parts, and a sense of well-balanced compositional hierarchy expressed through symmetry and axiality, although the axes were hardly developed in the grand manner (Pls. 43, 45, 46). The elevations of these buildings, whose invented

Art Deco details could not hide an all-too-superficial effort to vitalize their limp monumentality, appear much less competent than the plans. In the 1930s, this traditionalist mode at the Academy was reflected in a half-hearted search for an idiosyncratic expression—something that looked modern without losing its classical qualities and without challenging the established, academic attributes of good taste. The results, although not altogether lacking in points of interest, were not remarkable and were often dull. Cecil Briggs would have definitely considered them "nothing to write home about." There was also a sharp decline in the quality of draftmanship. Starting in 1936, the drawings were kept much smaller in scale and "rendered more quickly," the competition time being reduced from thirty or thirty-two days to eighteen. Consequently, the drawings were sketchy and mechanical; some were even sloppy and unfinished.

Perhaps the most significant change in the Collaborative Problem in the 1930s concerned the main issue: the spirit of collaboration among the arts, which had really never been strong, seemed to have been reduced to a rather perfunctory application of mosaic panels, mural paintings, and sculpture on architecture. The "sister arts" were represented but never integrated into the architecture. Clearly, the Renaissance ideal of the unity of the arts, which had meant so much to the founders of the Academy and to the American Renaissance before 1917, had lost much of its intellectual and aesthetic appeal. The painter, the sculptor, and the architect were more interested in the individuality and personal expression of their art than in its subordination to the interests of a higher unity. One observes, almost with a sense of relief, the *coup de grâce* administered by the Second World War to this worthy project, which had outlived its day at the Academy.[12]

In the mid-1930s, the true scope and momentum of the modern movement and the diminishing stature of the Academy in the world of art and architecture had become an issue the trustees could no longer ignore. In 1935, Chester Holmes Aldrich, the newly appointed director in Rome and a successful New York architect (of the firm of Delano and Aldrich), solicited, no doubt with the approval of the board, the opinion of Henri Marceau (FAAR 1923–1925, architecture), then assistant director of the Philadelphia Museum of Art (director, 1955–1964), on a more forceful and effective art-education program for the Academy. Marceau's report, dated April 1935, is a well-thought-out recommendation for an overall liberalization policy. Marceau noted that of the forty-nine sculptors represented in the 1933 Century of Progress Exhibition in Chicago, only two had been fellows of the Academy, and the same two were the only former fellows included in the 1934 exhibition when sixty-one sculptors showed their work. In the section on contem-

porary American painting, of the 180 and 159 painters invited to exhibit in 1933 and 1934, respectively, the Academy was represented by only 1, the same fellow in both years.[13] After documenting other instances from the contemporary art and museum world in which Academy fellows unequivocally appeared in an unflattering light, Marceau asked: "Have we really taken the lead in the field of contemporary sculpture and painting? If not, are we attracting the right talent? If we are, are we guiding it intelligently?" The inevitable answer was no; the Academy did not attract creative talent to its competitions for fellowhips because the talented and creative artists and architects wanted greater liberty and opportunities for originality that the Academy did not, or could not, offer. He suggested that the juries be more evenly balanced, including "so-called advanced groups" with the "so-called 'Academic' groups": "Shouldn't we go outside our own group for the personnel of our juries? Shouldn't we relate our activities to the *'contemporary parade'*?" On the subject of the students' work in Rome, Marceau's criticism of the traditional policies of the Academy was equally penetrating and frank:

Do we require too much stated work—too little original work? Should not our architects be required to familiarize themselves with the contemporary phases of their profession—should they be excluded from the rich experience of visiting Germany, Austria and other centers where keen minds are solving modern problems? Should we not encourage students to use source material intelligently to produce new forms rather than promote eclecticism in the arts?[14]

Marceau also boldly proposed that a "Fine Arts Research Institute" be established at the Academy, where graduate students from fine-arts departments of American universities might carry on research projects centering around archival and library research and travel. He envisioned at the Academy a vibrant program of seminars, colloquiums, and lectures, as well as brisk scholarly articles published in the Academy's *Memoirs* and scholarly journals. Although no official "Fine Arts Research Institute" materialized, the program outlined by Marceau describes with considerable accuracy the goals and activities of the Academy's community of art historians and classical and postclassical scholars since the 1950s; it is as valid today as it would have been then.

Taken as a whole, Marceau's proposed reforms were too drastic for the Academy at that time, weighed down as it was by tradition. However, they appear to have been considered seriously and sincerely as the suggestions of an alumnus who occupied a significant position in the art world. There was no major change, but a noticeable relaxation of the rules and the intellectual

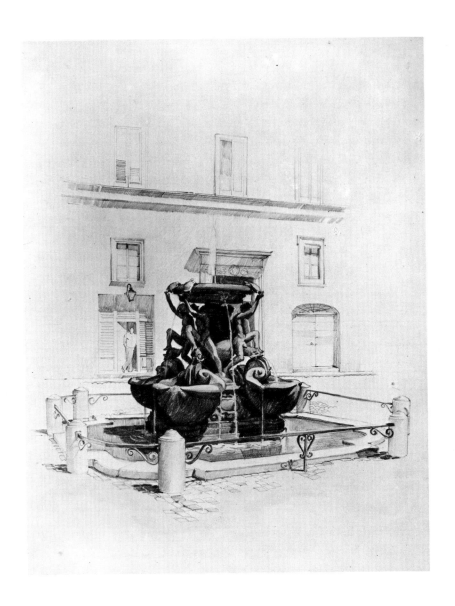

outlook of the Academy in the mid-1930s, which may be attributed to the collective effect of such opinions and pressures brought to bear from the inside as well as the outside. And many of Marceau's progressive ideas were reintroduced during a more comprehensive policy review attempted by the Academy a decade later.

Along with the modern, baroque tendencies also found occasion to display their "brazen countenances" at the Academy during the mid-1930s, but the manner in which the Academy attempted to curb and chastise such deviations had lost its early vigor and conviction. The studies for two nude figures in combat by Reuben R. Kramer, one of the fellows in sculpture in 1935, caused some concern because they revealed violent contortions suggestive of Bernini's Fontana dei Quattro Fiumi in the Piazza Navona (and

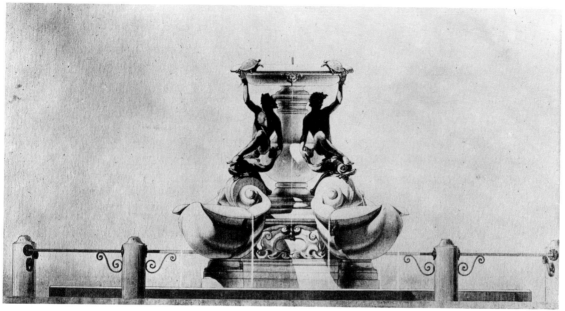

[44] Pencil studies of Fontana delle Tartarughe, Rome, by Robert S. Kitchen (FAAR, 1936) (*left*) and Philip Trammel Shutze (FAAR, 1916) (*above*). Kitchen's three-quarter view and the low angle emphasize the dramatic aspects of the design. By carefully adjusting his viewpoint, Shutze saw in the composition what he wanted to see and imbued it with classical qualities.

recalled Berthold Nebel's problematic *Wrestlers* of 1918 [Fig. 21]). John Walker III, a bona-fide art historian who had replaced Fairbanks as professor-in-charge of the School of Fine Arts[15] did not actually interfere, although in his Annual Report of 1935 he noted with some degree of relief that in the final version "this Baroque treatment gave way to a movement slower and more restrained in feeling."

Harrison Gibbs, a first-year sculptor in 1936, produced a very fine bronze entitled *Hercules and Hydra*, very much in the baroque mode and spirit of a late Hellenistic work. Landscape architect Robert S. Kitchen studied Taddeo Landini's Fontana delle Tartarughe in Rome, emphasizing in his sketches its elongated figures and contorted, Manneristic composition. In 1919, Philip T. Shutze had admired the same fountain, but had emphasized the classical qualities of the composition, as seen in his drawings (Fig. 44). Neither of these works raised adverse comment; both were illustrated in the Annual Report of 1936/1937. In the same report, Walker observed significantly: "Several students of History of Art, who stayed at the Academy, by

their training encouraged vigorous discussions of taste and aesthetics." Among them was Sydney J. Freedberg, a Sachs research fellow who was to become known for his contributions in the study of Renaissance and baroque painting.

Any mention of sweeping goals and ideologies is noticeably absent from the Academy's publications and the private letters of its officers in these years, as the Academy was forced to take notice of the contemporary art world and its opinion. Prescribed work and archaeological exercises continued, but even here an apologetic note crept into their assessment and criticism. Walker felt the need to explain and justify such archaeological exercises shown in the annual exhibition of 1936 in Rome:

Once the purpose of the work of the Fellows had been explained to the critics of the Italian newspapers, and it had been pointed out that these years in Italy corresponded with the "journeyman period" of earlier artists, and that their object is to study and learn the vocabulary of the great classical tradition rather than create original works of art, the press reviews were in the highest degree sympathetic and understanding.[16]

It took the Academy nothing short of a world war for a full reform of its artistic and educational policy. The Second World War, in which the United States and Italy fought each other, disrupted the life and educational program of the Academy much more than the First World War had done. The Academy was closed for almost eight years, from 1940 until 1948, when it resumed its activities in Rome under the able directorship of Laurance P. Roberts. During this period, many of the older trustees died or retired. The sensibilities of postwar America into which the Academy stepped were fundamentally different from those of the interwar years. It was a world of optimism but also of hard realism and technology, which, gradually and at its intellectual best, developed into a questioning and analytic spirit. It was also a world of emerging new nations; of acute social, political, and ethnic consciousness; and of the affirmation of basic human rights and egalitarianism. A person or an institution would feel uncomfortable making broad, sweeping, and unsupportable generalizations on culture, art, and human nature. And, perhaps, it was a world destined for occasional intellectual migraine because the innocence—or the simple nescience—required to maintain such beliefs had been lost forever.

There was no more talk among the Academy's upper echelon of aesthetic superiority or the preeminence of pure styles or of the opiate loveliness of Quattrocento Italy in twentieth-century America. There were no more sincere but self-righteous efforts to cloister and protect the fellows against the

"vulgarizing and puerile effects" of unsanctioned styles in art, especially the modern, which had clearly emerged triumphant. Rome no longer seemed to occupy a key position in the study of art and architecture. This point, which had been made by Marceau a few years earlier, was painfully brought home in 1938 when Judge McCarthy ruled that the fellows of the National Academy of Design in mural painting, who had customarily spent their fellowships at the American Academy in Rome, need not do so anymore because, as paraphrased by the Valentines "the development of modern art made it possible for a young painter to secure training and inspiration without exposure to the classical world."[17] The fellowships at the Academy were reduced to two years. No "prescribed work" was expected of the artists and architects. Mural painting, as a category, was no longer given supremacy over easel painting and in time almost completely died out. The growing sense of individualism in the arts wiped out the Collaborative Problem, once considered an irreplaceable intellectual and artistic mainstay of the Academy's educational policy. Rightly or wrongly, the romantic image of Howard Roark, Ayn Rand's genius architect of *The Fountainhead* (1947), struggling alone and heroically against the combined forces of academic classicism and institutional bullishness, was becoming irresistibly appealing to young architects.[18]

The memory of the postwar Academy also proved uncommonly short. Few, if any, fellows or resident scholars remembered Gorham Phillips Stevens and the tradition for which he had so long and hopelessly crusaded. Hardly anyone knew that the designer of the Academy's Janus seal was William M. Kendall from McKim's firm, who had also been responsible for the design of the main building.[19] Many may have been aware that the fountain in the middle of the courtyard (dedicated as the Founders' Courtyard, but the name never caught on), depicting the infant Hercules strangling the serpent, had been created and donated to the Academy by Paul Manship (FAAR, 1912) (Fig. 5). But few knew that it had been intended as an allegory of youth vanquishing the forces of inertia and complacency—a theme not inappropriate for the Academy of Manship's years.

The Academy's scholar-guides, who frequently take distinguished visitors to the handsome main hall of the Academy library, are unlikely to remember that it was inspired by the Piccolomini Library in Siena and that its walls and vaulting were to have been decorated by frescoes, offered to the fellows in painting with perennial insistence in the 1920s and 1930s, but finding no takers.[20] And when the same visitors are taken to the roof terrace of the Villa Aurelia for the famous view, there is no recall of C. Grant La Farge's once extremely popular and repeatedly reproduced poetic description of Rome from the same spot (Fig. 7).

None of the fellows of today, and only a few of the older trustees, remember that William R. Mead, a close friend and the principal partner of McKim and the longest-serving Academy president (1910–1928), is buried virtually a stone's throw from the Janiculum, at the Protestant Cemetery in Rome. Stevens, as director, and a small group from the Academy used to visit his grave on the anniversary of his death. As for the founder of the Academy, Charles Follen McKim, his memory may have fared better because of the handsome fountain and inscription plaque at the entrance to the building, even though few of the artists and only some of the scholars can read Latin.

VIII. Architectural Practice and Architectural Education in America Between the Wars

Much as the Academy during the interwar years may appear to have been a stronghold of academic classicism resisting the rising tide of modernism, its educational policy and aesthetic preference only reflected the greater artistic and professional ambiance at home. Until the early 1920s, it was a school to train an elite corps of young architects to take on the task of propagating the Renaissance that Charles McKim and his circle wished to bequeath to American architecture. At the end of the nineteenth century, this was a modern and progressive stance, and the Academy occupied a vanguard position in the direction American architecture was then moving. Some of the fellows from this period—John Russell Pope, Harold Van Buren Magonigle, Philip Trammel Shutze, Paul Manship, Barry Faulkner, Allyn Cox—proved to be among the successful and eminent artists in their fields, despite the change of the times and attitudes. Soon after the death of McKim in 1909, and the symptomatic Armory Show of 1913, the creative forces of the American Renaissance began to work out their course. By the end of the First World War, the leaders, who only a generation before had been the insurgents, found themselves as the old guard defending their positions against young artists and young movements of the early twentieth century.[1] These movements—Expressionism, Cubism, Futurism, Surrealism, the Bauhaus—also had their centers in Europe, but not in Rome.

Still, the acceptance of modernism in America did not occur suddenly. Between the wars, the architectural Establishment evinced a conservative, if not an entirely complacent, attitude toward experiment and change. Al-

though Le Corbusier's *Vers une architecture* had been translated into English by 1927 (in England) and the International Style Exhibition at the Museum of Modern Art in 1932, along with Hitchcock and Johnson's *International Style*, published in the same year, received considerable acclaim, these milestones in the history of architectural thinking did not reflect the attitudes and convictions of the architectural profession as a whole. In an opinion poll for the best American building, conducted among twenty-six well-known architectural firms by the the *Federal Architect* in 1932, there were no real modern buildings in the top nine positions: Henry Bacon's Lincoln Memorial led the list among the most admired buildings, followed by the Empire State Building, the Nebraska State Capitol, the Pierpont Morgan Library, and the Chicago Daily News Building.[2] The winners of the AIA Gold Medals in the 1920s and 1930s, primarily architects known for their traditionalism, also indicate the profound conservatism of the profession.[3]

The predominant question during this period was not so much whether modern architecture should be accepted but what it should be. By 1930, even the ultraconservative editorial view of the *Federal Architect* could accept defeat with a touch of self-effacing humor:

The germ of Modern Architecture is with us. Quarantining at the respective state borders has been of no avail. Spraying with strong solutions has failed. The deadly germ, propagating like the Japanese beetle in obscene profusion, leaped all geographic borders, thrived heartily upon all poisons set out to destroy it. It is too strong to combat. Rather, we must accept it.[4]

Accepting it, however, was not easy, and defining exactly what it was, harder still. Richard G. Wilson has named two broadly separated stylistic approaches of the period as "Conservative Modern" and "Radical Modern" (Henry-Russell Hitchcock had earlier referred to the two groups as the "New Traditionalists" and the "New Pioneers").[5] In the United States, there were very few practitioners of the radical, machine-oriented European modernism before the end of the Second World War.

The great majority of architects warmed up to the concept of modernism by cautiously modifying classicism. The stripped (or "starved") classicism of federal buildings, the inventive, stylized eclecticism of Art Deco, the hierarchical layouts of the late Beaux-Arts tradition—all sought to retain the fundamental formal characteristics, the symmetry, balance, and harmony of a classical composition, often without the telltale orders. During this period, all three approaches were tolerated if not encouraged at the American Academy, whose ideal, however, was still the correct and monumental classicism of Imperial Rome and Renaissance Italy.

One building that was greatly admired by both the conservative modernists of the profession in America and the Academy circles in Rome was Ragnar Östberg's Stockholm City Hall of 1923. Described by Wilson as "aggressively picturesque," this handsome building combined a storybook medievalism with an alluring and discreet medley of motifs from Art Noveau, Swedish vernacular, and regional crafts traditions. The unique and privileged position that the Stockholm City Hall enjoyed at the Academy, even though it belonged to a world clearly outside the Academy's sanctioned styles, is attested by a beautiful watercolor rendering of the building by Cecil C. Briggs done in 1930[6] (Pl. 53).

One of the most talented and admired practitioners of this kind of stripped classicism was Paul P. Cret, whose work (ca. 1910–1940) showed a steady development from a pure Beaux-Arts classicism to a soft picturesque modernism. In buildings such as the Folger Shakespeare Library in Washington, D.C. (1929), Cret's work displays character and sensitivity that rise far above the usual platitudes of this style.[7] Cret appears to have exerted considerable influence on the architectural work of some of the fellows while they were in Rome, particularly C. Dale Badgeley (FAAR, 1927–1930) (Pls. 13–15). His reputation as a successful architect and educator with progressive but moderate views made Cret the kind of person the Academy wished to consult by the mid-1930s as an outside adviser to help revitalize its ailing architectural policies.

Into the late 1940s, the United States government and capital were the most important patrons and promoters of this lean classical style. The inherent conservatism of federal agencies sponsoring architecture, the desire "to follow the stamp set on the early builders of Washington, a national inheritance that the United States Government should cherish,"[8] and the genuine belief that classicism was the most appropriate (and the *only*) style to confer the nobility and monumentality required of public buildings supported its use.

The architecture of the Federal Triangle (1932–1936), in Washington, D.C., is a vast stage set for a limp Beaux-Arts classicism with little conviction or unity[9] (Fig. 45). The classical spirit, running low throughout the scheme (with the exception of John Russell Pope's National Archives), reaches its nadir in the buildings at the east end of the triangle: the unfluted Ionic columns without bases or entasis, some carrying archaizing "Bassae" capitals, were probably intended to prove that their architects could be inventive or expand their vocabulary of classical architecture, but the results appear simply confused and lifeless. In contrast to these buildings, the correct and full-bodied Greco-Roman classicism of Pope, the initial fellow in architecture

at the American Academy, attains the fundamental qualities of unity, simplicity, and grandeur. Despite the polemics of its contemporary detractors (who labeled Pope as *ultimus Romanorum,* quite inappropriately), Pope's National Gallery of Art (1939–1941) displays such an assured and professional handling of these fundamentals and such a subtle knowledge of classical form, composition, and vocabulary that any reproach because of its "historical style" seems misplaced and insignificant. The building is destined to age well, and it recently found a worthy companion in the pristine "classicism" of I. M. Pei's East Building.

The assessment of Pope's work by the leading modern critics and historians of the 1940s and 1950s was unjust because it was based primarily on functionalist and moralist criteria—that the external appearance of a building should follow and express its function. To this mode of thinking, all forms of historicism and revivalism were equally and categorically unacceptable. Such critics made little or no attempt to analyze the quality and content of a particular building or a particular historical style objectively and on its own merits. Nor did they have any interest in discerning who, among the traditionalists, was a better architect. It seems unfair and too easy to dismiss the National Gallery as "a costly mummy" or "an outdated extravaganza of multiple-returned cornices, pilasters and entablatures"—and shows insufficient knowledge of classical architecture.[10]

To label Pope as the "last of the Romans" (as Joseph Hudnut has done) and subscribe to the assumption that Pope simply followed his illustrious mentor McKim are signs of misapprehension. With the exception of the use of the Pantheon motif (pedimented porch with a dome behind), Pope's aesthetic preferences ran in the direction of high classical Greek and Hellenistic rather than Imperial Roman. Perhaps the building he most admired was the Erechtheum on the Athenian Acropolis, of which he made ten sheets (22 × 30 inches) of measured drawings on the site, in 1896, including some extremely accurate profiles and moldings. These original drawings, which may be the first examples of measured drawings by an American architect, are preserved in the National Gallery of Art.[11]

The general conservatism of the architectural profession in the United States between the wars was paralleled by the conservatism in architectural education. The Beaux-Arts system, which had been adopted at the end of the nineteenth century to satisfy the needs of the profession for higher social standing and higher artistic and technical standards, dominated architectural education by the end of the first quarter of the twentieth. The system was based on teaching design through historical precedents.[12] Its objectives were clearly and simply stated in the mid-1930s in the *Bulletin* of the Architecture

[45] Federal Triangle, Washington, D.C., 1932–1936.

School of the University of Pennsylvania: "Modern problems to be successful must have modern solutions; the proper approach to modern solutions is through a study of the solutions of the past. Good design—good proportion and composition—are the growth of past ages of art."[13] Once a progressive and rational method of education, the Beaux-Arts lost touch with the social and economic realities of the twentieth century and appeared increasingly irrelevant and stilted. Furthermore, its overt historicism became anathema to the principles of the modern movement.

The educational goals and policies of the Academy conformed to the objectives and practices of this nationally accepted system of architectural education, with one possible difference: the Beaux-Arts approved, to a certain extent, the use of medieval and Gothic styles for certain buildings, such

as churches, educational institutions, and skyscrapers. The Academy remained pure in its insistence on the classical and the Italian Renaissance. The intellectual and artistic compatibility of the two institutions was natural. Many of the founders and the leaders of the Academy had been instrumental in the formation of the Society of Beaux-Arts Architects and the Beaux-Arts Institute of Design. Some of the former fellows occupied responsible positions in the leading schools of architecture: Edgar Williams (FAAR, 1912) at Columbia University, George Koyl (FAAR, 1914) at the University of Pennsylvania, James Chillman (FAAR, 1922) at Rice University, Arthur F. Deam (FAAR, 1926) at the University of Pennsylvania, Cecil C. Briggs (FAAR, 1928) at Columbia University and the University of Illinois, and Olindo Grossi (FAAR, 1934) at the Pratt Institute of Design. All the fellows, without exception, were the products of architectural schools committed to the Beaux-Arts methods of education.

Predictably, the dissatisfaction universally felt with architectural education in the 1930s was reflected at the American Academy in Rome.[14] As related by a contemporary source, in architecture schools across the nation, as well as at the Academy, students "wrestled with monumental schemes of a type never seen or likely to be seen on land and sea," and many realized the absurdity of it in a world crippled by the Great Depression.[15] Exciting new ideas of European modernism, from the International School and the Bauhaus, had gradually begun to infiltrate the system against all attempts to sequester the students from such influences. The desire for originality ("God help the term!" Frank Fairbanks had exclaimed in 1930) was a particularly critical and damaging issue at the Academy because the fellows were older and professionally more mature than typical architecture students. As recalled by Joseph Esherick, it was possible for an advanced student at the University of Pennsylvania in the early 1930s to carry on and submit a project in the modern style against the apparent resistance of the faculty. A design critic of exceptional sensitivity and competence, such as Paul Cret, after exhausting all attempts to dissuade a recalcitrant student from continuing to work on an uncooperative modern scheme, could sit down and really show him how to do it right. Esherick remembered one such instance as a "memorable experience."[15] That kind of experience, or tolerance, was not ordinarily enjoyed by the architecture fellows at the American Academy.

The attempts of some of the leading schools of architecture, such as Harvard, the University of Pennsylvania, and Columbia, to modify the Beaux-Arts methods and modernize education in the mid-1930s may have been reflected in the noticeable relaxation of the atmosphere at the Academy starting with the directorship of Chester Aldrich in 1935. During this period,

many schools formed special committees to report on architectural education and recommend changes, or sponsored round-table discussions on modernism.[17] A special committee on architecture, appointed by President Nicholas M. Butler of Columbia University in 1934, disapproved of an education rooted in history and observed that such an attitude "assumes that by studying historic styles and academically determined 'correct elements,' the student will become able to achieve personal expression in terms of his day."[18] The chairman of this committee was C. Grant La Farge, the veteran secretary to the board of the American Academy, not at all known for his progressive views when dealing with Academy matters. Still, it may have been connections such as this that moved the Academy to solicit the opinion of Henri Marceau, in 1935, on similar issues.

In 1935, the Academy board was not ready to accept Marceau's progressive suggestions. A decade later, soon after the Second World War, a more determined and serious effort to seek outside opinions and recommendations on educational policies brought positive action. After all, even Columbia retreated to a more traditional pattern after Joseph Hudnut, the progressive dean of the Architecture School, left for Harvard in 1937. Indeed, it was not before the early 1950s that a thoroughly modernized curriculum was embraced by most architectural schools in the United States.

IX. An Overview
of Architectural Education
at the Academy

Although the main lines of the educational policy of the Academy had been laid out in the early days, its application was never very strict and inflexible before the First World War. These were the years of formation. There were few fellows, and they worked as best they could under considerable financial and physical hardship, as the new institution was barely solvent and its physical plant far from ideal. But there seems to have been a team spirit mixed with pioneering excitement in the cozy clutter of the Academy's rented quarters.

John Russell Pope remembered his Academy days with fondness: "We were congenial and a happy family, tireless and united in our appreciation of McKim's object of building up the Academy. We worked together in Rome and throughout Sicily and Greece."[1] Writing from the congested Villa Mirafiori (whose informal atmosphere had been criticized by Francis Millet in 1909 as an "American *pensione*"),[2] Kenneth E. Carpenter, a first-year fellow in architecture in 1912, expressed his pleasure at being in Rome and at the Academy, describing his fellowship as a "great fortune." He ended his letter to C. Grant La Farge in New York:

I don't think that anyone can fully appreciate the value of study here until they have been here the full term. I am looking forward with pleasure and anticipation to the three years ahead of me and I trust my work here will be such as to meet with the approval of the trustees.[3] (Pls. 55, 56)

It seems that the Academy and Rome occupied a very special position in the minds and hearts of most of the fellows long after they were immersed in their careers. As touchingly narrated by Elizabeth M. Downing, Philip Trammel Shutze, at the age of ninety-two, received his last letter from his close Academy friend and collaborator Allyn Cox in 1982, the year both died: "that letter closes with the memory of what must have sustained each man's creativity: 'I think of you often, and the old days in Rome.'"[4]

With the completion in 1914 of the Academy's permanent headquarters in Rome, the educational policy started visibly to harden. Primarily, this must have been only a reaction to the newer generation of fellows, who proved more reluctant than some of their prewar colleagues to follow the classical tradition and readily accept the waning ideals of the Beaux-Arts system. But the sense of security and permanence brought about by the architectural consolidation of the Academy around its palatial main building and the elegant Villa Aurelia on the Janiculum Hill also seems to have hardened the thinking of its occupants and policy makers in a rigid, institutionalized mold.

The Academy had started its life and based its educational and artistic policies on the values of the American Renaissance at a time when the generative forces of this movement had almost run their course. What had begun as an exciting and creative experience for the older generation of the Academy's founders (Charles McKim, Daniel Burnham, Augustus Saint-Gaudens, John La Farge, Daniel Chester French, Francis Millet, Kenyon Cox, Henry Siddons Mowbray—to name a few) soon became a limp and lifeless tradition that resisted all efforts of resuscitation by the second generation, which found itself at the helm of the Academy after the First World War. As the nascent modern world posed a threat to the aims and ideals of the founders, many of whom were no longer living, the second rank and generation of leaders (such as William R. Mead, William Boring, Samuel Trowbridge, Charles Adams Platt, C. Grant La Farge) formed a loyal inner circle to defend concepts that were becoming increasingly difficult to support. It was as though, along with the "Cult of Rome," a cult of the founders had been created, and its adherents displayed all the characteristic irritability and irrationality of the cultic mentality.

The "Credo" was the product of such a mentality. It would have been better not to take it seriously and not make an issue of it had it not affected Academy life in a major way during the period it was implemented as the basis of the educational policy. Barely a decade after the publication of the "Credo" in 1924, the Academy quietly pretended that it had never existed, and hardly any of the trustees of today had heard of it. Yet some of the

prophets and protagonists of the modern movement, in their newly found zeal for functionalism, were intellectually and artistically as narrow-minded, barren, and dogmatic as the academic Establishment they set out to destroy.

In the 1940s and 1950s, the polemical rhetoric of modernism did, to a large extent, destroy the academic and classical Establishment along with some of the finest buildings and spaces of the nineteenth and early twentieth centuries, such as Pennsylvania Station in New York, in whose daring span and grand manner a functionalist critic such as Joseph Hudnut could see nothing more than the "pale translations of the garish vaults of [the Baths of] Caracalla."[5] Or consider Sheldon Cheney's extremely disparaging (and uninformed) view of Roman architecture in his pro-modern architecture book published in 1930: "Rather empty, rhetorical, uncreative"; "Vulgarest display of surface grandeur in the history of the world"; "Of all the great architectural styles . . . the vulgarest, dullest, spiritually the emptiest". Such an attitude replaces one kind of bigotry, the antibaroque of the preceding generation, with another.[6]

Why did the Academy insist on following so narrow and retrogressive a course during the two decades between the wars? Why was Janus, the double-headed symbol of the Academy, so myopic when looking back to the past and so blind when looking into the future? Part of the answers to these questions lies in the nature of any institution—the premise of *any* academy to conserve and uphold historical traditions and styles. The situation was not much different among the other major national schools and academies in Rome, although the American institution appears to have embraced the tenets of classicism with a sincere, but immutable and almost militant zeal not embraced by other institutions during that period. Quite apart from the French Academy, the envied model and the acknowledged crown of the purest academicism in art, the history of the British School presents a comparable development. Stephen Farthing, a former director of the School, summarized the tendency:

For a long time [after the opening of the School in 1913], Rome scholarships were strongly linked to the more conservative tradition of British art, the rather academic realism which dominated the annual summer shows at the Royal Academy. Only after the Second World War did artists begin to be chosen who worked in decisively modern styles.[7]

The real reason for the Academy's traditionalism, however, lies in the fact that it was (and still is) a private institution and owed a large part of its existence to a conservative and powerful social, educational, and architectural

world centered in New York and on the East Coast that, like all powerful and elitist Establishments, resisted change. The Academy espoused the values and ideals of this world and Establishment. It would hardly be an exaggeration to state that until quite recently (covering an impressive time span of sixty-four years, between 1894 and 1958), the Academy remained very much an extension of the firm of McKim, Mead and White: many of the board members and four of the first five presidents were architects and partners in this private firm. The men who represented this social and professional world, the upper echelon of the Academy, were talented and hard-working professionals who displayed the curiously contrasting qualities of businesslike realism and irrational, romantic idealism—both deriving from their nineteenth-century roots. They were sincere in their fight against commercialism and tastelessness, but misguided in their inability to see in modernism a legitimate expression of their era. They knew one another in a clubby, family sort of way and identified with the "Old Academy" as an exclusive inner circle. The policies of the Academy, not surprisingly, reflected all the self-satisfied and self-congratulatory qualities that are typical of clubbish behavior anywhere. There may have been some good in this, but there was also a lot of harm, the worst being the inbreeding that inevitably developed.

The pattern that became established was a tediously familiar one: a fellow was chosen for his professional talent, his general level of education, his gentlemanly qualities, and his background. During his stay in Rome, if he worked hard, fitted in, and developed along the desired lines, he was admired as the "right stuff." If socially, professionally, and, to a certain extent, economically successful in later life, he was asked to be a jury member of the Academy or to be a resident artist or architect in Rome. Then, perhaps, he became a trustee or even the president. Such an uncommonly high proportion of jury members and trustees who enjoyed the same socioeconomic background, attended the same schools, and bore the Academy stamp created a staid and inflexible outlook. This elitist uniformity also hampered very seriously the principles of fairness in awarding fellowships. The Academy's reluctance to open its juries and its top-level decision-making machinery to the greater artistic and intellectual community, representing the entire country, stunted its growth and marred its reputation, so that the best creative talent may not have been even attracted by it.

During the decades that followed the Second World War, the Academy fell in step with the greater world around it and gradually began to take a more active and significant position in relation to the later developments in modern and postmodern architecture. Indeed, as early as 1945, the Executive Committee of the board started an extensive review of the policies of the

School of Fine Arts. Through letters, questionnaires, and luncheon meetings, the opinions of selected Academy alumni and the deans of a number of schools of architecture were solicited. There were some very conservative responses, usually from the elderly alumni, who wanted to see no change at all. But the majority of the responses underlined the need to substantially overhaul the educational policies.[8]

Paul P. Cret recommended the relaxation of the American Academy's regulations and the program of "prescribed work," but otherwise remained generally conservative in his outlook:

To sum up, I believe that the Academy training is still of value to our architecture. I would favor a very broad policy, considering the Academy as a place where a man can do in peace a thorough piece of work, more than as a kind of "finishing school." I would not mind at all [if], as did Tony Garnier in 1900, a fellow would bring back from Rome, besides some studies in ancient art, a brand new plan for "an industrial city." You may say there is no need to go to Rome to do this. True, but it is of value to work in pleasant surroundings and company without the necessity or temptation to "hunt" for a job or a prospective client. I believe that there will be a reaction against the present distrust of beauty so loudly proclaimed by a certain intelligentsia. The Academy ought to be kept as an island of refuge during the flood of barbarians' invasion.[9]

Besides Henri Marceau (who had sent an unaltered copy of the report he had written a decade earlier), the most liberal attitude was represented by Olindo Grossi (FAAR 1934–1936, architecture). Grossi believed that the fellows should be selected for their capacity to handle modern problems and should be encouraged to travel and study in European cities other than Rome where ideas on architecture were abreast of the times: "I like to think that the Academy was originally established to lead in the art that was prevalent at the time, and it does not seem a radical thought to ask that it remain a leader in the philosophies that reflect our present era."[10] Grossi's suggestion to invite "men like Saarinen, Aalto, Frank Lloyd Wright, Mies Van Der Rohe and Le Corbusier . . . to visit the Academy to stimulate the Fellows" did not come to pass. But beginning with Louis I. Kahn in 1951, many of the creative names in architecture in the 1960s and 1970s made their peace with history through the Academy and through Rome—but, then, the postwar Academy had also learned to accept talent on its own terms. Perhaps, it had become an academy in name only.

PLATES

These 100 plates represent a selected group of original architectural drawings made by the Academy fellows between 1908 and 1939. Most have never been published. The original renderings vary in size, but most of them are very large, some 4 to 8 feet long, and include extremely fine detail. The prints are made from original 8 × 10-inch glass negatives kept at the Academy archives. Plates 1–46 are Collaborative Problems, chronologically arranged (1912–1939); plates 47–100 are historical and archaeological.

ELEVATION

[1] 1912: "A Small Municipal Building for an American City" (Richard H. Smythe, architect; Albin Polasek, sculptor).

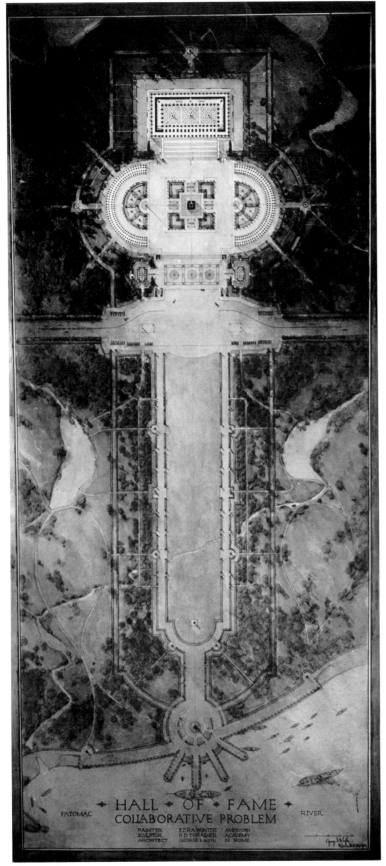

[2, 3] 1913: "A Hall of Fame for the USA" (George S. Koyle, architect; Harry D. Thrasher, sculptor; Ezra Winter, painter).

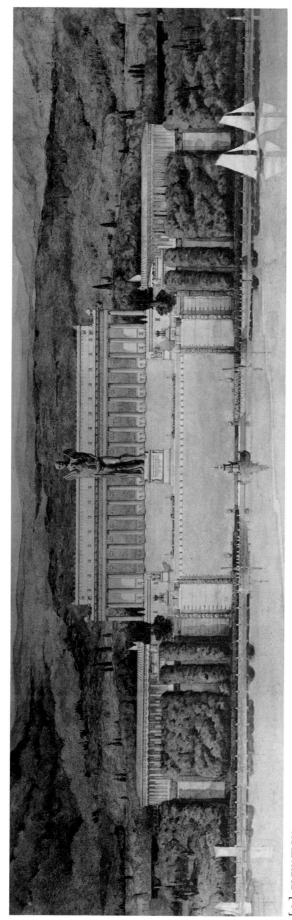

[3] ELEVATION

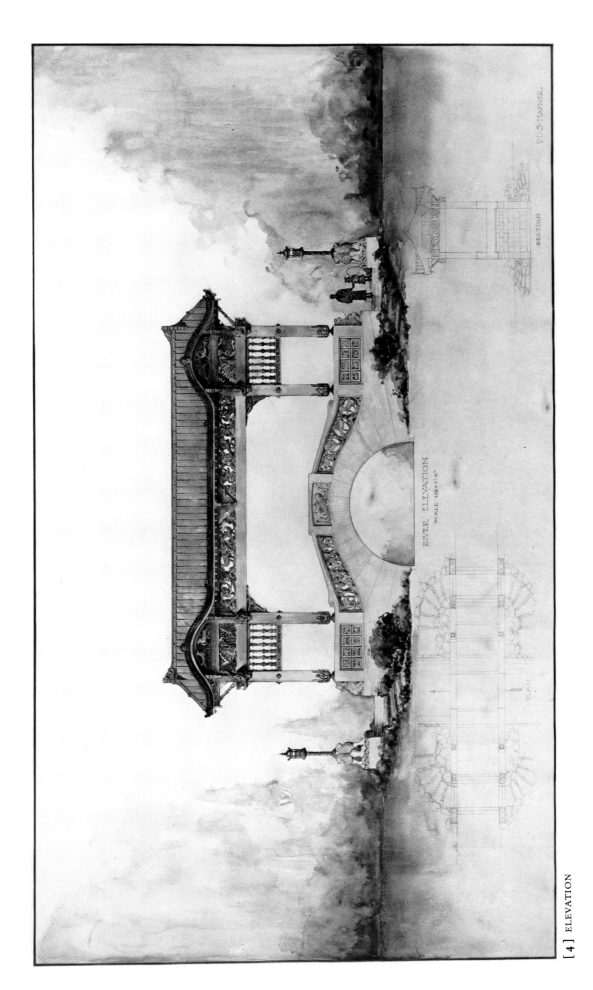

[4] ELEVATION

[4, 5] 1923: "A Bridge for Children in a Zoological Garden" (Victor L.
S. Hafner, architect; Gaetano Cecere, sculptor; Alfred E. Floegel, painter).

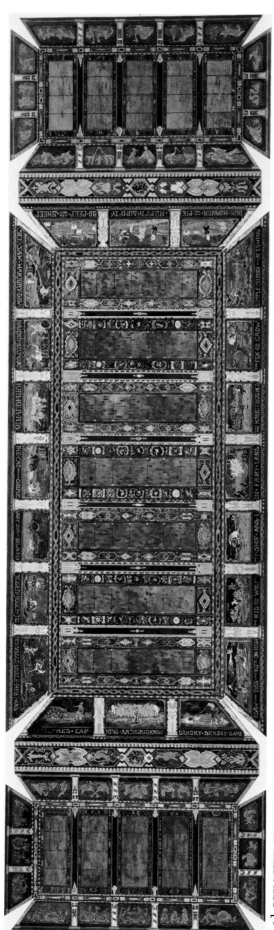

[5] REFLECTED CEILING PLAN OF ROOF

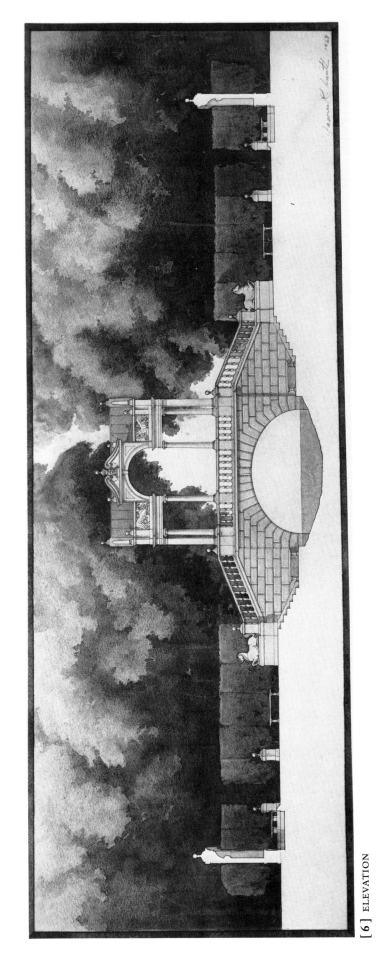

[6, 7] 1923: "A Bridge for Children in a Zoological Garden" (James Kellum Smith, architect; Lawrence T. Stevens, sculptor; Frank H. Schwarz, painter).

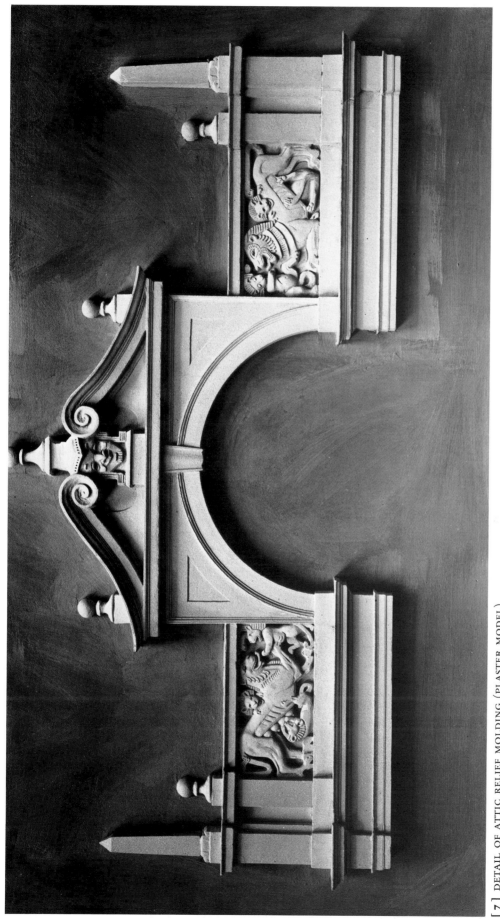

[7] DETAIL OF ATTIC RELIEF MOLDING (PLASTER MODEL)

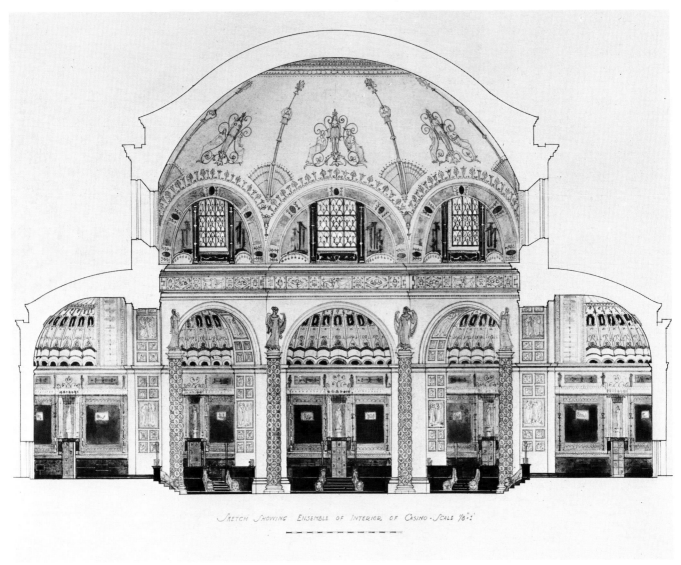

Sketch Showing Ensemble of Interior of Casino · Scale 1/8" : 1

[8] SECTION/ELEVATION

[8, 9] 1924: "A Casino at a Summer Resort" (Henri G. Marceau, architect; Alvin Meyer, sculptor; Frank H. Schwarz, painter).

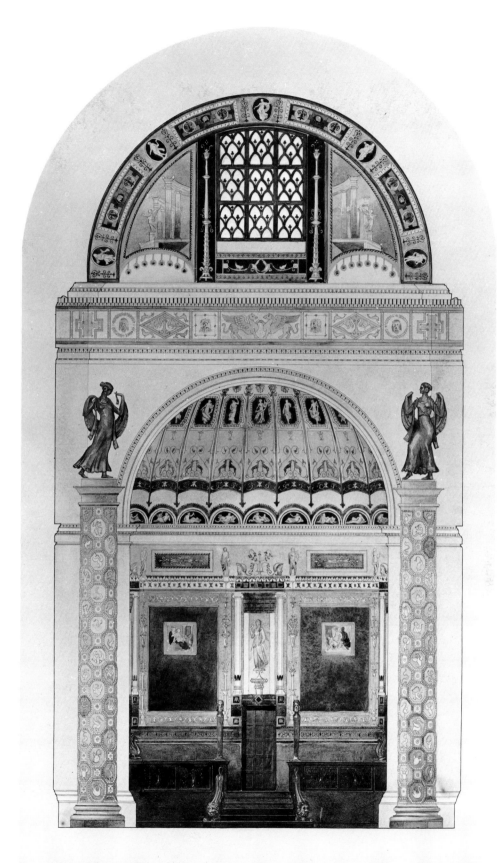

A CASINO AT A SVMMER RESORT

[9] ELEVATION DETAIL OF INTERIOR

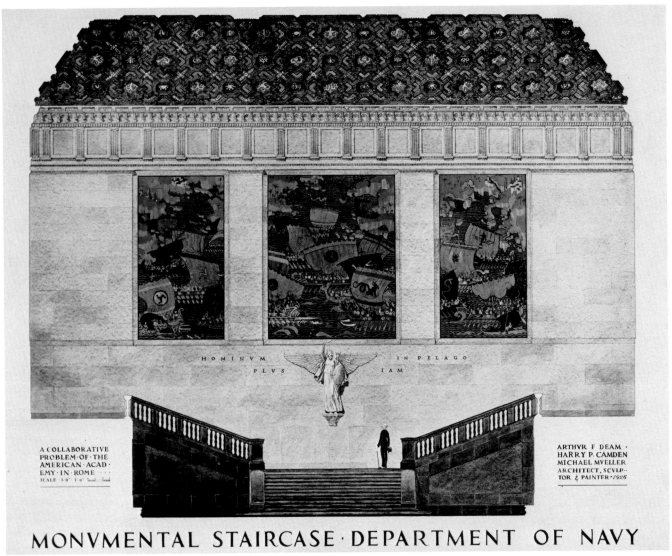

MONVMENTAL STAIRCASE · DEPARTMENT OF NAVY

[1 0] SECTION/ELEVATION

[1 0 , 1 1] 1926: "A Monumental Staircase for the
United States Navy Department" (Arthur F. Deam,
architect; Harry P. Camden, sculptor; Michael
Mueller, painter).

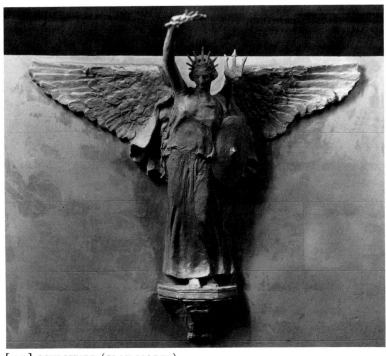

[1 1] SCULPTURE (CLAY MODEL)

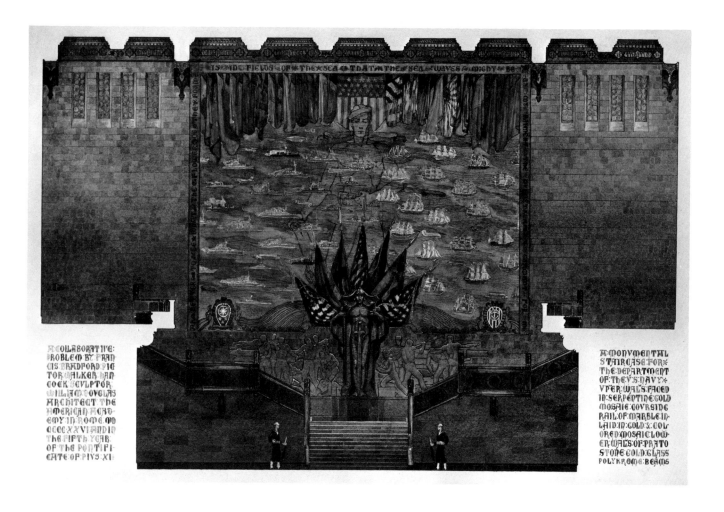

[12] 1926: "A Monumental Staircase for the United States Navy
Department" (William Douglas, architect; Walker K. Hancock, sculptor;
Francis S. Bradford, painter).

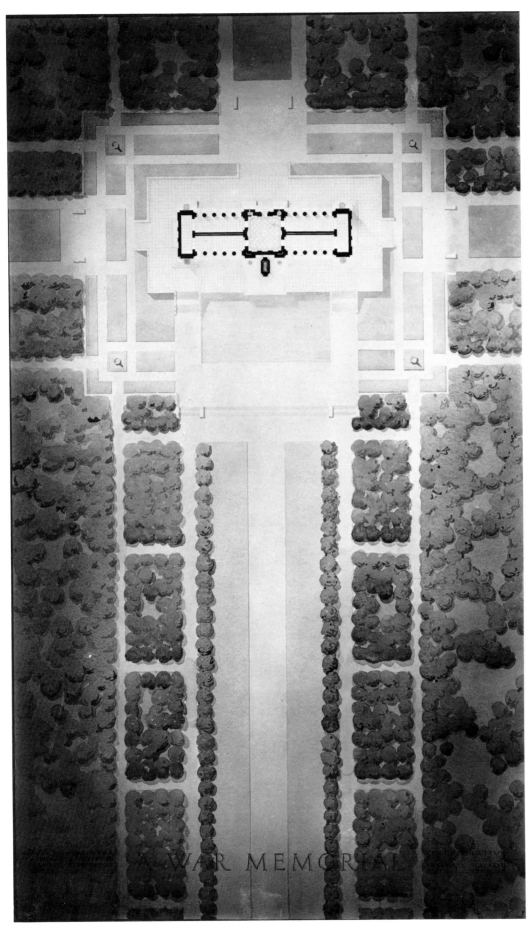

A WAR MEMORIAL

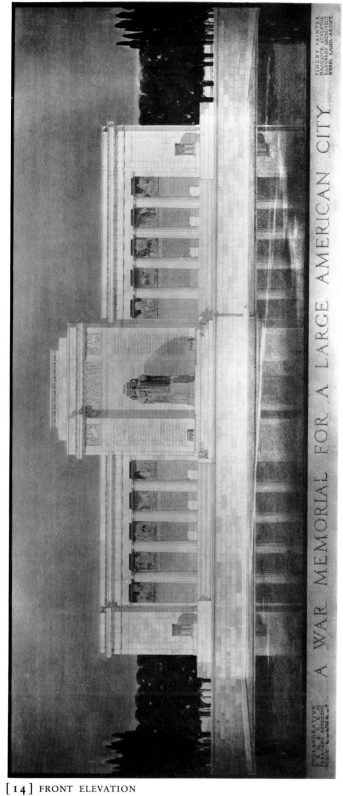

[14] FRONT ELEVATION

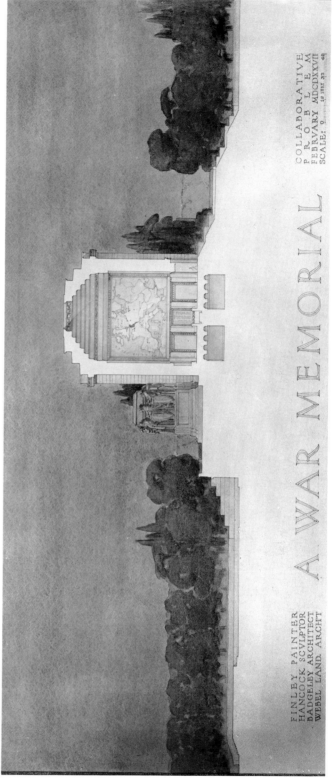

[15] SECTION

[13–15] 1927: "A War Memorial for a Large American City" (C. Dale
Badgeley, architect; Richard K. Webel, landscape architect; Walker K.
Hancock, sculptor; A. Clemens Finley, painter).

[133]

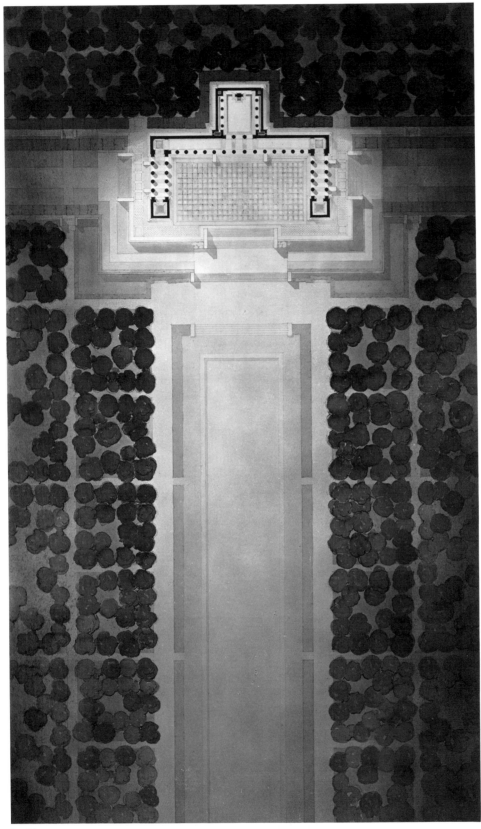

[16] PLAN

[16, 17] 1927: "A War Memorial for a Large American City" (Stuart M. Shaw, architect; Richard K. Webel, landscape architect; Joseph Kiselewski, sculptor; Michael Mueller, painter).

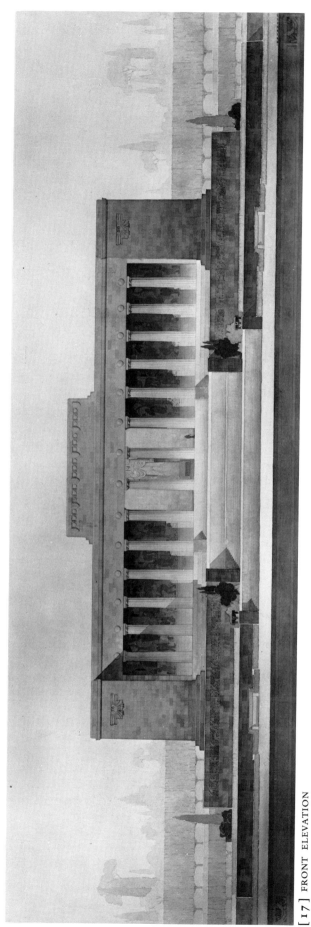

[17] FRONT ELEVATION

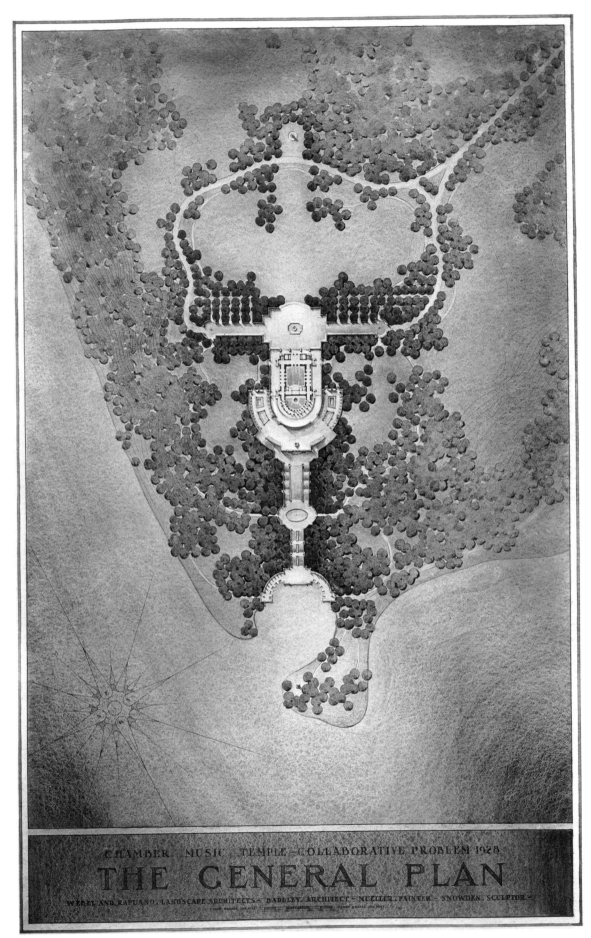

CHAMBER MUSIC TEMPLE — COLLABORATIVE PROBLEM 1928

THE GENERAL PLAN

WHEEL AND RAPUANO, LANDSCAPE ARCHITECTS ~ BADGLEY, ARCHITECT ~ MUELLER, PAINTER ~ SNOWDEN, SCULPTOR ~

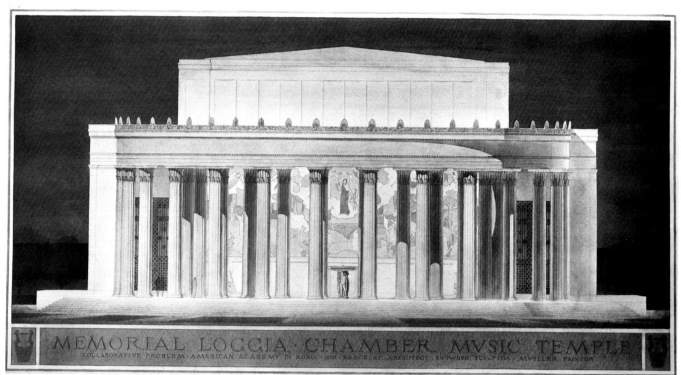

[19] MAIN ELEVATION

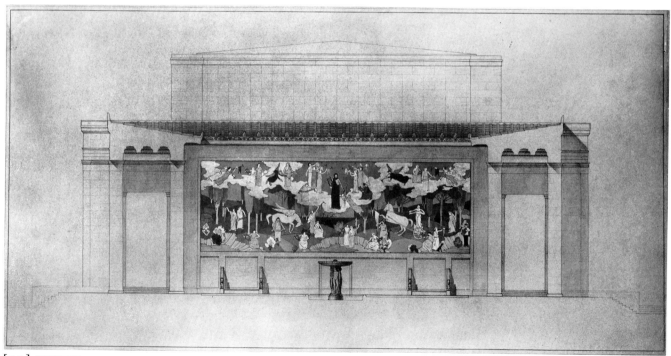

[20] SECTION

[18–20] 1928: "A Memorial Loggia for a Temple of Festivals of Chamber Music" (C. Dale Badgeley, architect; George H. Snowden, sculptor; Michael Mueller, painter).

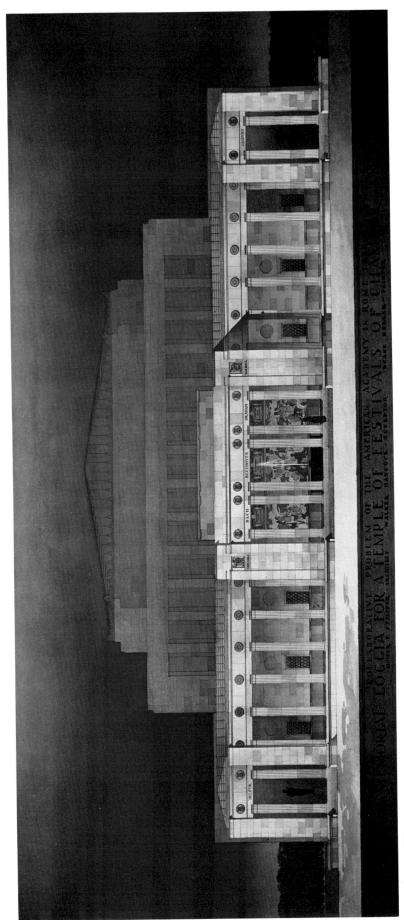

[**21**] 1928: "A Memorial Loggia for a Temple of Festivals of Chamber Music" (Homer F. Pfeiffer, architect; Walker K. Hancock, sculptor; Deane Keller, painter).

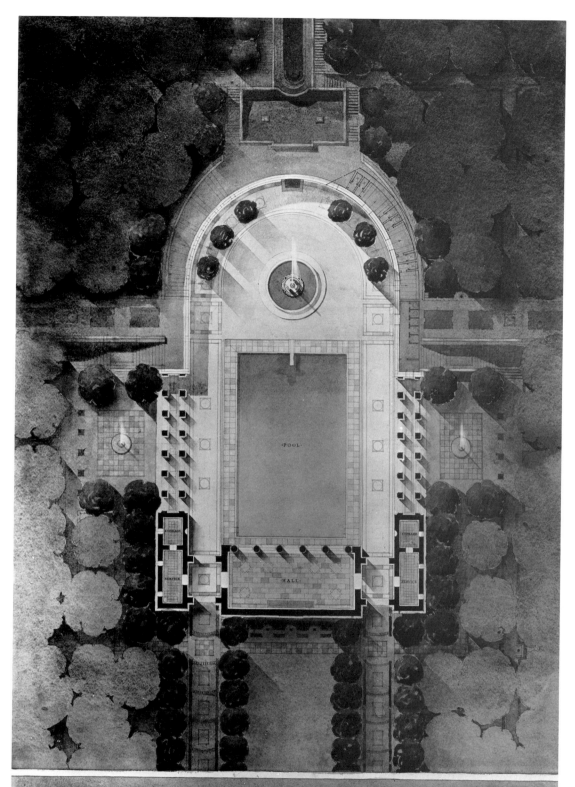

A·COMBINED·CASINO·AND·BATHING·POOL
COLLABORATIVE·PROBLEM·1929·AMERICAN·ACADEMY·IN·ROME

[22] PLAN

[22–24] 1929: "A Casino and Bathing Pool for a Rich Gentleman's
Country Estate" (Cecil C. Briggs, architect; George H. Snowden,
sculptor; Deane Keller, painter).

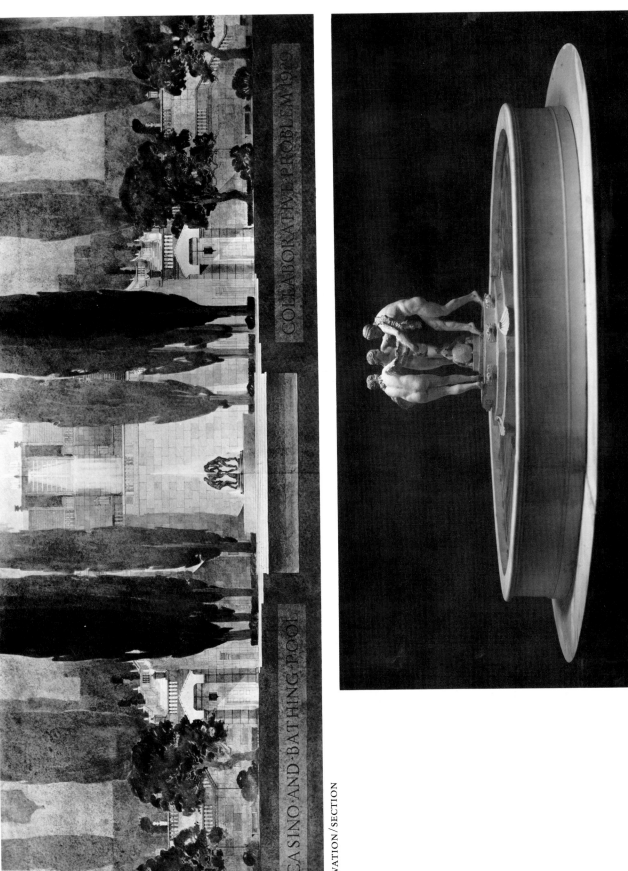

[23] ELEVATION/SECTION

[24] SCULPTURE DETAIL OF POOL (CLAY MODEL)

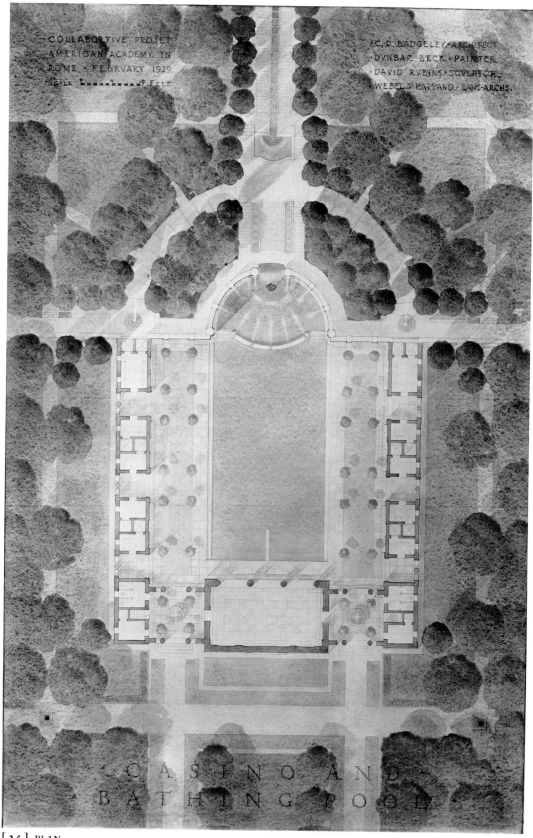

COLLABORATIVE · PROJET
AMERICAN · ACADEMY · IN
ROME · FEBRVARY · 1929
SCALE FEET

·C. D. BADGELEY · ARCHITECT
·DVNBAR · BECK · PAINTER
·DAVID · RVBINS · SCVLPTOR·
·WEBEL · S · RAPVANO · LANS·ARCHS·

CASINO · AND·
·BATHING · POOL·

[**25**] PLAN

[**25–27**] 1929: "A Casino and Bathing Pool for a Rich Gentleman's Country
Estate" (C. Dale Badgeley, architect; David K. Rubins, sculptor; Dunbar
D. Beck, painter; Richard Webel and Michael Rapuano, landscape architects).

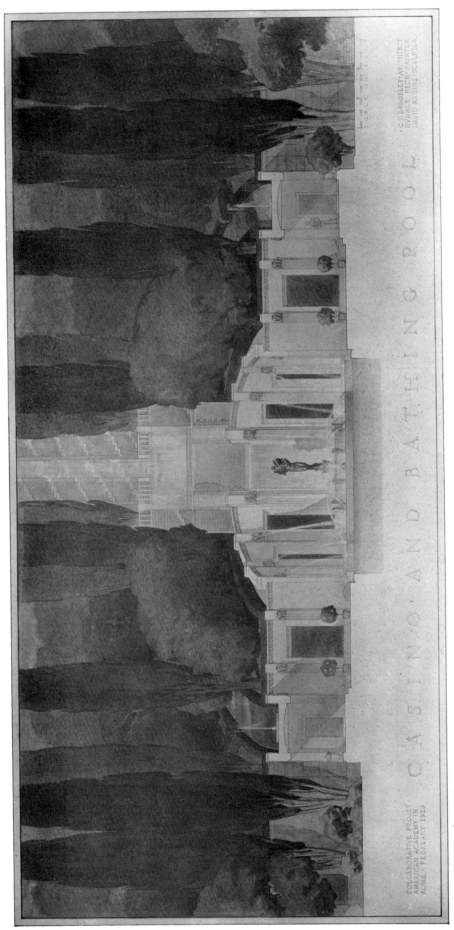

COLLABORATIVE PROJECT
AMERICAN ACADEMY IN
ROME · FEBRUARY 1929

C A S I N O A N D B A T H I N G P O O L

C.R.BADGLEY·ARCHITECT
DVNBAR·BECK·PAINTER
DAVID·R·BINS·SCVLPTOR·

[26] ELEVATION/SECTION

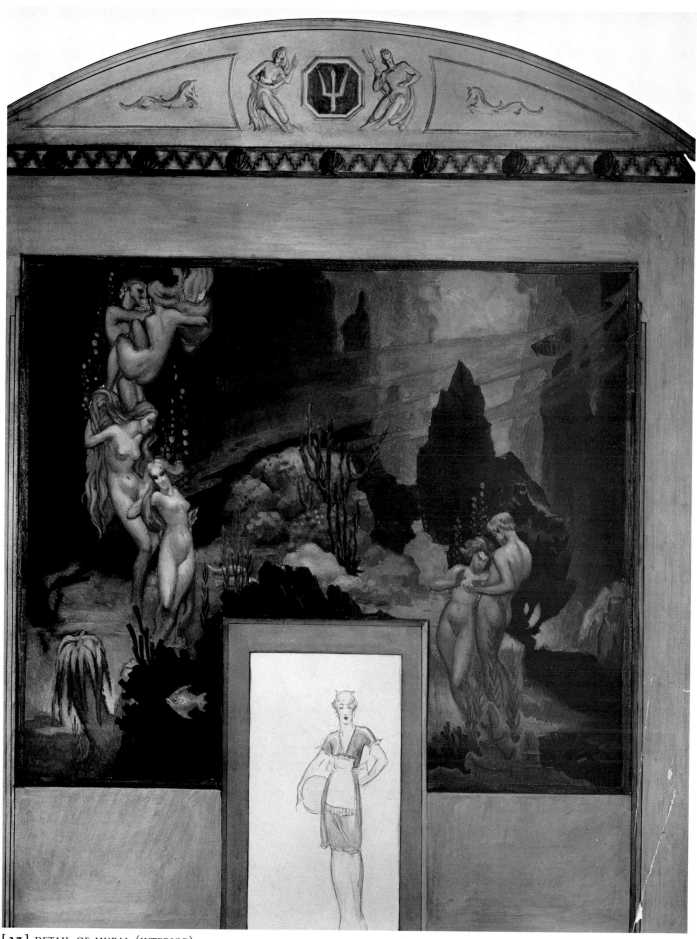

[27] DETAIL OF MURAL (INTERIOR)

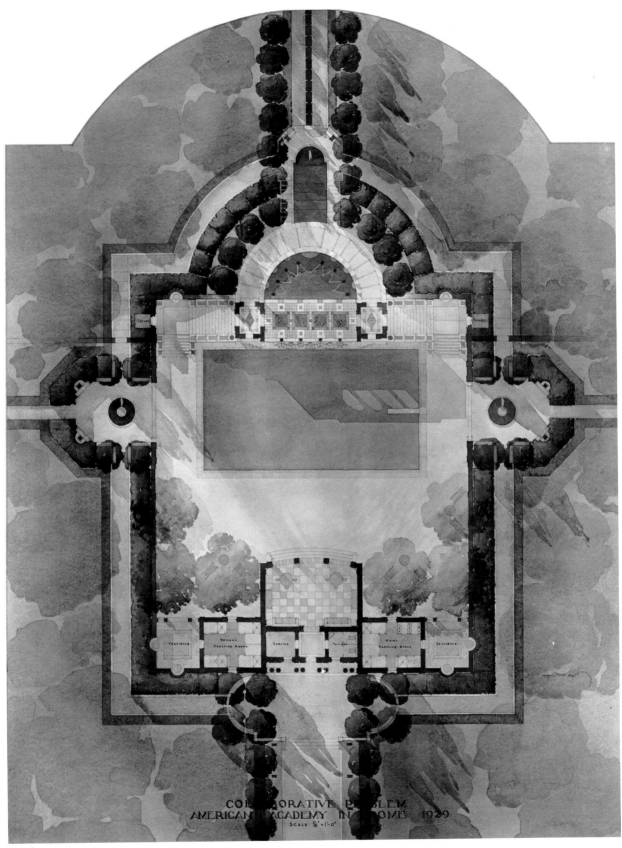

[28] PLAN

[28–30] 1929: "A Casino and Bathing Pool for a Rich Gentleman's
Country Estate" (Homer F. Pfeiffer, architect; Joseph Kiselewski, sculptor;
Donald M. Mattison, painter).

[30] SCULPTURE DETAIL OF PARAPET WALL (PLASTER MODEL)

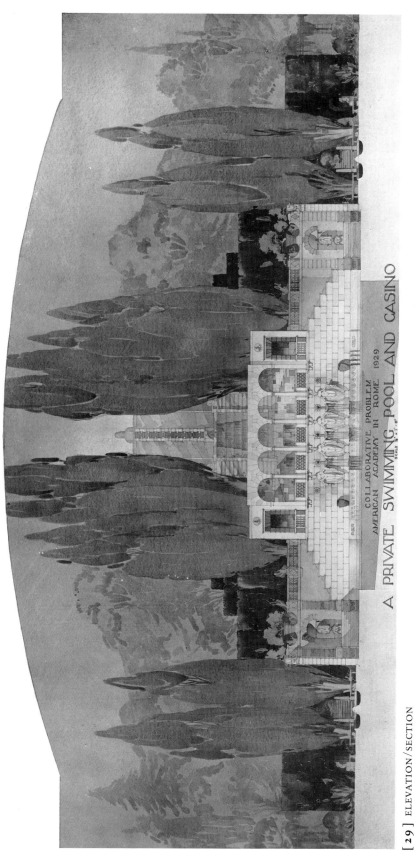

COLLABORATIVE PROBLEM
AMERICAN ACADEMY IN ROME 1929

A PRIVATE SWIMMING POOL AND CASINO

[29] ELEVATION/SECTION

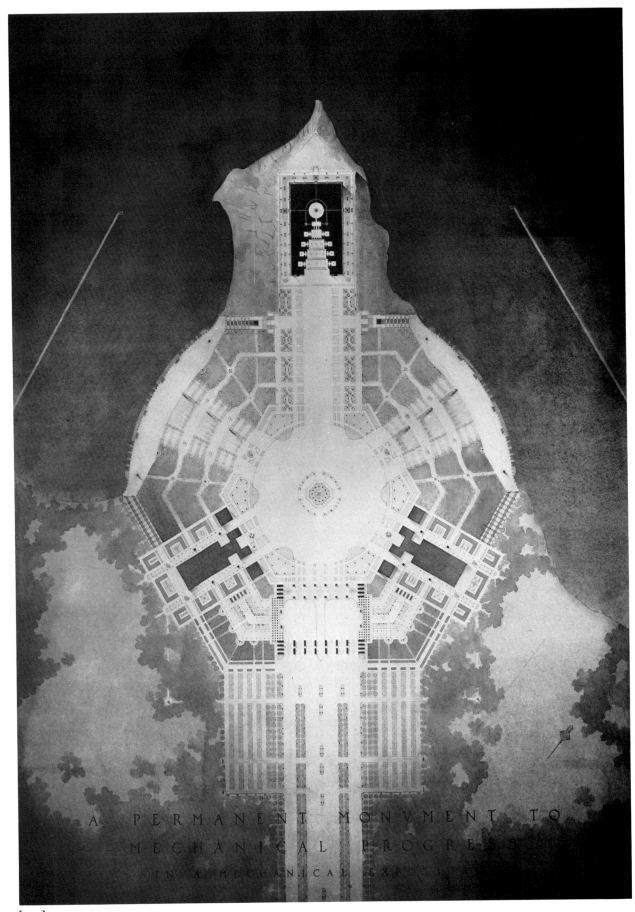

A PERMANENT MONUMENT TO
MECHANICAL PROGRESS
IN A MECHANICAL EXPOSITION

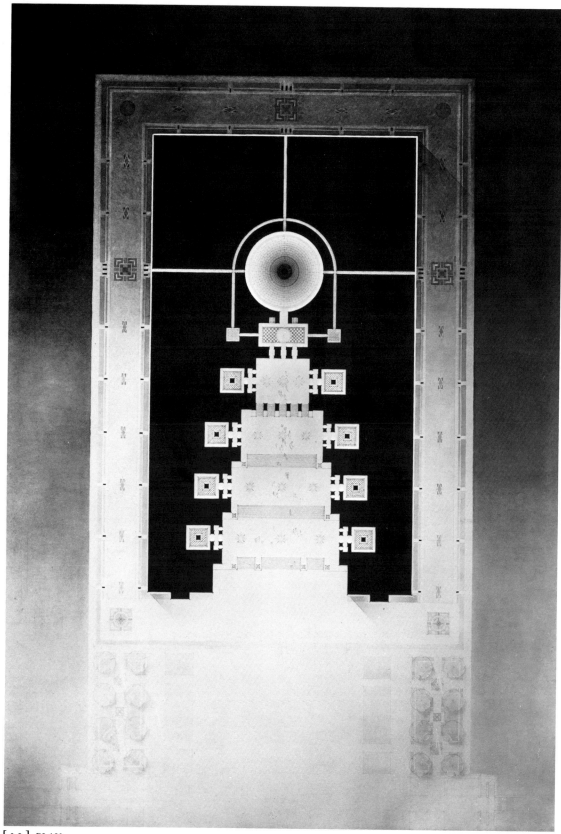

[32] PLAN

[31–34] 1930: "A Monument to Mechanical Progress in an Exhibition"
(Kenneth B. Johnson, architect; George H. Snowden, sculptor; Donald M.
Mattison, painter; Michael Rapuano, landscape architect).

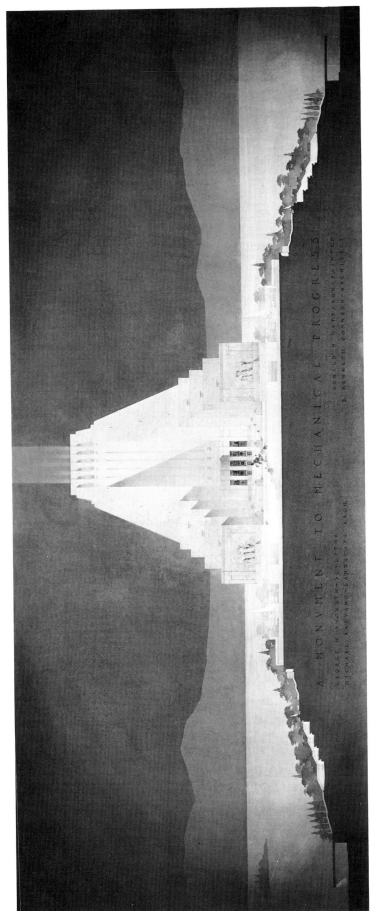

[33] ELEVATION

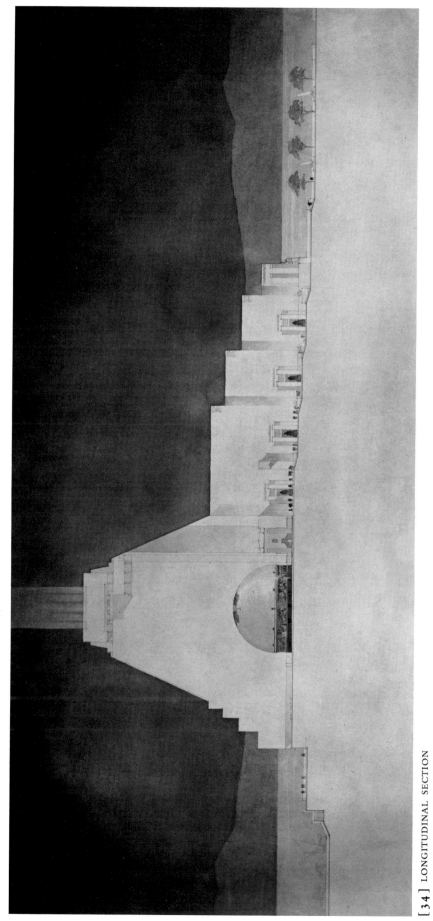

[34] LONGITUDINAL SECTION

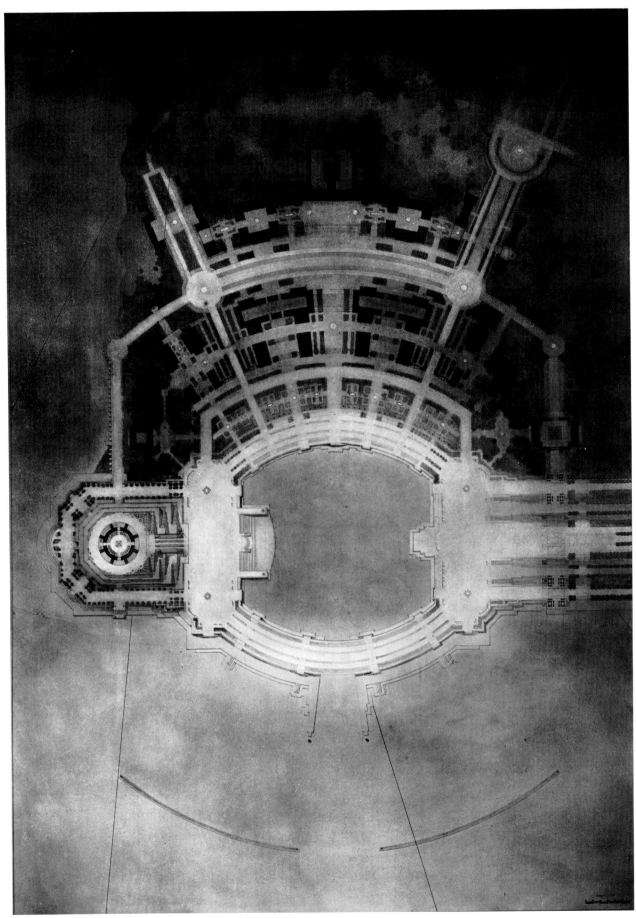

[35] SITE PLAN

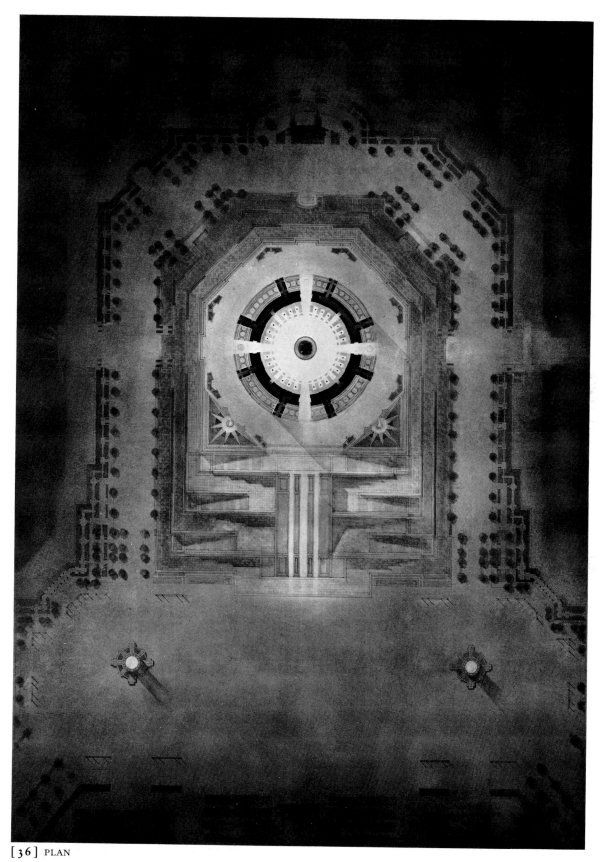

[36] PLAN

[35–37] 1930: "A Monument to Mechanical Progress in an Exhibition"
(Cecil C. Briggs, architect; Sidney B. Waugh, sculptor; Dunbar D. Beck,
painter; Charles R. Sutton, landscape architect).

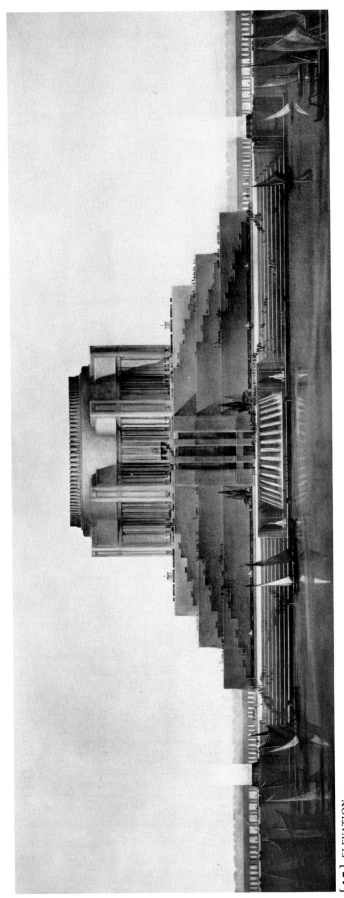

[37] ELEVATION

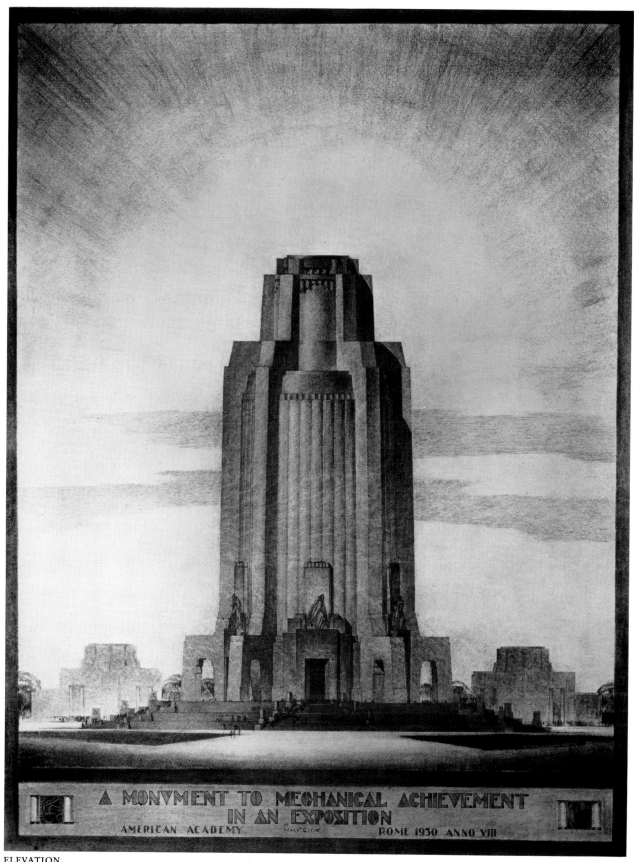

ELEVATION

[38] 1930: "A Monument to Mechanical Progress in an Exhibition"
(Homer F. Pfeiffer, architect; David K. Rubins, sculptor; John Sitton,
painter; Thomas D. Price, landscape architect).

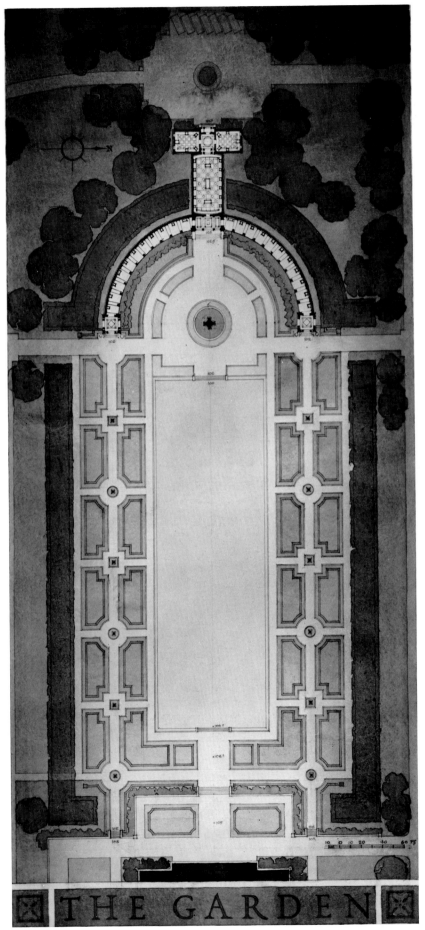

[**39**] 1931: "A Small Museum on a
Private Estate" (Walter L. Reichardt, architect;
Sidney B. Waugh, sculptor; Donald M.
Mattison, painter; Thomas D. Price,
landscape architect).

THE GARDEN

SITE PLAN

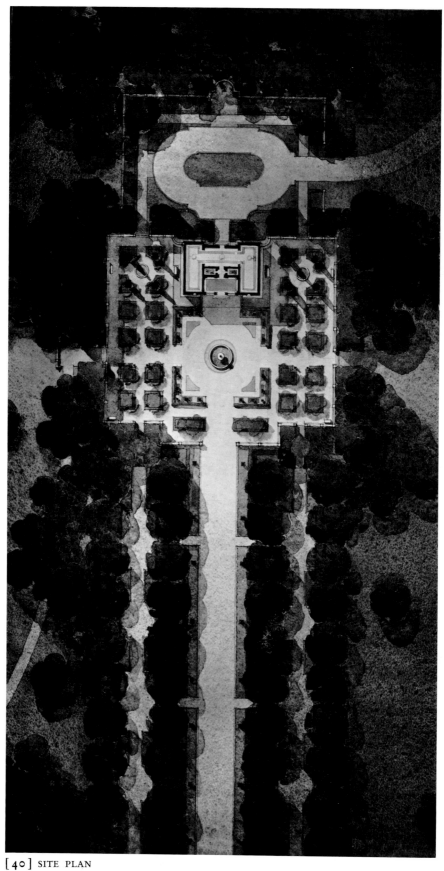

[40] SITE PLAN

[40, 41] 1931: "A Small Museum on a Private Estate" (Cecil C. Briggs, architect; William M. Simpson, sculptor; John Sitton, painter; Richard C. Murdock, landscape architect).

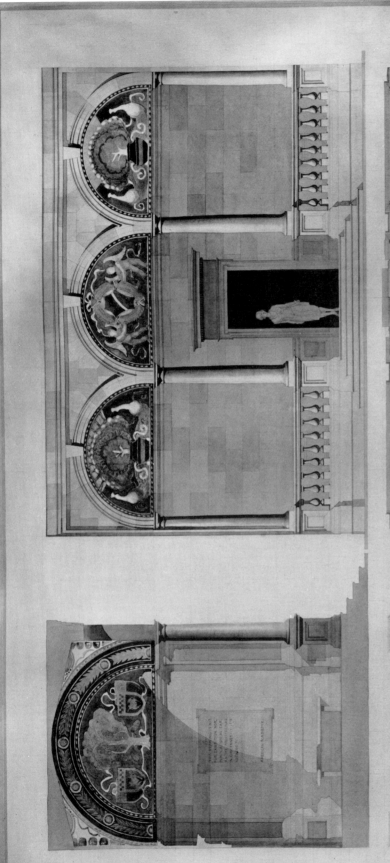

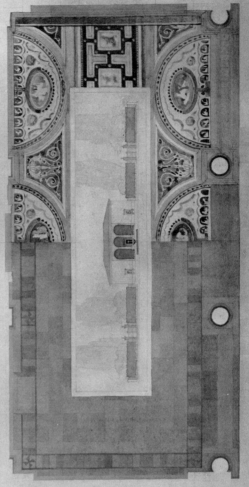

COLLABORATIVE
DRAWING·FOR·A
LOGGIA·IN·A·SMALL
PRIVATE MUSEUM

[41] ELEVATION AND DETAIL OF LOGGIA

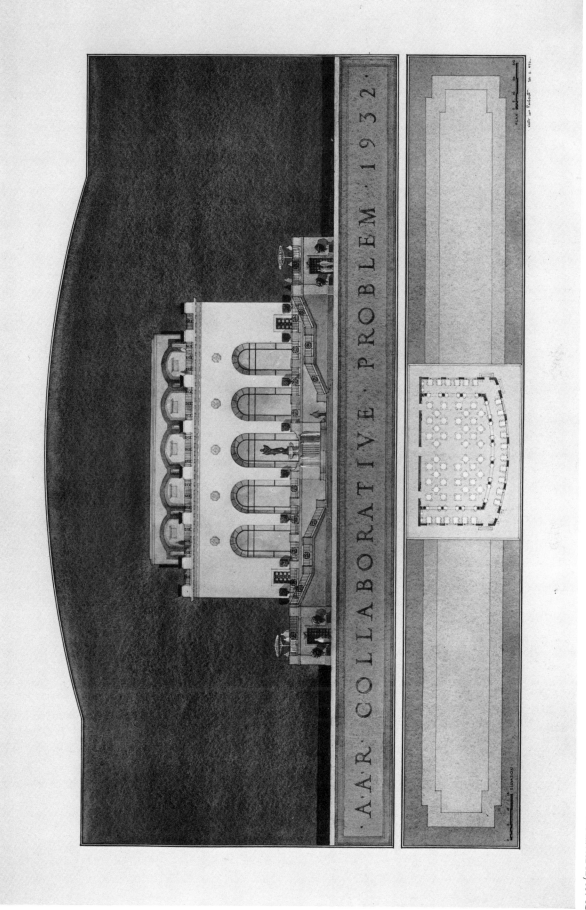

PLAN/ELEVATION

[42] 1932: "A Restaurant and a Ballroom in Connection to a Hotel" (Walter L. Reichardt, architect; Warren T. Mosman, sculptor; John Sitton, painter; Charles R. Sutton, landscape architect).

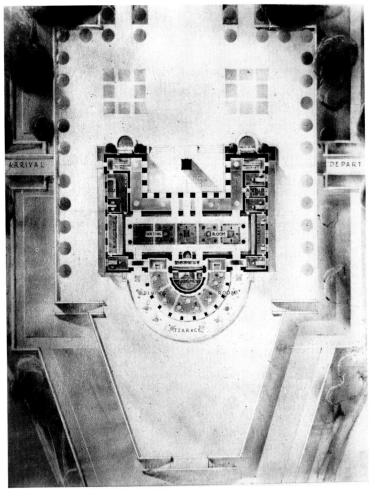

PLAN

[43] 1936: "A Hydroplane Airport with a Memorial Beacon" (Robert A. Weppner, Jr., architect; Reuben R. Kramer, sculptor; Gilbert Banever, painter; Alden Hopkins, landscape architect).

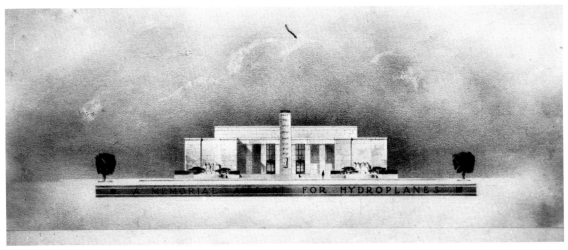

ELEVATION

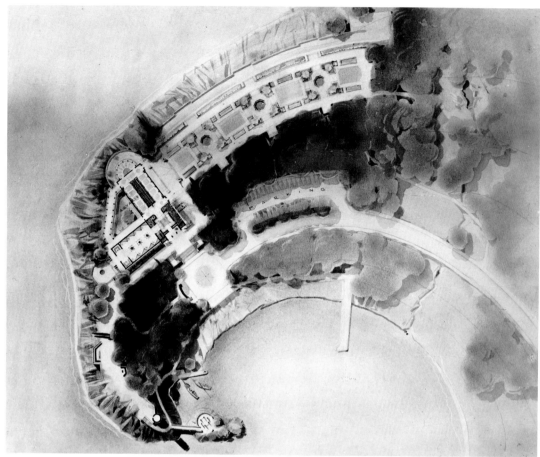

PLAN

[44] 1937: "A Marine Museum and Aquarium" (Richard W. Ayers, architect; Harrison Gibbs, sculptor; Matthew W. Boyhan, painter; Robert S. Kitchen, landscape architect).

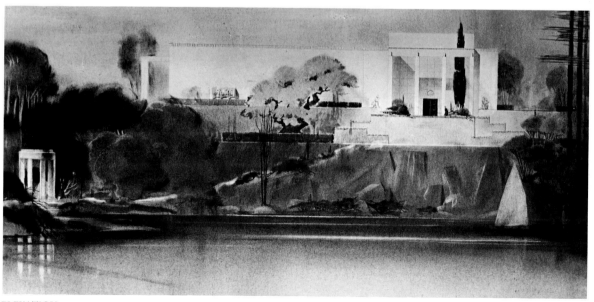

ELEVATION

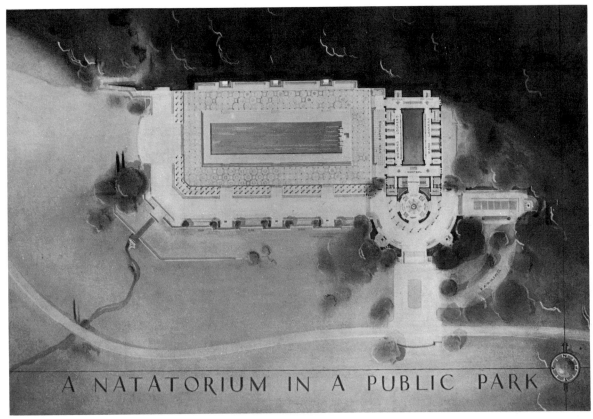

PLAN

[45] 1938: "A Natatorium in a Public Park" (Richard W. Ayers, architect; Harrison Gibbs, sculptor; Matthew W. Boyhan, painter; Robert S. Kitchen, landscape architect).

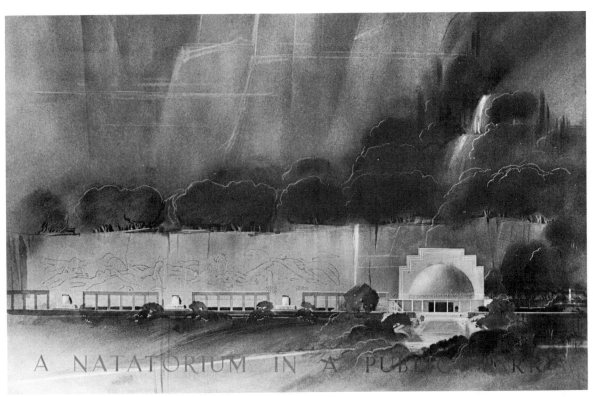

ELEVATION

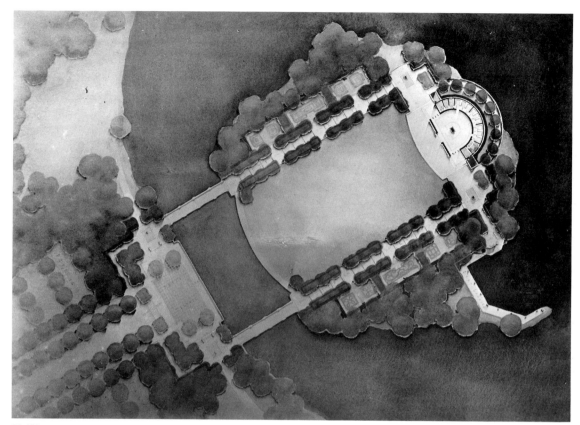

PLAN

[46] 1939: "A Pavilion for the United States Constitution" (Richard G. Hartshorne, Jr., architect; John Amore, sculptor; Harry A. Davis, Jr., painter; Stuart M. Mertz, landscape architect).

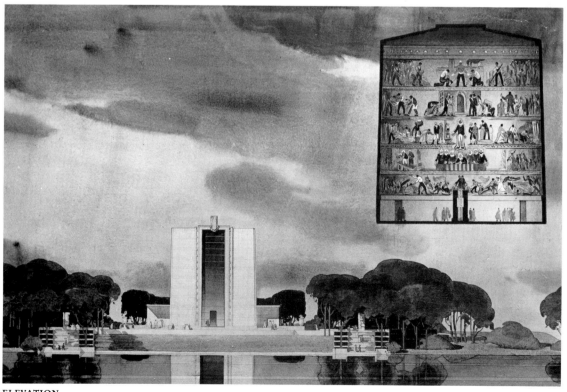

ELEVATION

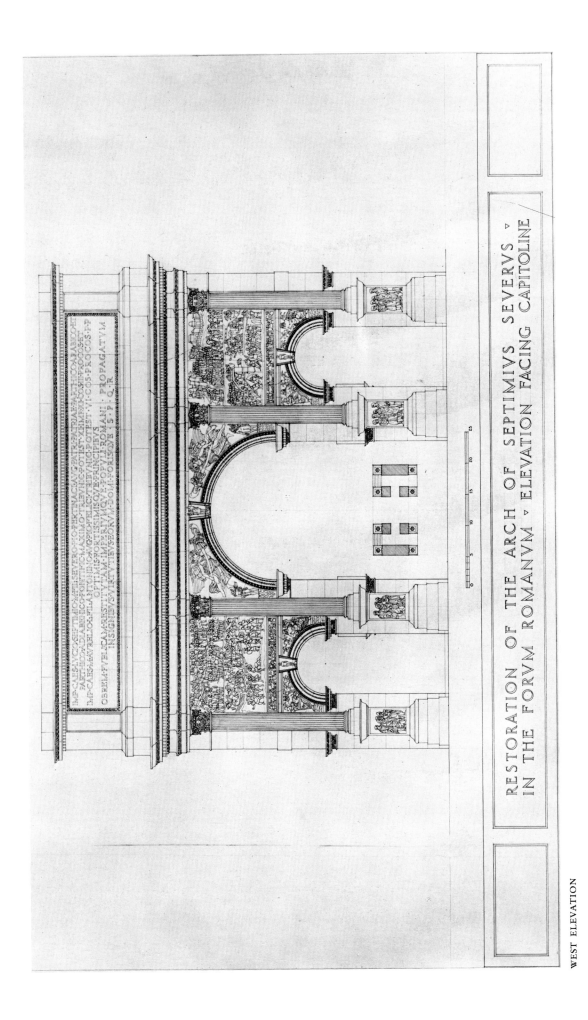

WEST ELEVATION

[47] Richard W. Ayers (FAAR, 1937–1939). Arch of Septimius Severus, Rome.

[48] C. Dale Badgeley (FAAR, 1927–1929), Capitolium at Ostia.

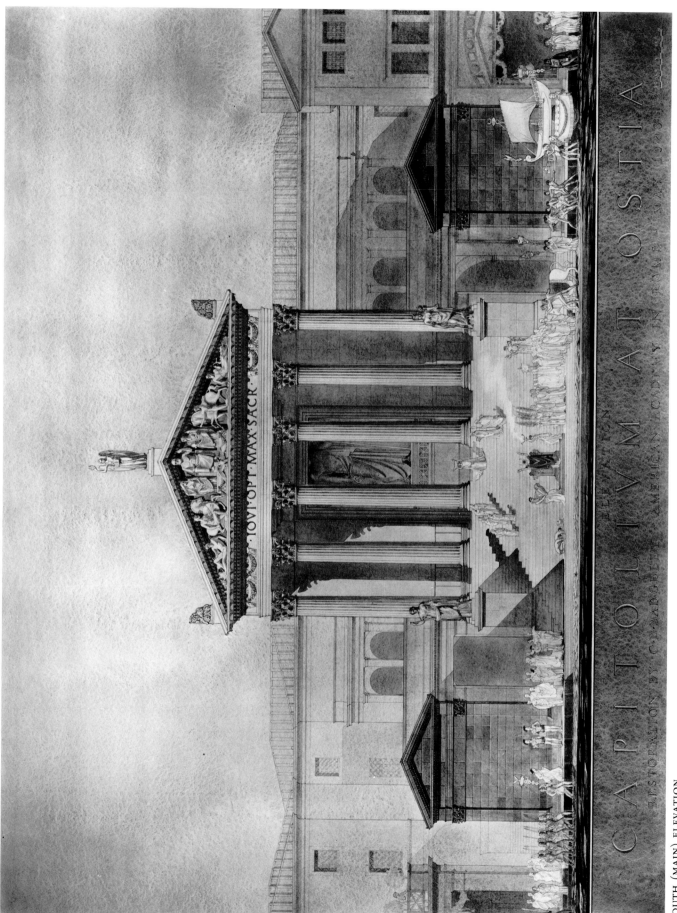

CAPITOLIVM AT OSTIA

RESTORATION BY C. D. BADGELEY, AMERICAN ACADEMY IN ROME, MAY, 1923

IOVI·OPT·MAX·SACR·

SOUTH (MAIN) ELEVATION

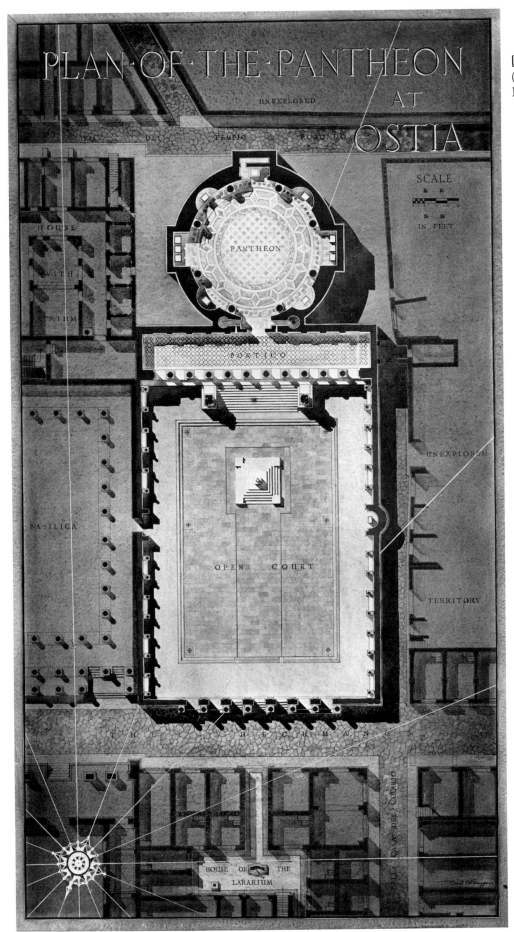

PLAN·OF·THE·PANTHEON
AT
OSTIA

UNEXPLORED

VIA DEL TEMPIO ROTONDO

PANTHEON

SCALE

IN FEET

HOUSE

WITH

ATRIUM

PORTICO

UNEXPLORED

BASILICA

OPEN COURT

TERRITORY

THE DECUMANUS

HOUSE OF THE
LARARIUM

[49-51] Cecil C. Briggs
(FAAR, 1929–1931),
Pantheon at Ostia.

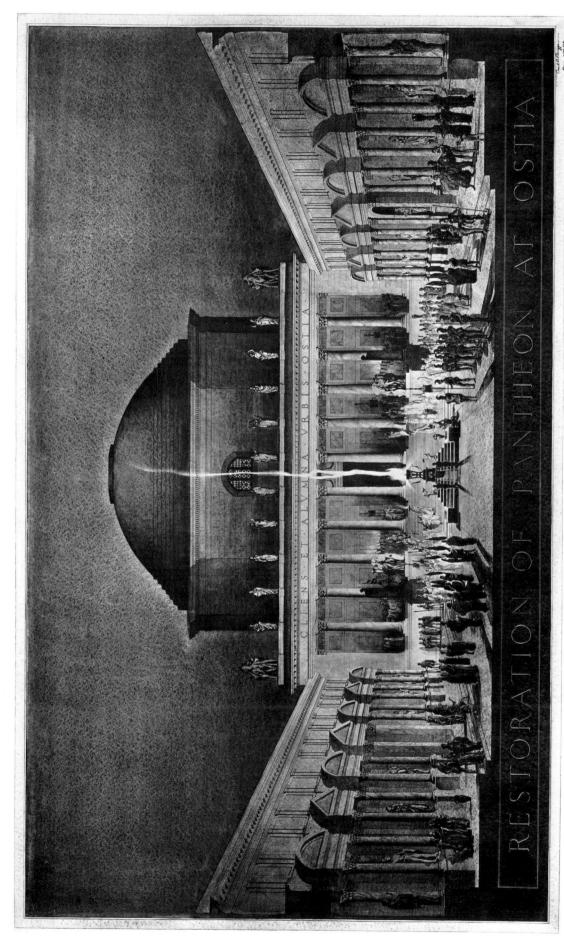

RESTORATION OF PANTHEON AT OSTIA

CLIENS · ET · ALVMNA · VRBIS · OSTIA

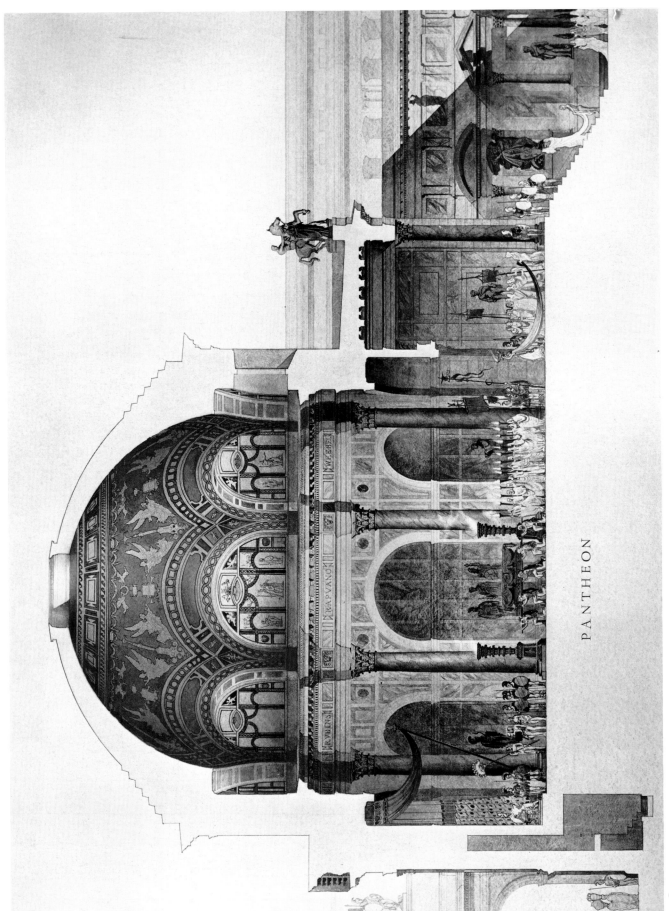

PANTHEON

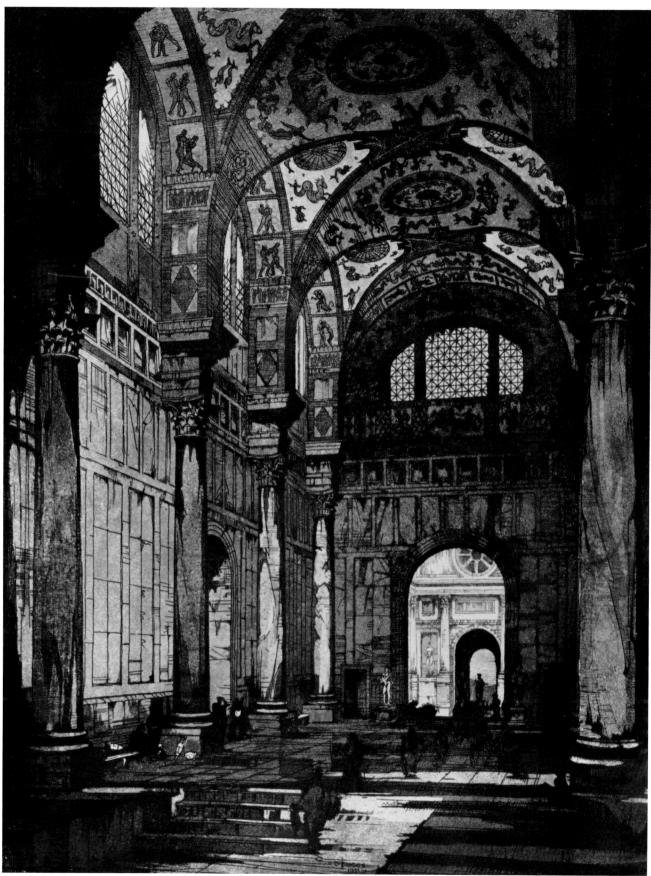

RESTORED INTERIOR PERSPECTIVE

[52] Cecil C. Briggs, Frigidarium of the Hadrianic Baths, Lepcis Magna.

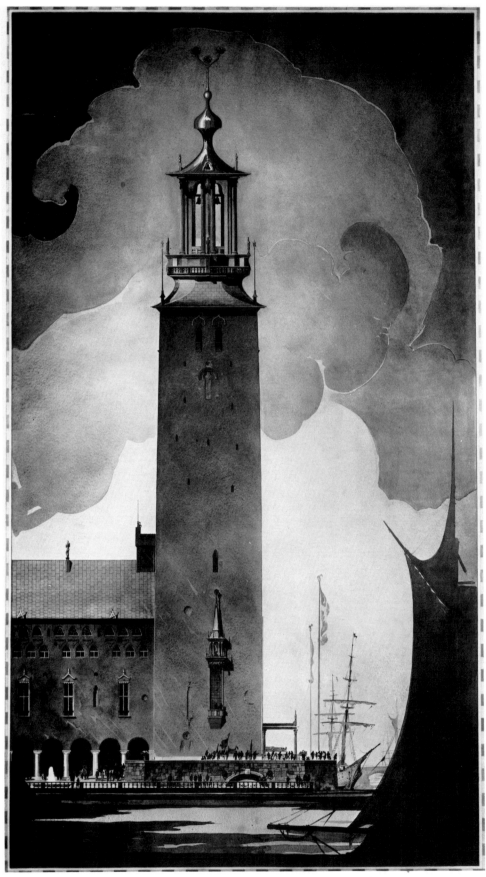

WATERCOLOR DRAWING

[53] Cecil C. Briggs, Stockholm City Hall (Ragnar Östberg, architect).

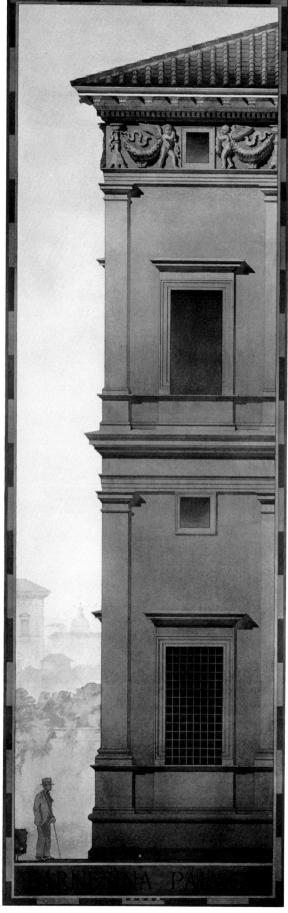

[54] Cecil C. Briggs, Farnesina Palace, Rome.

DETAIL OF ELEVATION

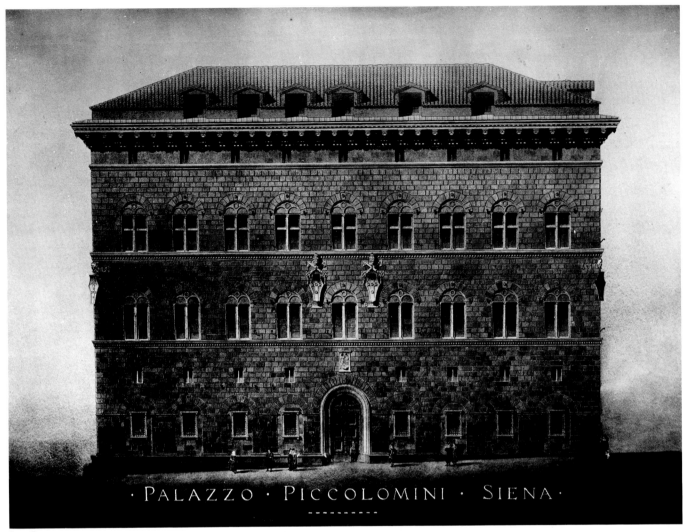

·PALAZZO · PICCOLOMINI · SIENA·

[55] ELEVATION

[55, 56] Kenneth E. Carpenter (FAAR, 1913–1915), Piccolomini Palace,
Siena.

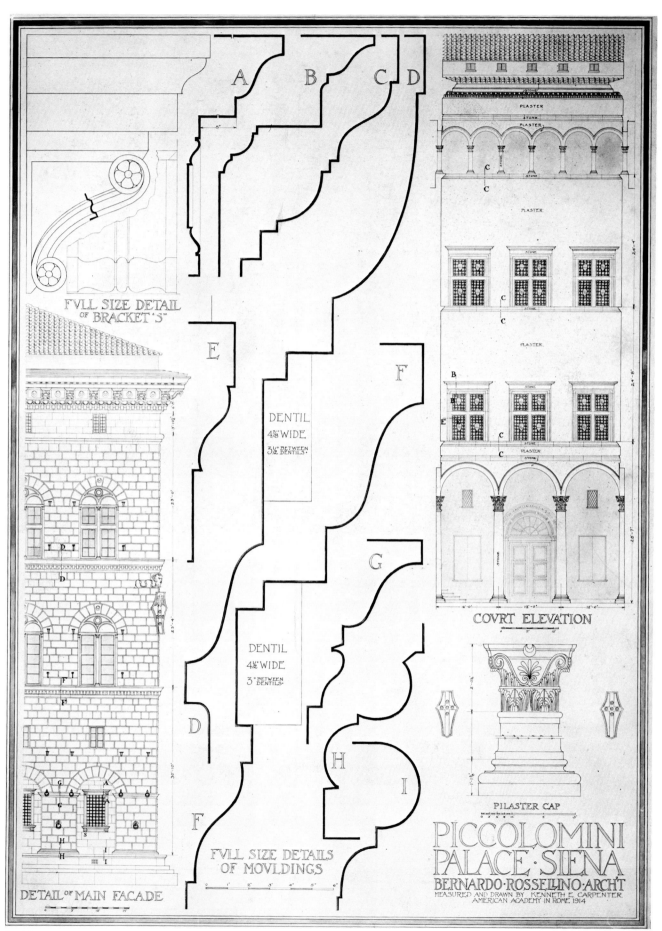

FVLL SIZE DETAIL OF BRACKET "S"

DENTIL 4⅞" WIDE 3½" BETWEEN 3½" DENTILS

DENTIL 4½" WIDE 3" BETWEEN DENTILS

FVLL SIZE DETAILS OF MOVLDINGS

DETAIL OF MAIN FAÇADE

COVRT ELEVATION

PILASTER CAP

PICCOLOMINI PALACE · SIENA
BERNARDO · ROSSELLINO · ARCHT
MEASVRED AND DRAWN BY KENNETH E. CARPENTER
AMERICAN ACADEMY IN ROME 1914

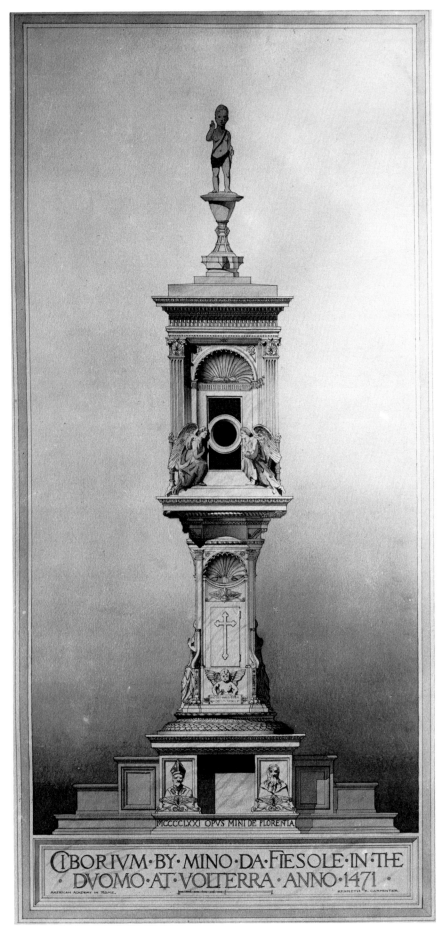

[57] Kenneth E. Carpenter, Ciborium (Mino da Fiesole, sculptor) in the Duomo, Volterra.

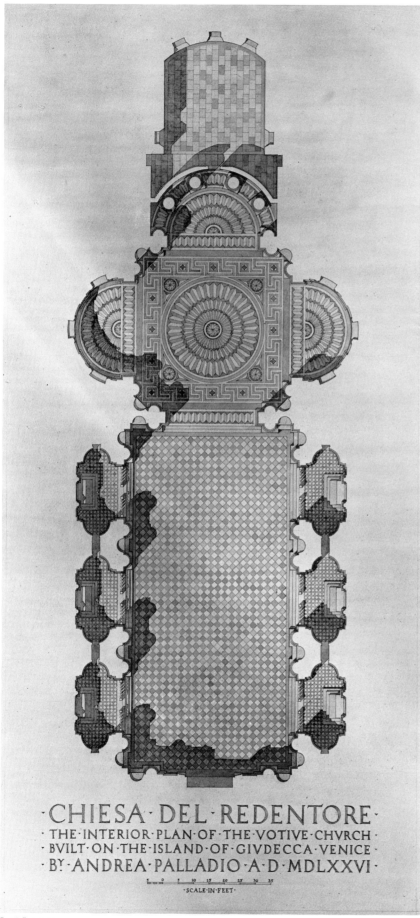

CHIESA · DEL · REDENTORE ·
· THE · INTERIOR · PLAN · OF · THE · VOTIVE · CHVRCH ·
· BVILT · ON · THE · ISLAND · OF · GIVDECCA · VENICE ·
· BY · ANDREA · PALLADIO · A · D · MDLXXVI ·

·SCALE·IN·FEET·

[58, 59] James Chillman, Jr. (FAAR, 1920–1922), Church of Il Redentore, Venice.

[58] PLAN

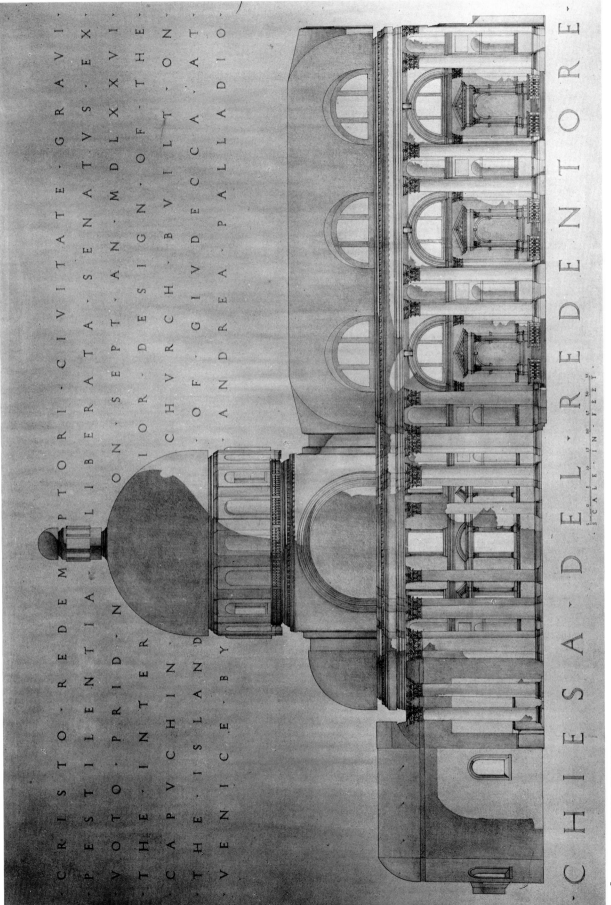

CRISTO · REDEMPTORI · CIVITATE · GRAVI · PESTILENTIA · LIBERATA · SENATVS · EX · VOTO · PRID · NON · SEPT · AN · MDLXXVI · THE · INTERIOR · DESIGN · OF · THE · CAPVCHIN · CHVRCH · BVILT · ON · THE · ISLAND · OF · GIVDECCA · AT · VENICE · BY · ANDREA · PALLADIO ·

· CHIESA · DEL · REDENTORE ·

SCALE · IN · FEET

[59] LONGITUDINAL SECTION

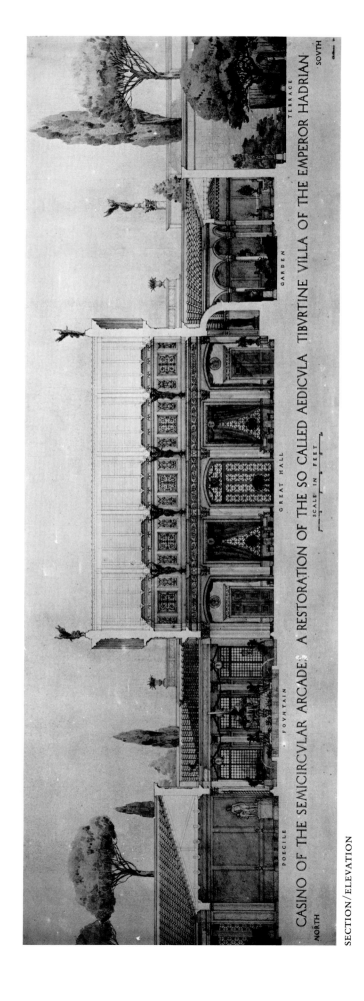

SECTION/ELEVATION

[60] James Chillman, Jr., Casino of the Semicircular Arcades
(Triclinium), Hadrian's Villa, Tivoli.

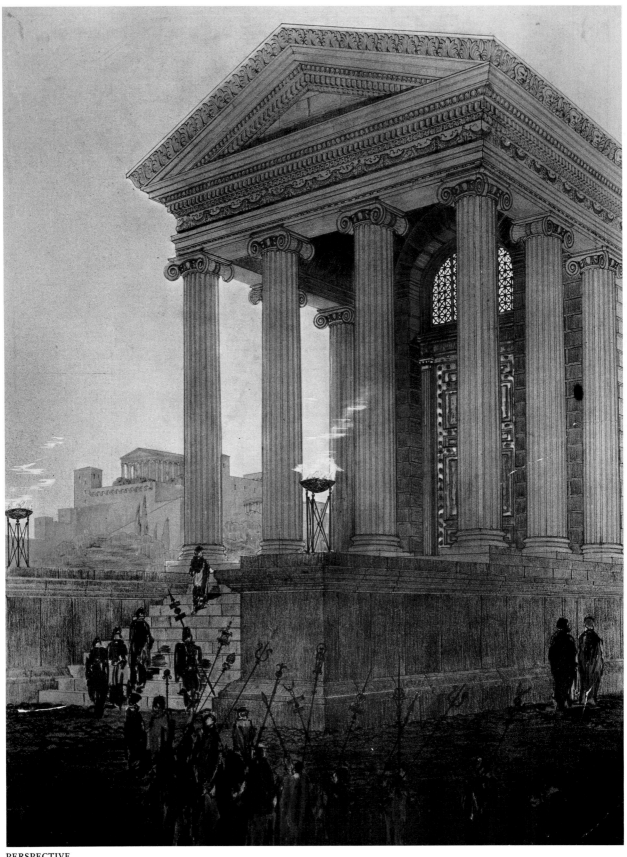

PERSPECTIVE

[61] Arthur F. Deam (FAAR, 1924–1926), Temple of Fortuna Virilis
(Temple of Portunus), Rome.

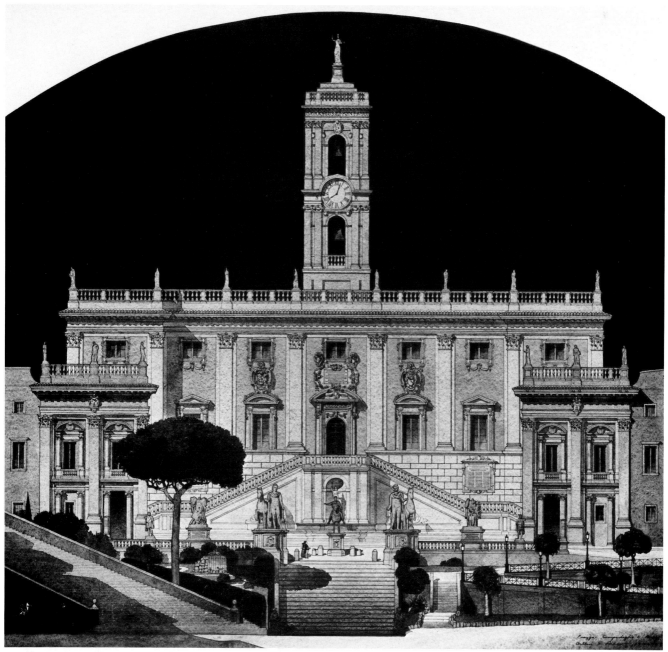

ELEVATION

[62] Arthur F. Deam, Palazzo Senatorio, Piazza Campidoglio, Rome.

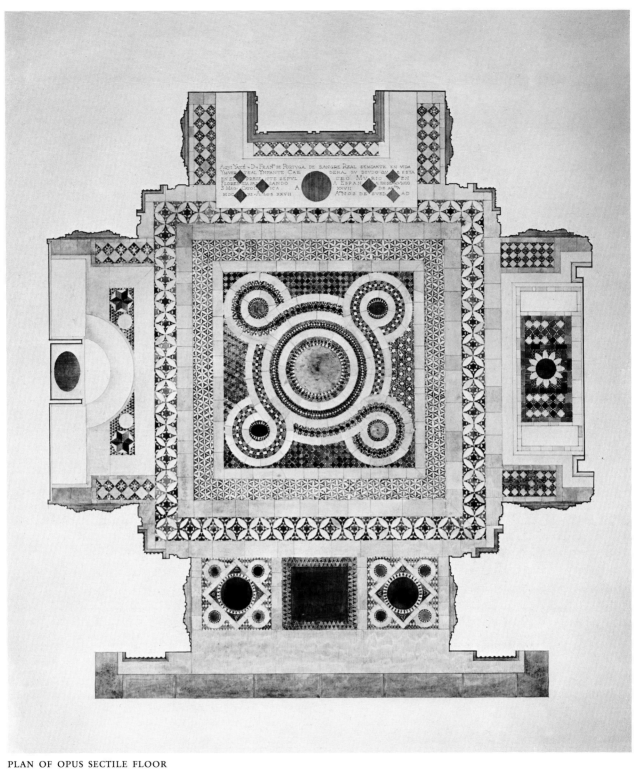

PLAN OF OPUS SECTILE FLOOR

[63] William Douglas (FAAR, 1925–1926), Chapel of Cardinal Jacopi in
San Miniato al Monte, Florence.

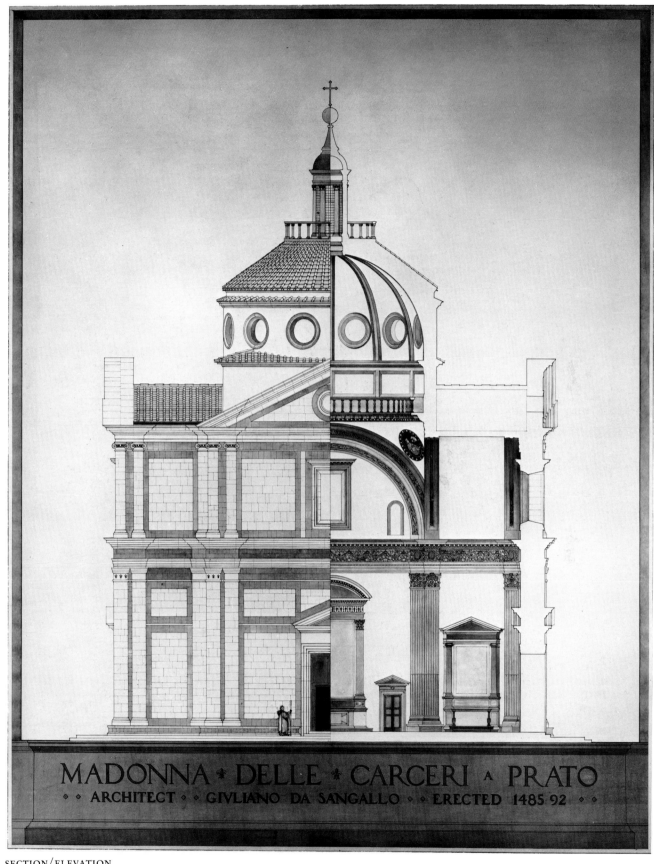

MADONNA · DELLE · CARCERI · A · PRATO
· · ARCHITECT · · GIVLIANO · DA · SANGALLO · · ERECTED 1485·92 · ·

SECTION/ELEVATION

[64] George Fraser (FAAR, 1926–1928), Church of Madonna delle
Carceri, Rome.

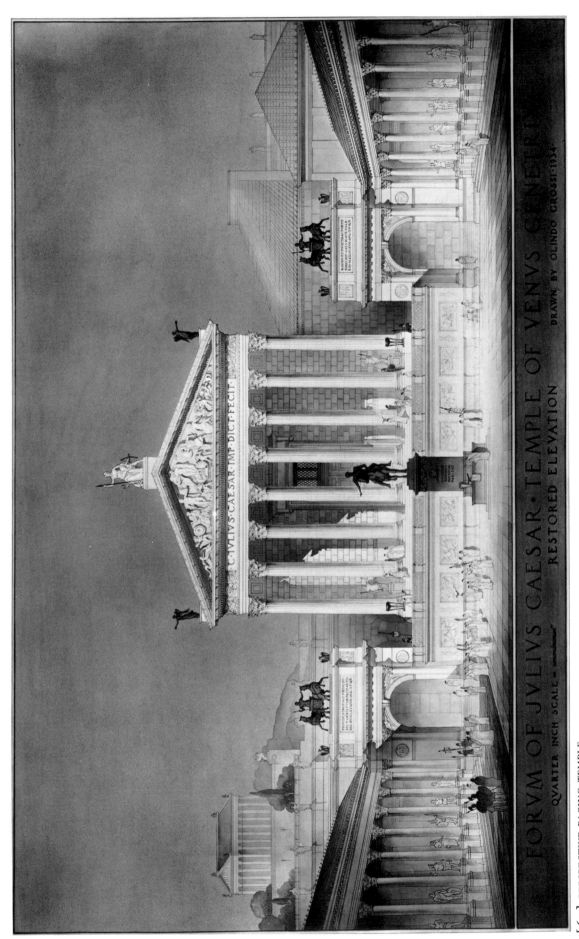

[**65**] PERSPECTIVE FACING TEMPLE

[**65, 66**] Olindo Grossi (FAAR, 1934–1936), Forum of Julius Caesar and
the Temple of Venus Genetrix, Rome.

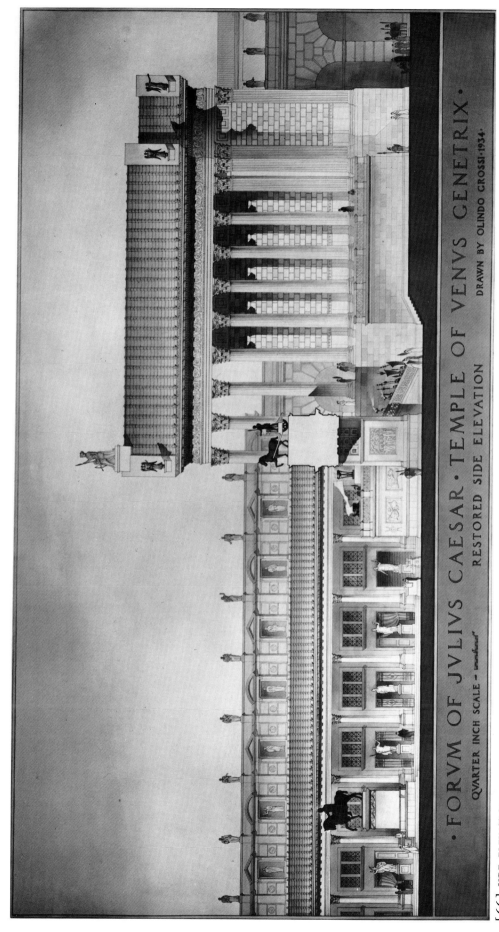

· FORVM OF JVLIVS CAESAR · TEMPLE OF VENVS GENETRIX ·

RESTORED SIDE ELEVATION

QVARTER INCH SCALE ~ unofficial

DRAWN BY OLINDO GROSSI·1934·

[66] SIDE ELEVATION

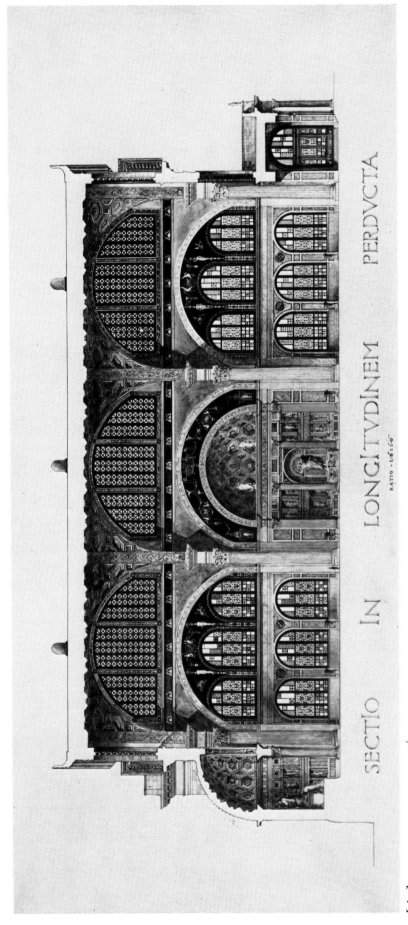

SECTIO IN LONGITVDINEM PERDVCTA

RATIO · 1/16 = 1′-0″

[**67**] LONGITUDINAL SECTION/ELEVATION

[**67, 68**] Victor L. S. Hafner (FAAR, 1922–1924), Basilica of Maxentius/Constantine, Rome.

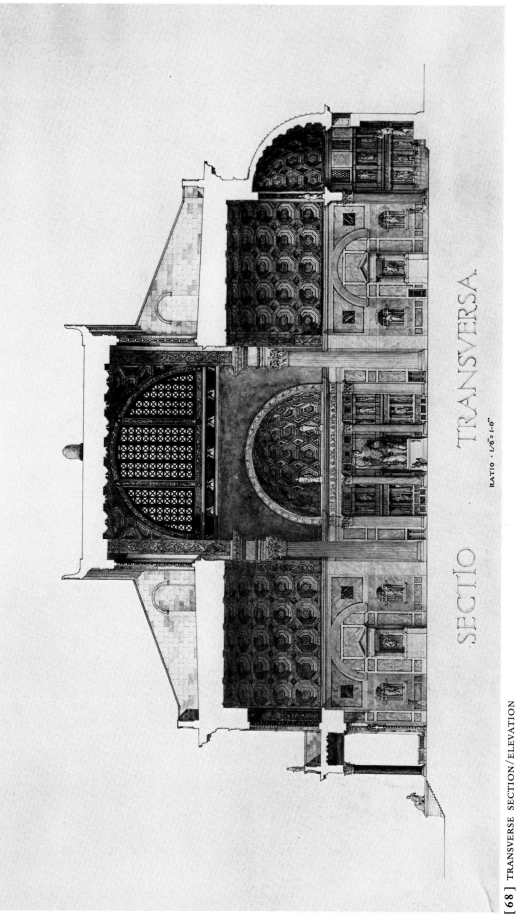

SECTIO TRANSVERSA

RATIO · 1/8" = 1'-0"

[68] TRANSVERSE SECTION/ELEVATION

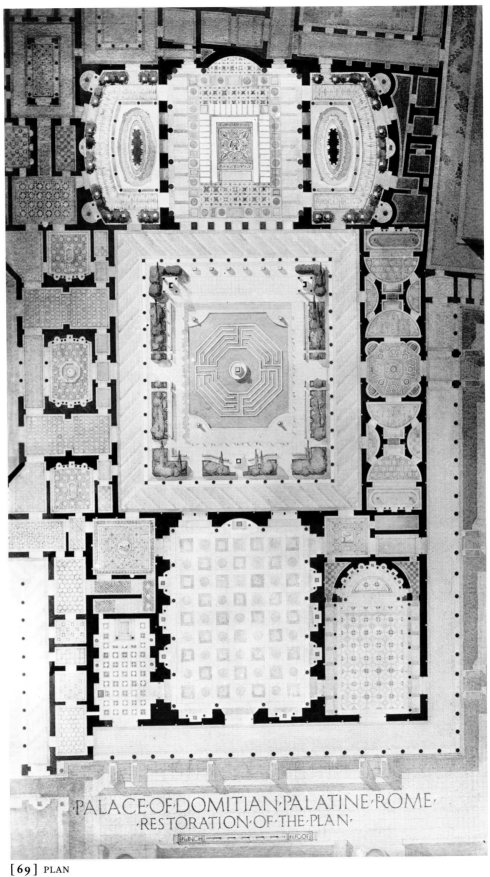

PALACE·OF·DOMITIAN·PALATINE·ROME·
RESTORATION·OF·THE·PLAN·

[**69**] PLAN

[**69, 70**] William J. Hough (FAAR, 1915–1917), Palace of Domitian
(Flavian Palace) on the Palatine, Rome.

[70] TRANSVERSE SECTION THROUGH AULA REGIA

[71] William J. Hough, Ponte Senatorio (Ponte Rosso), Rome.

[72] PLAN

[72, 73] Kenneth B. Johnson (FAAR, 1930–1932), "Temple of Neptune"
(Nymphaeum and the Temple of Aphrodite?), Hadrian's Villa, Tivoli.

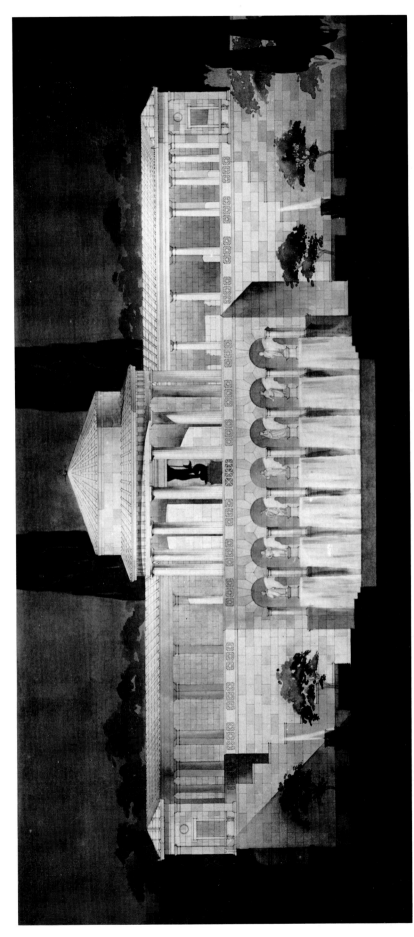

[73] MAIN ELEVATION

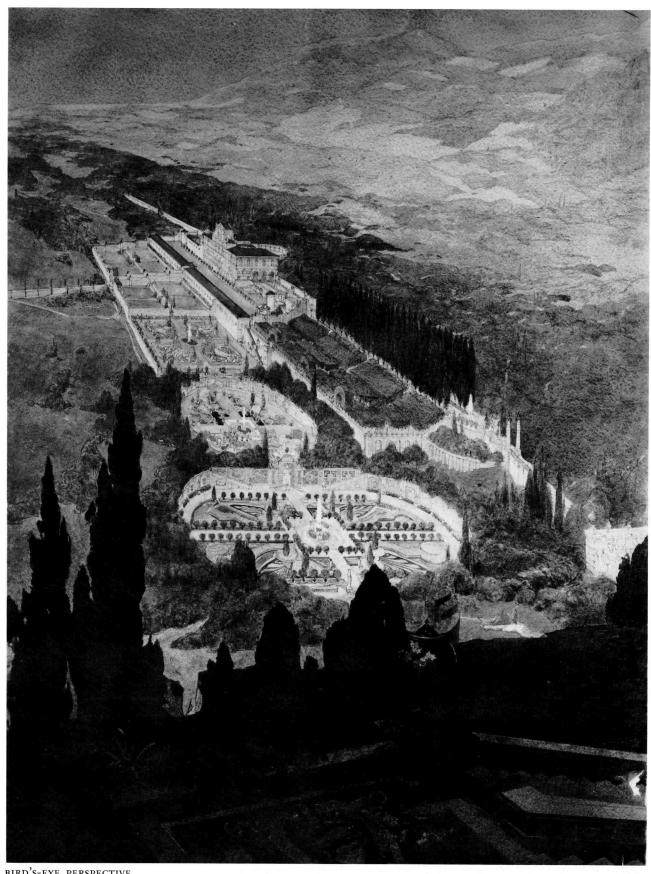

BIRD'S-EYE PERSPECTIVE

[74] Raymond M. Kennedy (FAAR, 1917–1920), Villa Madama, Rome.

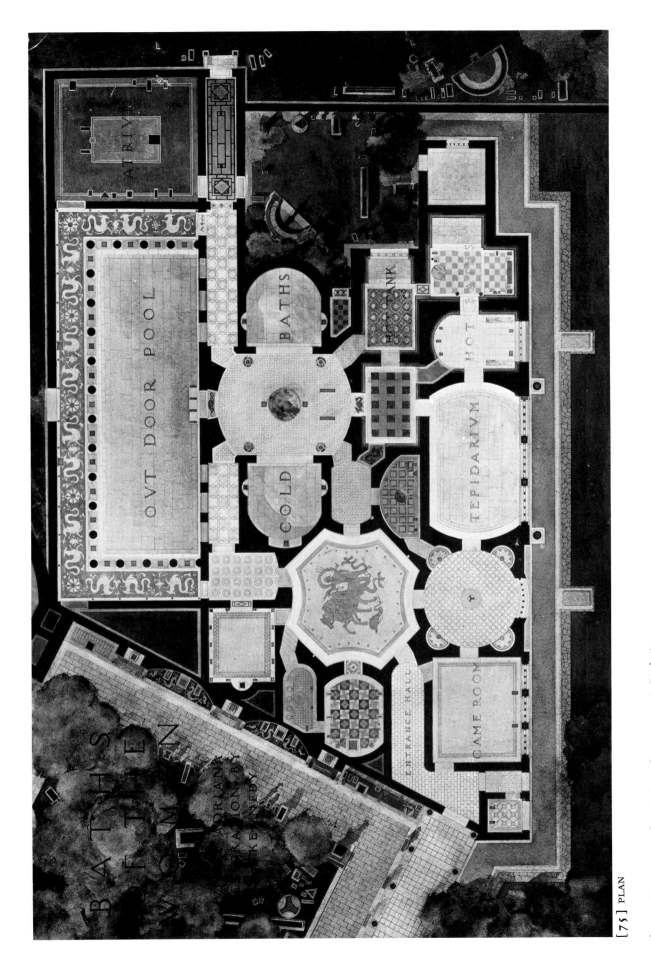

ATRIVM

OVTDOOR POOL

BATHS

HOT TANK

COLD

HOT

TEPIDARIVM

BATHS OF THE WOMEN

ADRIANA
KA ON BY
KE NEDY

ENTRANCE HALL

GAME ROOM

[75] PLAN

[75, 76] Raymond M. Kennedy, "Women's Baths" (Small Baths), Hadrian's Villa, Tivoli.

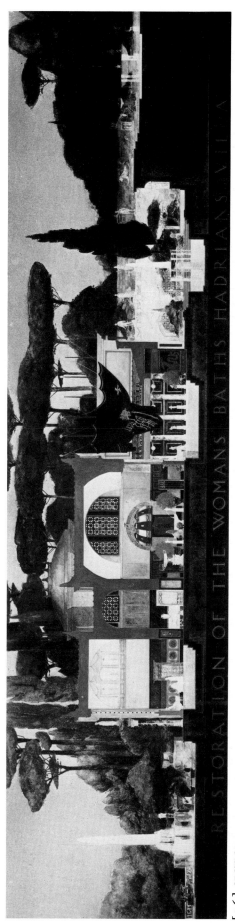

RESTORATION · OF · THE · WOMANS · BATHS · HADRIANS · VILLA

[76] SECTION

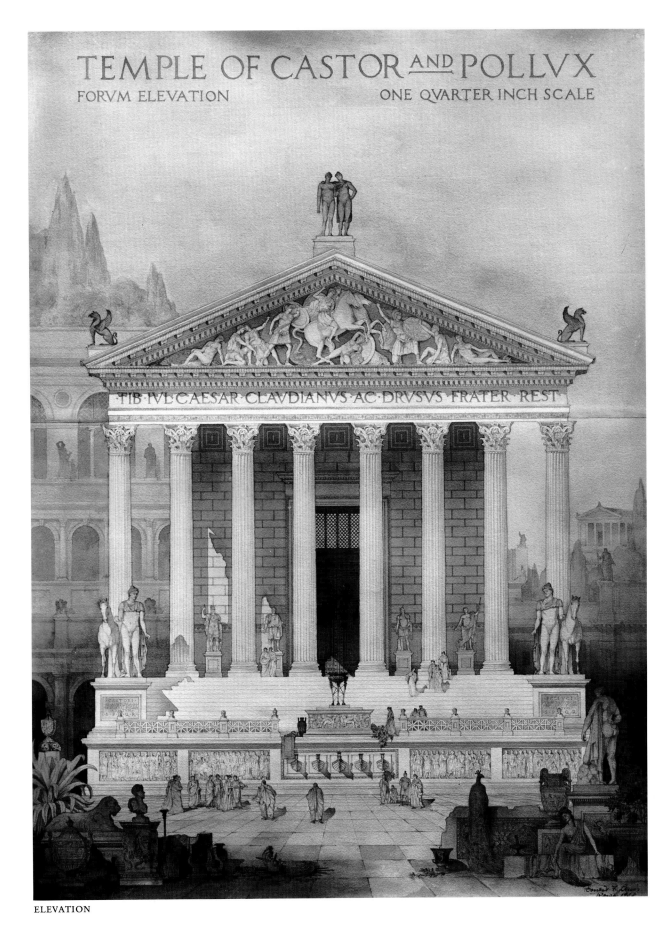

TEMPLE OF CASTOR AND POLLVX

FORVM ELEVATION ONE QVARTER INCH SCALE

TIB·IVL·CAESAR·CLAVDIANVS·AC·DRVSVS·FRATER·REST

ELEVATION

[77] Ernest F. Lewis (FAAR, 1908–1910), Temple of Castor and Pollux, Rome.

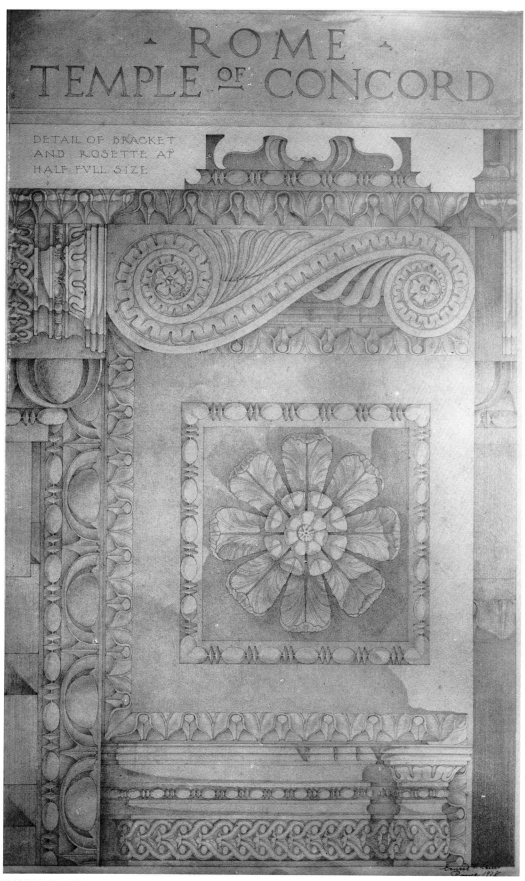

DETAILS OF CORNICE

[78] Ernest F. Lewis, Temple of Concord, Rome.

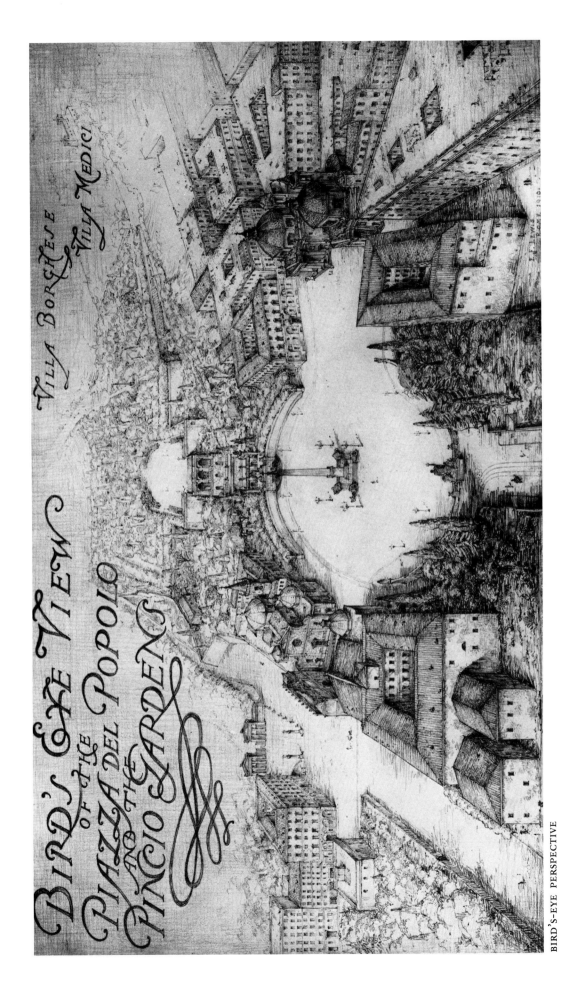

BIRD'S-EYE PERSPECTIVE

[79] Ernest F. Lewis, Piazza del Popolo and the Pincio Gardens, Rome.

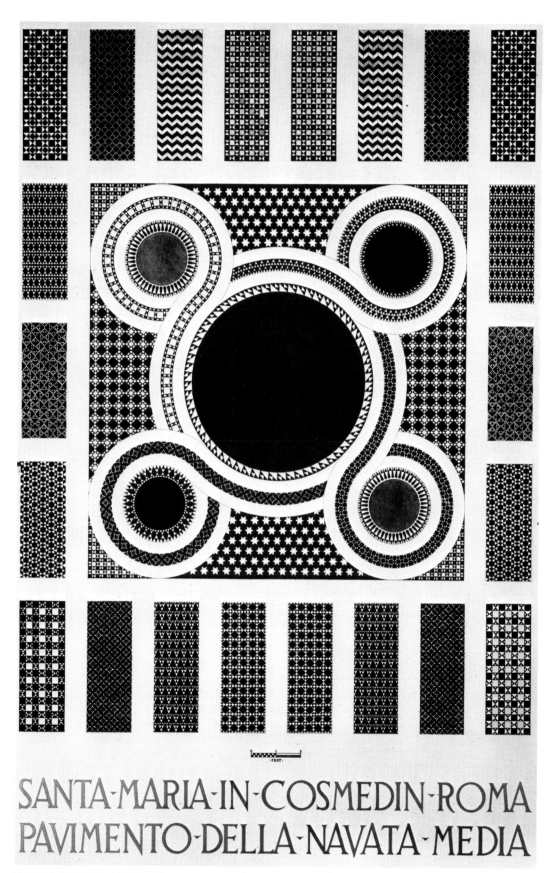

SANTA·MARIA·IN·COSMEDIN·ROMA
PAVIMENTO·DELLA·NAVATA·MEDIA

DETAILS OF NAVE OPUS SECTILE PAVEMENT (COSMATI WORK)

[80] George T. Licht (FAAR, 1935–1937), Church of Santa Maria in Cosmedin, Rome.

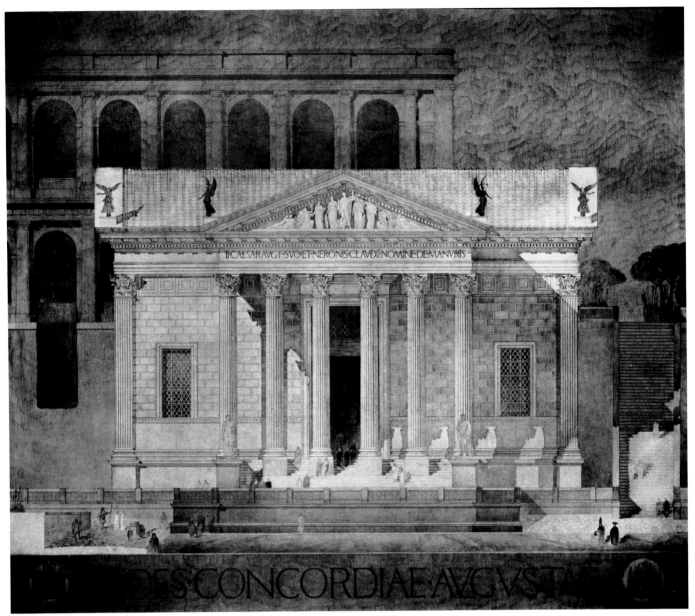

ELEVATION

[81] Henri G. Marceau (FAAR, 1923–1925), Temple of Concord, Rome.

[82] Henri G. Marceau, Capital from Megara Hyblaea, Sicily.

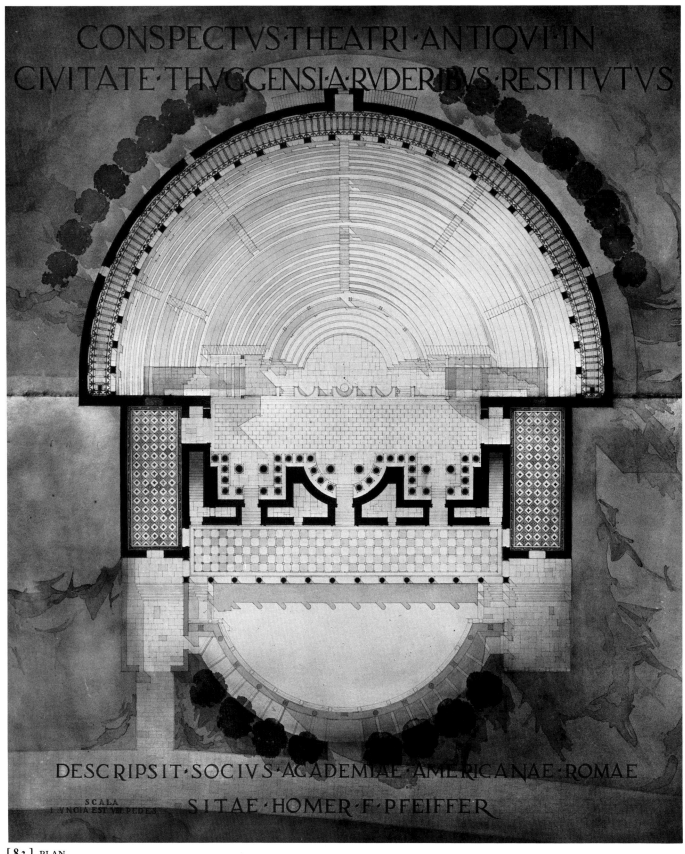

CONSPECTVS·THEATRI·ANTIQVI·IN CIVITATE·THVGGENSI·A·RVDERIBVS·RESTITVTVS

DESCRIPSIT·SOCIVS·ACADEMIAE·AMERICANAE·ROMAE SITAE·HOMER·F·PFEIFFER

SCALA I·VNCIA·EST·VII·PEDES

[83] PLAN

[83, 84] Homer F. Pfeiffer (FAAR, 1928–1930), Roman Theater, Thugga (Dougga).

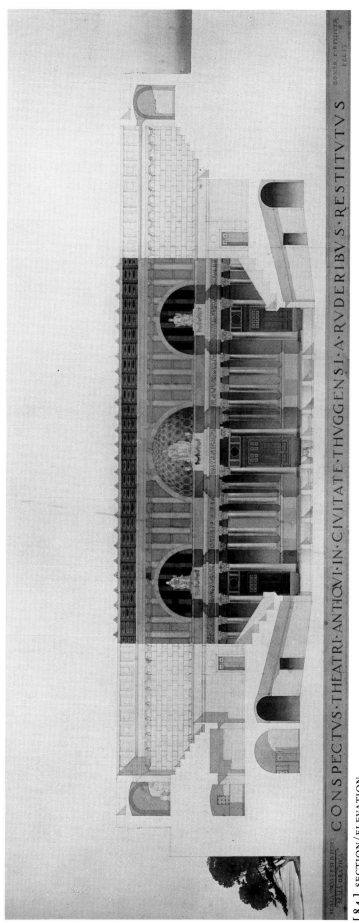

CONSPECTVS·THEATRI·ANTIQVI·IN·CIVITATE·THVGGENSI·A·RVDERIBVS·RESTITVTVS

[84] SECTION/ELEVATION

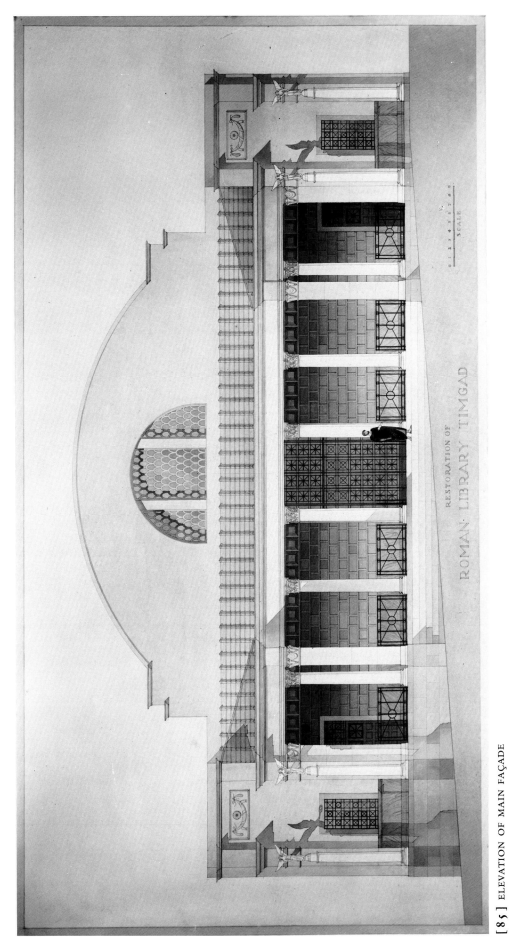

RESTORATION OF
ROMAN·LIBRARY·TIMGAD

SCALE

[85] ELEVATION OF MAIN FAÇADE

[85, 86] Homer F. Pfeiffer, Roman Library, Thugga.

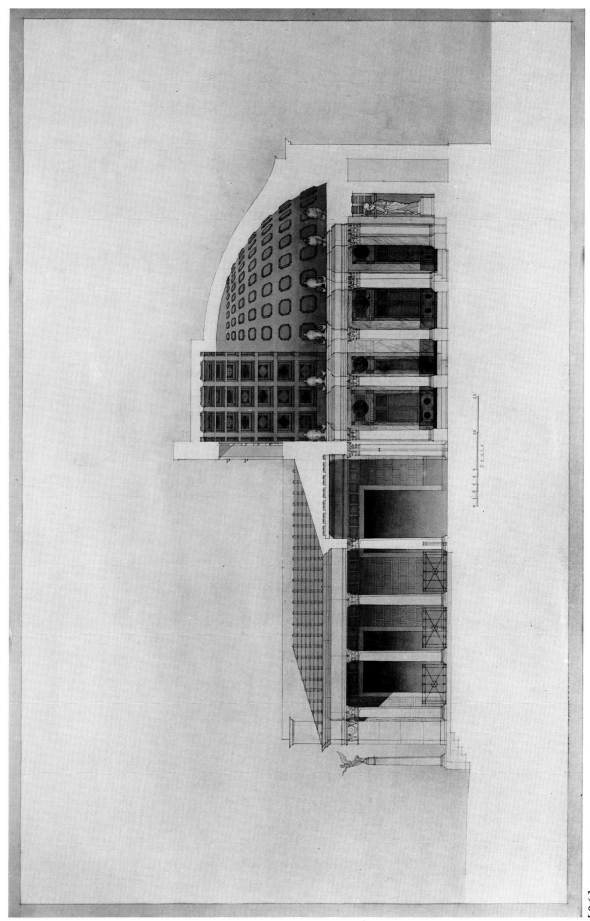

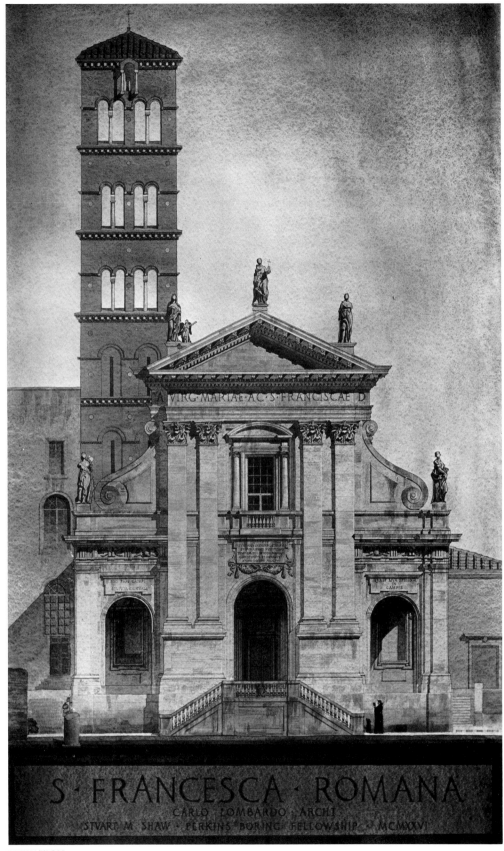

ELEVATION

[87] Stuart M. Shaw (FAAR, 1926–1928), Church of San Francesca, Rome.

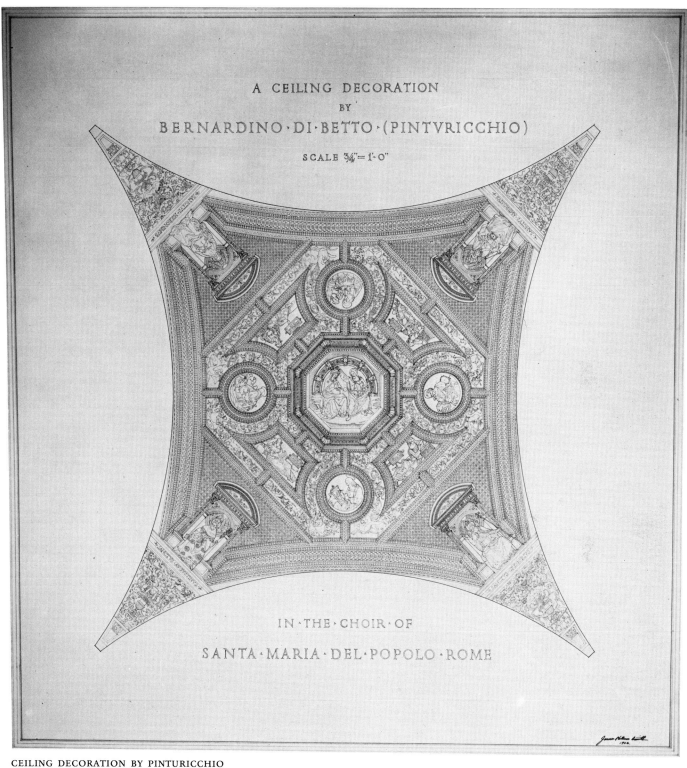

CEILING DECORATION BY PINTURICCHIO

[88] James K. Smith (FAAR, 1921–1923), Church of Santa Maria del Popolo, Rome.

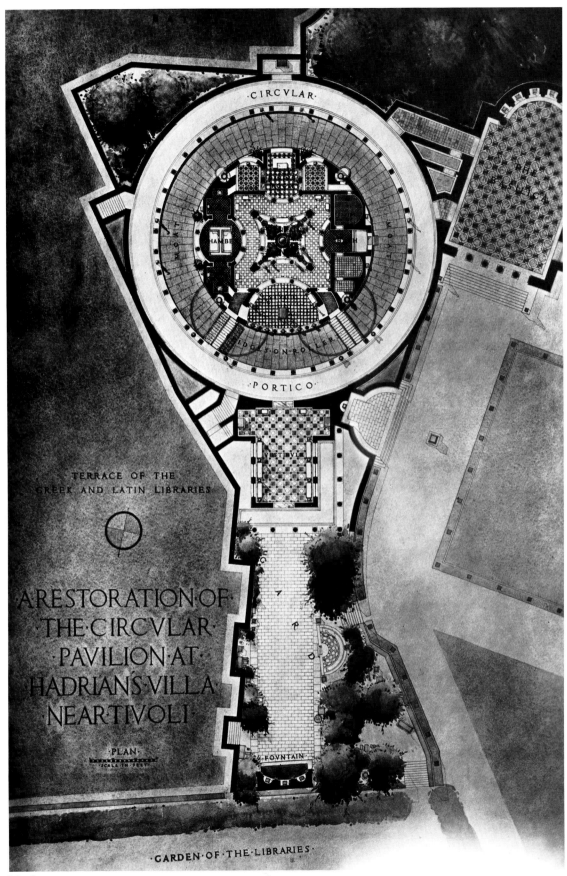

Within the plan image:

·CIRCVLAR·

MOAT

MOAT

·CHAMBE·

·PORTICO·

TERRACE OF THE
GREEK AND LATIN LIBRARIES

·VESTIBVL·

·A·RESTORATION·OF·
·THE·CIRCVLAR·
·PAVILION·AT·
·HADRIANS·VILLA·
·NEAR·TIVOLI·

·PLAN·
·SCALE·IN·FEET·

·FOVNTAIN·

·GARDEN·OF·THE·LIBRARIES·

[89] PLAN

[89–91] Philip T. Shutze (FAAR, 1916–1920), "Circular Pavilion"
(Maritime Villa), Hadrian's Villa, Tivoli.

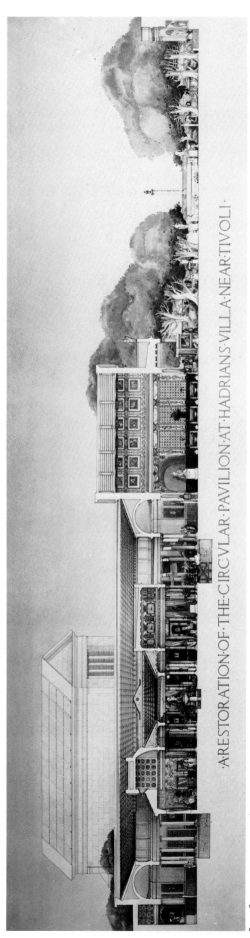

·A·RESTORATION·OF·THE·CIRCVLAR·PAVILION·AT·HADRIANS·VILLA·NEAR·TIVOLI·

[90] FULL SECTION/ELEVATION

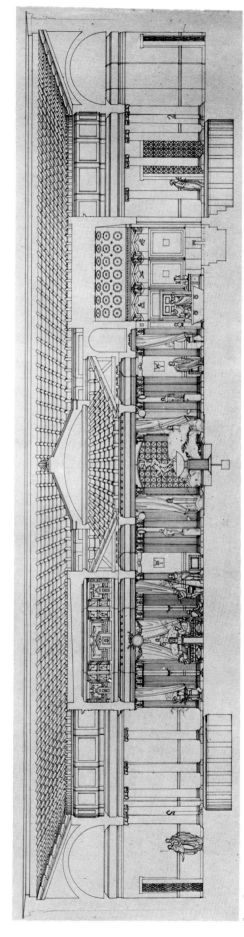

[91] DETAIL OF SECTION/ELEVATION

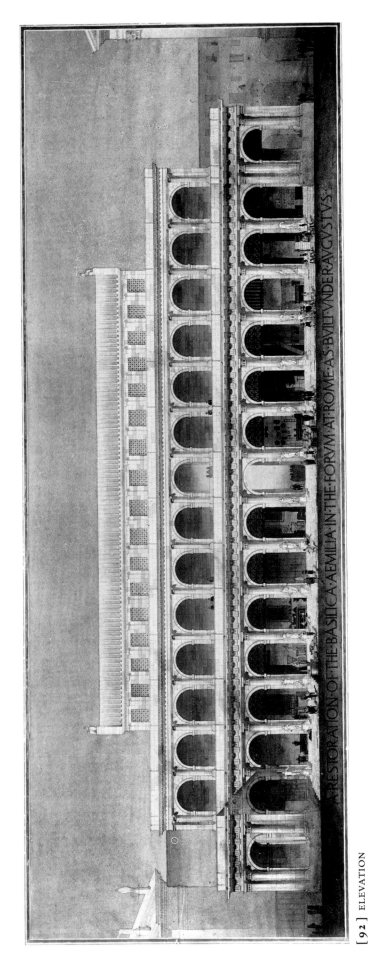

A RESTORATION OF THE BASILICA AEMILIA IN THE FORVM AT ROME AS BVILT VNDER AVGVSTVS

[92] ELEVATION

[92, 93] Richard H. Smythe (FAAR, 1911–1913), Basilica Aemilia in the Forum Romanum, Rome.

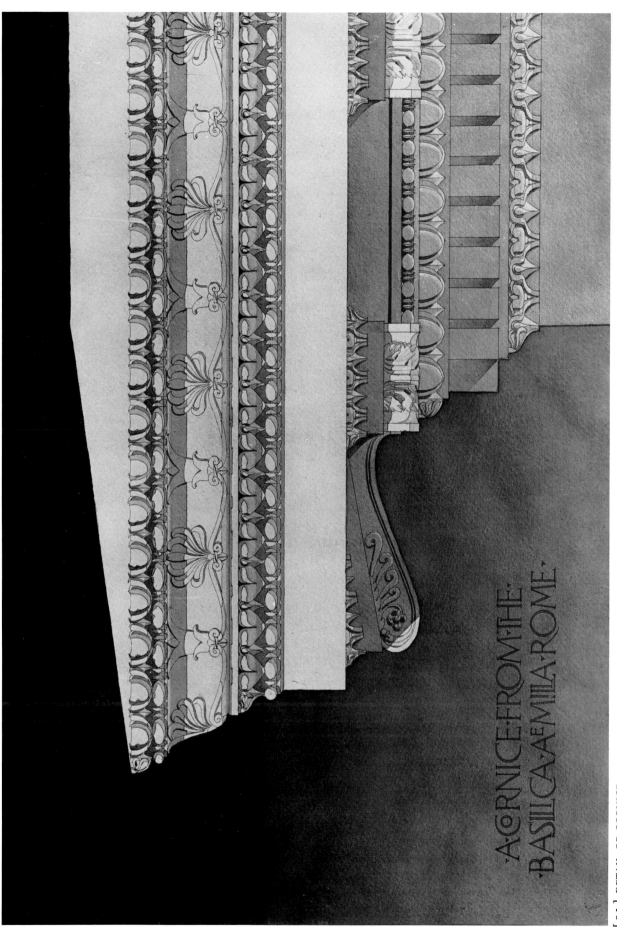

A·CORNICE·FROM·THE·
·BASILICA·AEMILIA·ROME·

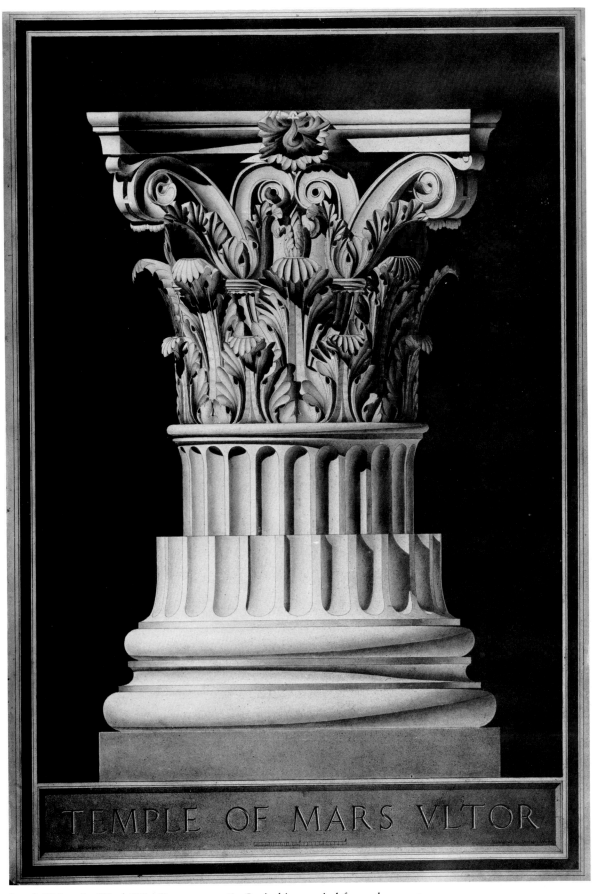

TEMPLE OF MARS VLTOR

[94] Walter L. Ward (FAAR, 1914–1916), Corinthian capital from the
Temple of Mars Ultor, Forum of Augustus, Rome.

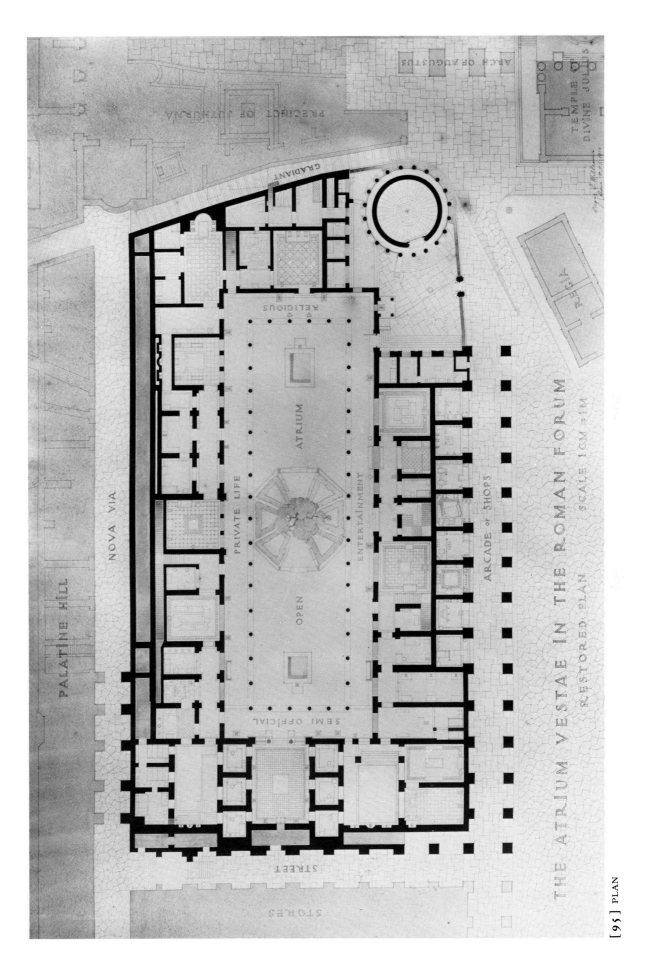

The labels visible in the plan include:

PALATINE HILL

NOVA VIA

PRECINCT OF JUTURNA

ARCH OF AUGUSTUS

TEMPLE OF DIVINE JULIUS

REGIA

GRADIANT

RELIGIOUS

ATRIUM

PRIVATE LIFE

OPEN

SEMI OFFICIAL

ENTERTAINMENT

ARCADE or SHOPS

STREET

STORES

THE ATRIUM VESTAE IN THE ROMAN FORUM
RESTORED PLAN SCALE 1CM = 1M

[95] PLAN

[95–99] Edgar J. Williams (FAAR, 1910–1912), Atrium Vestae (House of the Vestal Virgins) in the Forum Romanum, Rome.

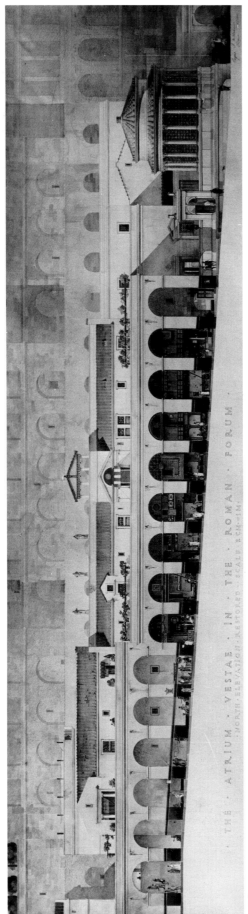

· THE · ATRIUM · VESTAE · IN · THE · ROMAN · FORUM ·
· NORTH · ELEVATION · RESTORED · · SCALE 2 CM.=1 M.

[96] FULL ELEVATION

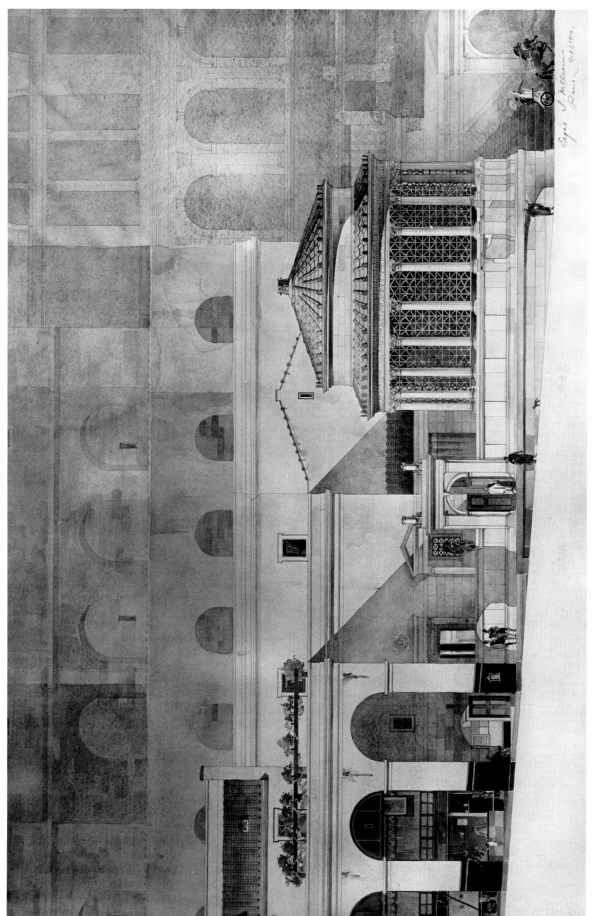

[97] DETAIL OF ELEVATION

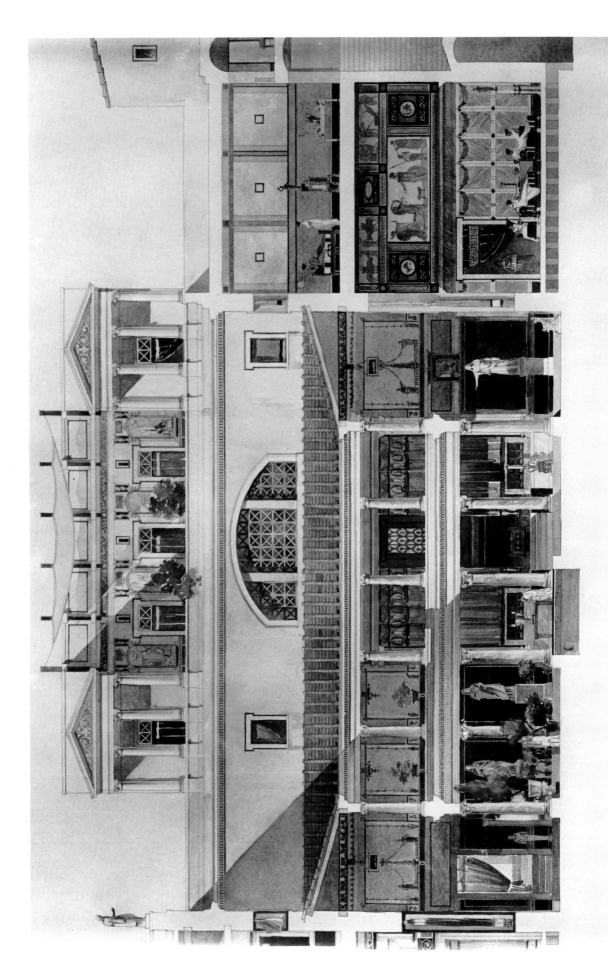

‹ R E S T O R E D · S E C T I O N ··· S C A L E · 2 C M = 1 M ·

[98] SECTION/ELEVATION THROUGH COURTYARD

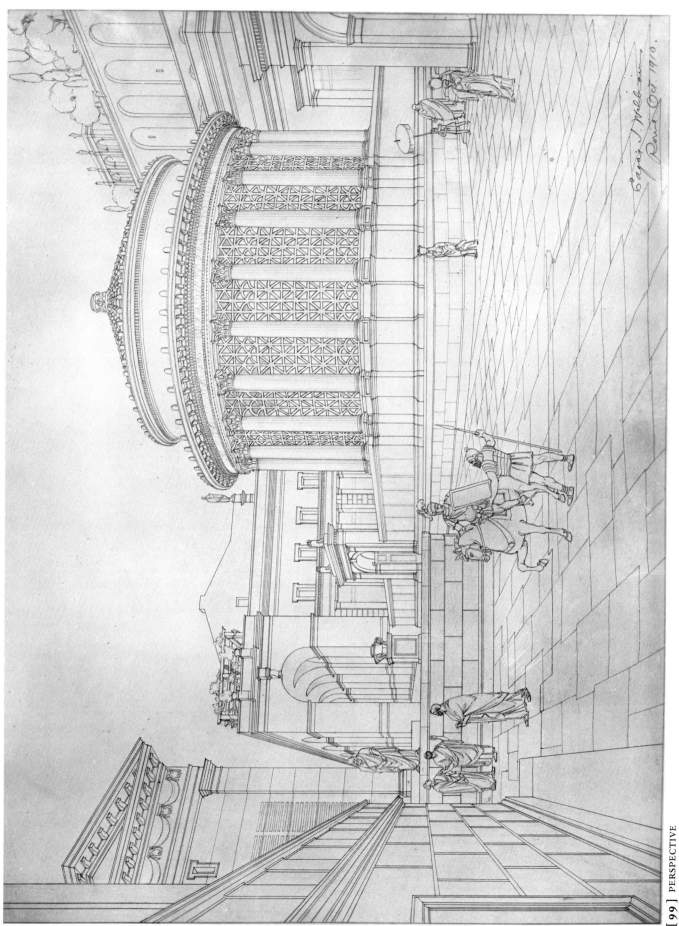

Edgar I. Williams
Rome Oct. 1910.

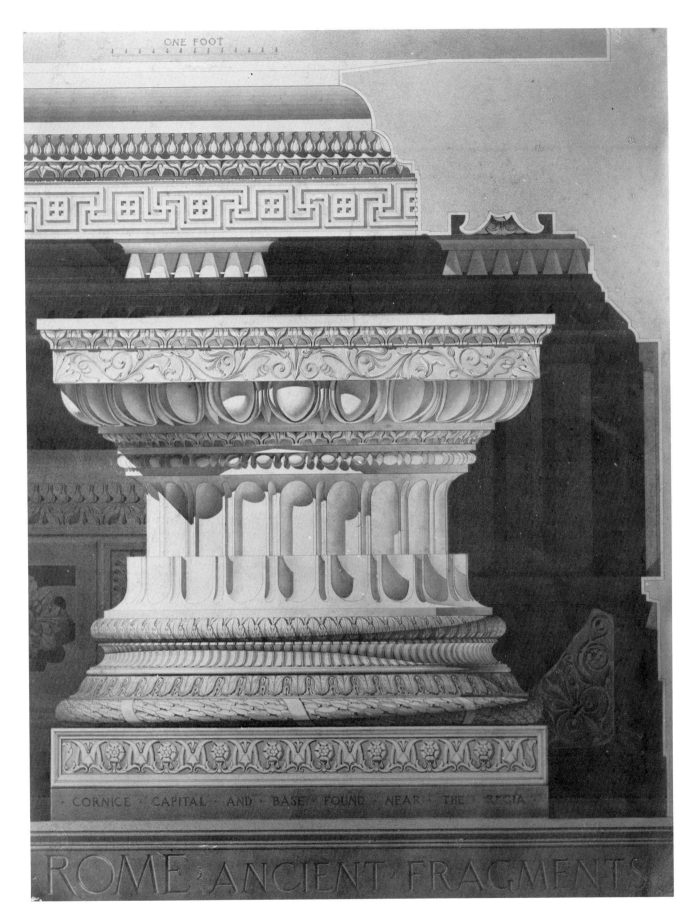

ONE FOOT

CORNICE · CAPITAL · AND · BASE · FOUND · NEAR · THE · REGIA

ROME · ANCIENT · FRAGMENTS

[100] Edgar J. Williams, Capital and cornice, Forum Romanum, Rome.

APPENDIX

Daniel Burnham's letter to Frank Joseph Forster, a twenty-two-year-old architecture student traveling in Europe in 1908, advises Forster to seek out the best examples of classically inspired landscape architecture in England, France, and Italy; tells him what to look for in each; and illustrates well Burnham's warm interest in the education of young architects. It also reveals Burnham's respect for historical precedent and for what he calls "the accumulated wisdom of the ages." Forster (1886–1948, FAIA) was a winner in the competition for design of the New York City Slum Clearance Project of 1911, contributed articles to architectural journals, and had a very successful practice in New York.

September 22, 1908

Dear Frank:

Mr. Foreman has asked me to say what in my opinion are things of special interest in your line in Europe. It is, of course, impossible to mention more than a few, but I am glad to help as much as I can.

It is the wrong time of the year to see out-of-door effects to the best advantage, so much depends on the foilage and the summer colorings, but nevertheless the layouts and structure of the great gardens is apparent enough even in winter.

In England you should see at least half a dozen great country estates, their broad parkings, their plantings and vistas of trees, gradings, avenues and formal gardens. There are hand books on these things. When the Washington Commission was in Europe we measured the widths of avenues, the spacing of trees and the heights of tree hedges, trying to get the sense of scale of all the good things, which sometimes has a reference to a man as measure, but far more often to some great buildings or even the size of the tree growth. In particular, Chatsworth, the region of Fountains Abbey, Eaton Hall, Hatfield House, Knowle House, Hampton Court, Bushy Park, Windsor Park and the parks in London dwell in my memory. An auto trip out of London to Cambridge and Oxford, Warwick Castle and down through the New Forest gives much help.

In France the things are unnumerable.

First. In Paris study the Luxembourg Garden. It is full of subtilties [*sic*]. It was designed after the palace was built and had to work up from this building. Notice the skill with which Le Nôtre did this difficult task. Then comes Versailles, the most important formal garden in the

world. Spend many days in it, noticing how everything is related not only in plan but as to every fountain, statue, vase or stairway. On the grand terrace in front of the Chateau every object is on some axis grand or minor of the building itself. The order and the system in this park are the best in the world except in some Italian examples.

Now comes St. Cloud, Fontainebleu, St. Germain, Vaux-le-Vicomte, and many others.

In Paris note the use of accents on the centers of vistas, especially the columns, the arches and corner buildings. Note the ease and perfection of the circulatory street system. It would be a good thing to keep a Paris map on your table, get your points of compass firmly fixed in your head as you study it, and never come in or go out without glancing at the map to direct or correct you. Remember that the city as a whole thing, as one grand design, is the major study and try to get the key and see how everything works out and is related. The great gardens of Paris are a part of a related system. Most people look at things only in detail. You should try to see the reasons, for the entire system has been studied and worked out as a whole. In detail study the river quays, bridges and boulevards, noting proportions and scale very carefully.

I find it important to look down on Paris. You get a very fine far-off view from St. Germain, another of vast importance from St. Cloud, and the greatest from the Eifell [sic] Tower. Spend a lot of time up there, map in hand; every minute of it will pay. After thus studying Paris you will not be able at first to recall it except as a confused mass. But later on when problems great and small come up in your work, details will suddenly jump in memory and be a great help to you. The reasons! The reasons! The reasons! Education lies in seeing them. They are the conclusions that the brightest minds have come to, after the experience of 2,500 years, from the Tower of Babel down to our time.

I won't say much regarding study in other places. What is above applies everywhere.

See:

The chateaux of the Loire
Nancy
Rome, give much time.

Drive on the Riviera from Nice, Villefranche, Monte Carlo, Mentone and Cannes. If you can do it, go over the upper drive from Nice to Monte Carlo.

Genoa. Study the gardens, and terraces all around the city and far down on the Italian coast as your time will allow. The Campo Santo here is the finest cemetery in the world. Note the boulevards on the water both here and on the Riviera; measure them and see the construction of the shores and the beaches.

The villas about the Italian cities are the greatest source of information for the landscape architect. You should give more time and careful study to them than to all other things put together. Note the scale of every object, from that of a broad vista to that of a mere vase or a little statue or bench. Note the perfect order and relationship. Note, very especially, the relation of the formal to the informal; in this is the soul of the great Renaissance period. Those men brought to light eternal principles and recorded them for all of us.

Around and in Rome are

The Villa Borghese
" " Albani
" " Medici
" " Lanti
" " d'Este

and many others. Study each of them very, very thoroughly, measuring, comparing, noting all effects of order, of contrast and of whole compositions. Get lots of photos; take lots yourself. Make careful notes, illustrated by your own sketches, no matter how crude. Respect your own thoughts, but be humbly receptive, Frank. Remember that the very greatest minds of all times have here recorded their dreams and their deliberate conclusions. No man is free until he knows the truth; he must get it from the accumulated wisdom of the ages. He can only help a little in a short life, but if he would be great he must most thankfully accept the roads laid out by others on which he can walk forward and make progress, instead of trying to blaze his own way through a, to him, untried wilderness.

There are scores of things that should be seen. The above are enough and more. If you can see them well with more or less thoroughness you will come home with

a full harvest, a better one, I assure you, than many purely art students acquired in a life time.

If one thing in Rome is greater than another it is the old, half ruined, Villa d'Este. There is enough in that one garden to furnish profitable food for thought to all landscape men in America.

Yours ever,
[signed]
D. H. Burnham

NOTES

Introduction

1. T. S. Hines, *Burnham of Chicago* (Chicago, 1979), 219.

2. Although the Academy had a legally unspecified agreement to retain the work undertaken by the fellows during their stay in Rome, this agreement was never implemented as right, and the fellows, without exception, took their drawings back to the United States. Therefore, unlike the work of the architects of the French Prix de Rome, which is retained at the Ecole des Beaux-Arts in Paris, there is no central collection of the architectural drawings of the American Academy fellows. Some of this work was kept by the fellows, their families, or their business associates; a small amount found its way into architectural archives and university collections; but the great majority appears to be lost or destroyed. Fortunately, however, the Academy kept a full photographic record of almost anything its fellows in architecture, landscape architecture, painting, and sculpture produced until 1939.

3. L. Valentine and A. Valentine, *The American Academy in Rome, 1894–1969* (Charlottesville, Va., 1973), iii. A valuable study restricted mainly to the founding years is M. N. Woods, "Charles Follen McKim and the Foundation of the American Academy in Rome," in *Light on the Eternal City. Papers in Art History from the Pennsylvania State University*, ed. H. Hager and S. S. Munshower (University Park, Pa., 1987), 2:307–20. For an overview of the Academy within the larger theme of American presence in Rome, see W. L. Vance, *America's Rome* (New Haven, Conn., 1989), 1:372–74; 2:272–76.

Chapter I

1. One of the best general treatments of the American Renaissance (ca. 1876–1917), the late-nineteenth-century interest in America in what the Renaissance in Italy stood for, is R. G. Wilson, D. H. Pilgrim, and R. N. Murray, *American Renaissance, 1876–1917* (New York, 1979). This study was published as the catalogue for the exhibition of the same name, held at the Brooklyn Museum in 1979. See also R. G. Wilson, "Architecture and the Reinterpretation of the Past in the American Renaissance," *Winterthur Portfolio* 18 (1983):69–87. The cultural and artistic background against which the American Academy in Rome was conceived and developed and the people who created this era and the Academy are also discussed in H. M. Jones, "The Renaissance and American Origins," in *Ideas in America* (Cambridge, Mass., 1945), 140–51.

2. Jones, "Renaissance and American Origins," 150–51; L. Valentine and A. Valentine, The *American Academy in Rome, 1894–1969* (Charlottesville, Va., 1973), 1–2.

3. A. D. F. Hamlin, "The Influence of the Ecole des Beaux-Arts on Our Architectural Education," *Architectural Record* 23 (1908): 242. See also A. D. F. Hamlin, "The Battle of Styles," *Architectural Record* 1 (1891): 265–75. An early supporter of the Academy's cause in New York's social circles, Edith Wharton remembered the Manhattan of 1870s in her autobiography: "Cramped horizontal gridiron of a town without towers, porticoes, fountains or perspectives, hidebound in its deadly uniformity of mean ugliness. . . . How could I understand that

people who had seen Rome and Seville, Paris and London, could come back and live contentedly between Washington Square and the Central Park?" This grim view of the immediate past and confidence in the future was shared by McKim. In 1909, the year of his death, he wrote to Lawrence Grant White, his partner's son, who was about to complete his architectural studies at the Ecole des Beaux-Arts in Paris and return to the United States: "Uncle Sam is now proud of what is being done, and is going to demand the very best that millions can purchase; and there is no fear of falling back into the degenerate order of things which has heretofore always existed. . . . When you get through with your work on the other side and come home to build, you will find opportunities awaiting for you that no other country has offered in modern times. The scale is Roman, and it will have to be sustained" (quoted in W. Andrews, *Architecture, Ambition and Americans* [New York, 1955], 172, 202).

4. Wilson, Pilgrim, and Murray, *American Renaissance*, 28.

5. H. W. Desmond and H. Croly, "The Work of McKim, Mead and White," *Architectural Record* 20 (1906): 227. Desmond and Croly viewed the last two decades of the nineteenth century as a period of rapid, even chaotic change and discovery in American architecture: "During the eighties no one tendency of design, no single choice of style had been adopted by any large number of architects. A firm beginning to practice in that decade found no specific technical tradition, to which it could conform or from which it could revolt. The genius of Richardson had, indeed, provoked a Romanesque Revival; but it was only a spasm" (157). The authors credited McKim, Mead and White with the creation of a new tradition in architecture. The firm not only promoted a high level of technical proficiency, but was instrumental in inspiring and educating public taste. Pointing to contemporary criticism of the firm's overt historical tendencies—sacrificing function to exterior forms and style—Desmond and Croly asked, "Was there any other way to provoke on behalf of their buildings the interests of an indifferent public, and perhaps an ignorant client, than to make them first of all reminiscent of memorable examples of European architecture?" (185). They judged that an imitation of European buildings had always been a necessity for Americans, who "had no architecture of their own and were lacking entirely in the intellectual culture" (218). Along with other architects, McKim and his parners borrowed from the past, "but they did not borrow either indiscriminately, carelessly or pedantically. . . . The period from which they derived their forms must be described as in general that of the Renaissance; and it is absolutely essential to the appraisal of their work that the meaning of this selection should be fully understood" (221).

6. J. Burchard and A. Bush-Brown, *The Architecture of America* (Boston, 1961), 85–96; T. F. Hamlin, *Greek Revival Architecture in America* (New York, 1944), 17–62, esp. 17–21.

7. Desmond and Croly, "Work of McKim, Mead and White," 225–26.

8. Jones, "Renaissance and American Origins," 140ff., esp. 143–46; Wilson, Pilgrim, and Murray, *American Renaissance*, 11ff.; R. G. Wilson, *The AIA Gold Medal* (New York, 1984), 14–17. The particular suitability of fifteenth-century Italian sensibilities to "modern" America was articulated by the noted art historian and critic Bernard Berenson: "Every generation has an innate sympathy with some epoch of the past wherein it seems to find itself foreshadowed. . . . We ourselves because of our faith in science and the power of work, are instinctively in sympathy with the Renaissance" (*The Venetian Painters* [1894], in *Italian Painters of the Renaissance* [New York, 1952], iii; see also M. N. Woods, "Charles Follen McKim and the Foundation of the American Academy in Rome," in *Light on the Eternal City. Papers in Art History from the Pennsylvania State University,* ed. H. Hager and S. S. Munshower [University Park, Pa., 1987], 2:309). The nineteenth-century interest in classicism in the United States extended to Greco-Roman as well as Quattrocento Italian and seventeenth-century French sources. The definition of each source and style was often blurred by its practitioners, and their choices, largely based on pragmatic reasons, were eclectic. For the purpose of this book, to try to distinguish one kind of "classicism" from another would be pointless.

9. The enthusiasm of late-nineteenth-century New England for an aestheticism with a distinct Italianate flavor is recalled by Van Wyck Brooks: "Young men of means roamed over Italy, inspired with a wish to see sincerely the fruit of their reading of Ruskin. They copied Roman inscriptions in their pocket notebooks. They studied Sienese architecture and Tuscan sculpture; and they went to Verona to examine the Lombardic pillars, often with a mounting scorn of all things modern. . . . This Italianate circle was closely connected with Boston, and the rage for art was all-engrossing. Days that had once been merely misty were described now as 'Corot days,' and Giotto and Cimabue, as themes of conversation, vied with castled crags and historic landscapes" (*New England: Indian Summer* [Boston, 1940], 153–55).

10. The primary objective of the art academies of the Renaissance was to elevate the position of the artists over that of the craftsmen and to free them from the restrictions imposed by the medieval guild system. Although the theoretical study of art constituted the major concern of these cultural institutions, many offered educational and training programs under supervision. The first academy to address the fine arts exclusively and to encourage the collaboration and unification of architects, painters, and sculptors around a common interest in "design" was the Accademia del Disegno, founded in Florence by Vasari in 1563 under the patronage of Cosimo de' Medici (G. Scivizzi,

"Institutes and Associations," in *Encyclopedia of World Art* [New York, 1963], 8:150–57; N. Pevsner, *Academies of Art, Past and Present* [1940; reprint, New York, 1973], 25–66, esp. 43–48).

11. An exception to this rule was a course in encaustic and fresco painting given from 1921 to 1923, under the supervision of S. Lascari, a fellow in painting. The fresco-painting course was offered also in 1936 under the supervision of Ferruccio Ferrazi from the Italian Royal Academy of Art. These courses, however, were postgraduate studies for learning special skills.

12. "The school is not, primarily, one of design, nor . . . is it one of copying, in the sense of storing the mind with the 'motifs' of old masters to be reproduced with pedantic exactness at home. It is rather to educate the tastes and thoroughly to impress upon the mind by daily contacts with the great monuments those principles which are essential to the enduring quality in Architecture, *be the style what it may* [italics mine]" (Memorandum, February 1895, Archives of American Art, Smithsonian Institution, Washington, D.C.). The liberal and progressive attitude reflected especially in the last sentence of this early memorandum was not maintained in later years when the Academy strictly controlled the styles allowable for study.

13. Charles McKim to Daniel Burnham, 12 June 1905, Burnham Papers, Chicago Art Institute Library.

14. T. S. Hines, *Burnham of Chicago* (Chicago, 1979), 224–25. For a more detailed account of Burnham's interests in the founding and welfare of the Academy, see pp. 217–25.

15. Rome Prize (the term was clearly inspired by the Prix de Rome of the French Academy in Rome) was the official title for the fellowship provided by the Academy's own resources, either one-time grants or, from 1909 onward, a regular endowment. Between 1897 and 1909, however, students of architecture holding fellowships and grants from outside sources could live and work at the Academy. Indeed, room and work-space privileges, extended to outside fellows in architecture and the envoys of accredited architecture schools, were maintained into the 1930s. A drafting room for the use of outside students and traveling scholars was kept until 1927, when it was moved to rented quarters in downtown Rome because of the lack of space in the main Academy building. The downtown atelier had an enrollment of twenty-seven architecture students in 1927; this number had dropped to seven by 1932. It was abandoned in 1933 for lack of interest and lack of funds.

16. For the early history of the Academy, especially the economic hardships it suffered until the end of the First World War, see Valentine and Valentine, *American Academy in Rome*, 21–65. See also G. Brown, "McKim and the American Institute of Architects," *Architectural Record* 38 (1915): 575–82, esp. 582.

17. H. L. Satterlee, *J. Pierpont Morgan, An Intimate Portrait* (New York, 1939), 579–80; Valentine and Valentine, *American Academy in Rome*, 64.

Chapter II

1. Memorandum on the American Academy in Rome (1913), 9–10, Archives of American Art.

2. L. Valentine and A. Valentine, *The American Academy in Rome, 1894–1969* (Charlottesville, Va., 1973), 22.

3. "Students' Works from the Roman Academy," *Nation*, 13 February 1913, 147.

4. C. H. Cheney, "The American Academy in Rome," *Architectural Record* 31 (1912): 253.

5. "Remarks of Mr. Kenyon Cox," *The American Academy in Rome: Addresses at the Annual Dinner, September 10, 1913* (New York, 1914), 22.

6. J. B. Carter, in American Academy in Rome. Annual Report (1913), 18.

7. A. W. Van Buren, "The American Academy in Rome and Classical Studies in America," *Classical Journal* 9 (1913): 78. See also E. K. Rand, "The School of Classical Studies of the American Academy in Rome," *Art and Archaeology* 1 (1914): 13–20.

8. William R. Mead to Charles E. Norton, 1915, quoted in Valentine and Valentine, *American Academy in Rome*, 70.

9. American Academy in Rome. Annual Report (1931–1932), 33. The first women fellows were Astra Zarina, in architecture, and Marjorie E. Kreilick, in painting.

10. The review of the Women's Building at the Columbian Exposition of 1893, designed by Sophia Hayden Benett (the first woman graduate of the MIT School of Architecture, in 1890), was disparaging, for the wrong reasons: "As a woman's work, it 'goes,' of course; fortunately, it was conceived in the proper vein and does not make a discordant note: it is simply weak and commonplace" (*American Architect and Building News* 39 [1893]: 159; L. Craig et al., *The Federal Presence* [Cambridge, Mass., 1977], 219). See also J. Paine, "Some Professional Roles: 1860–1910," in *Women in American Architecture: A Historic and Contemporary Perspective*, ed. S. Torre (New York, 1977), 70–73.

11. C. H. Meltzer, "Two Homes of Art in Rome, the Academies of Old France and Young America," *Arts and Decoration* 16 (1921): 15. The Grand Prix was open to women at the French Academy from 1903 onward. The first woman *pensionnaire*—Lili Boulanger, in musical composition—was admitted in 1913. In 1920, another woman, Marguerite Canal, received the Grand Prix, also in music (J.-P. Alaux, *Académie de France*

à Rome [Paris, 1933], 2:361–65). The residency of women artists at the British School in Rome started in the early 1920s (S. Farthing, "La Scuola Britannica a Roma," in *Artisti di Quattro Accademie Straniere in Roma* [Rome, 1982], 72).

12. American Academy in Rome. Annual Report (1914), 29–30.

13. Quoted in Valentine and Valentine, *American Academy in Rome*, 57–58.

Chapter III

1. The anonymous author of a paper on the American Academy in Rome, written in 1903, quoted the impressions of Joseph Wood, an English architect who had been in Rome in 1817, to emphasize the same point of view: "A vague feeling of admiration [for the buildings of Rome] mixes itself with every perception and every recollection, and the mind forcibly rejects all inharmonious ideas. It is not any one thing that you see any more than it is a point of history that you have to remember; multitudes of fragments are included in one view, not very perfect and distinct in their forms, yet sufficient to excite the imagination. They crowd on the eye as the scenes of history on the memory" ("Rome as an Art School" [Paper presented at the thirty-seventh annual meeting of the American Institute of Architects, 1903], *American Architect* 82 [1903]: 59).

2. C. G. La Farge, *History of the American Academy in Rome* (Rome, 1915; reprint, New York, 1920), 22–23. La Farge's argument echoed that of his illustrious artist father, John La Farge, expressed exactly a decade earlier, in 1905, when the suitability of Rome as a center for an art school was the subject of an intense debate and seemed to affect the future of the Academy ("Mr. La Farge on Useless Art," *Architectural Record* 17 [1905]: 347; J. La Farge, "The American Academy in Rome," *Scribner's Magazine*, August 1900, 253–56).

3. Quoted in C. Moore, *The Life and Times of Charles Follen McKim* (Boston, 1929), 131–32.

4. American Academy in Rome, Report of the School of Fine Arts (1919), 5, American Academy Archives, New York.

5. "There was a time when Rome was the world's art center. . . . That day has gone by, however, and a change has taken place. Paris usurped the prerogative of the old city, and it is to her that the world now turns for new ideas in art. The Italian galleries remain, the masterpeices hang in their accustomed places, the sky is as blue, the air as soft, and the outlook as lovely; but the glory of Roman art life has departed. The humanity that gave art impetus, the interest to the student, has betaken itself from the Seven Hills to the peaceful Seine, where it flourishes in a wilder, more luxuriant growth, nurtured by the

hothouse forcing of *fin-de-siècle* ideas, untrammelled by convention or tradition. For good or bad . . . today Paris is the hub about which the wheel of art revolves" (A. Hoeber, "The Prize of Rome," *Century Magazine*, May 1905, 4).

6. Senator James McMillan, a staunch supporter of the Academy, stated in 1902 the rationale behind the founding of the Academy in Rome: "It is the general opinion that, for monumental work, Greece and Rome furnish the styles of architecture best adapted to serve the manifold wants of today. . . . Therefore, a school located at Rome . . . offers the student an opportunity to make a thorough acquaintance with both classical models, and also with the models which mark the revival of classicism known as the Renaissance." McMillan observed, "Up to this time, the American student has resorted to Paris, there to take a second-hand instruction which may best be obtained from the original sources; and the Academy was founded by men who were trained in Paris and who recognized the limitations of their instruction" ("The American Academy in Rome," *North American Review* 174 [1902]: 628).

7. The Society of Beaux-Arts Architects (of which McKim was a charter member) condemned the newly established "American School of Architecture in Rome" as "unnecessary and unjudicious" (Resolution of the Society of Beaux-Arts Architects, August 9, 1894, Archives of American Art). The society had reestablished its support by 1907.

8. Honoré Mereu, in a sharply worded essay in 1905, not only criticized the founding of the American Academy in Rome, but also questioned the validity of all academies, including the French Academy: "What there is strange about the founding of the American Academy in Rome is that its accomplishment takes place at the very moment when those countries which have up to now maintained such institutions in the Eternal City are asking themselves whether these academies are really useful, whether, such as they actually are, they really achieve the end for which they were created" ("The American Academy at Rome," *American Architect* 88 [1905]: 99). Mereu condemned academic and historical formulas encouraged by these institutions and observed that they should achieve the goal of ripening and perfecting talent without crippling the originality and individuality of the artist.

9. T. Hastings, "Influence of the Ecole des Beaux-Arts upon American Architecture," *Architectural Record* [special issue] (1901): 82.

10. A. W. Lord, "The Significance of Rome to the American Architectural Student," *American Architect* 82 (1903): 43.

11. C. H. Cheney, "The American Academy in Rome," *Architectural Record* 31 (1912): 251. Cheney logically pointed out that with better schools of art and architecture, the technical expertise of Paris could be duplicated in the United States, but it

"never will be possible to transplant the classic monuments of antiquity, nor the setting which inspires and frames them. For this reason there will, for several generations at least, be pressing need of a central institution in Rome to provide for their proper study" (255). John Galen Howard, a member of the Society of Beaux-Arts Architects, apparently had a different view about the relative importance of Rome and Paris and the ability of creating beautiful façades in the training of an architect: "Shall we send boys to Rome to make dainty drawings of elevations and details before they understand the principles and needs of which those are mere clothing and expression: or shall we send them to Paris, first to learn the why and how by exercising their own powers and developing them to the utmost" (Howard to Charles McKim, 23 July 1894, Archives of American Art).

12. E. H. Blashfield, "Rome as a Place of Schooling for a Decorative Painter," *American Architect* 82 (1903): 51.

13. Ibid.

14. F. D. Millet, "The American Academy in Rome," *American Monthly Review of Reviews* 31 (1905): 713–15.

15. J. La Farge, "American Academy in Rome," 253.

16. Lord, "Significance of Rome to the American Architectural Student," 45. For similar ideas expressed by Senator James McMillan, see note 6.

17. Lord, "Significance of Rome to the American Archetectural Student," 45.

18. Lord's subsequent career as the director of the School of Architecture at Columbia University was also short-lived (1912–1915) and anticlimatic. He seems to have been unable to get his ideas across to the students or devote sufficient time to teaching (S. M. Strauss, "History III, 1912–1933," in *The Making of an Architect, 1881–1981*, ed. R. Oliver [New York, 1981], 87–90). One should also consider that during its fledgling years, the Academy may have had to cultivate relationships with influential and wealthy men; Lord was neither. Consider President William Mead's request to Director Gorham Stevens to try to get Charles A. Platt, a successful New York architect and landscapist, to stay at the Academy during his visit to Italy in the fall of 1918: "He is a man of independent means, and his architectural work has been done for rich people. I hope after the war we may have him on our Board of Trustees, because I know he is interested in our work and his connections would be of great value to us in many ways" (Mead to Stevens, 16 October 1918, Archives of American Art). Platt did, indeed, become a trustee, and after Mead's death in 1928, he became the president of the Academy (1928–1933). His son, William Platt, also an architect, followed his father onto the board less than ten years after his father's death in 1942.

19. "Remarks of Mr. Royal Cortissoz," *The American Academy in Rome: Addresses at the Annual Dinner, September 10, 1913* (New York, 1914), 18–19.

20. G. M. Trevelyan, *Garibaldi's Defenses of the Roman Republic* (London, 1912), 1.

21. American Academy in Rome. Annual Report (1913), 9.

22. A. W. Van Buren, "The American Academy in Rome and Classical Studies in America," *Classical Journal* 9 (1913): 74.

23. W. B. McDaniel, "The American Classical Schools in Rome and Athens," *Classical Journal* 19 (1924): 441. McDaniel was the resident professor of classical studies at the American Academy from 1919 to 1921.

24. S. B. Trowbridge, "Report of the Committee of the School of Fine Arts on Revision of Regulations for Competitions and Course of Study," American Academy in Rome. Annual Report (1918–1919), 30–34.

25. "If the deepest thinkers of our own and other countries are right in their interpretations of the signs of the times, the world is soon to behold a revival of Arts and Letters in the spirit of the humanists. Many of these thinkers believe that this revival will have its center in America.

"There is a reason for an American Academy in Rome. It is because the Eternal City is the city of eternal youth, and that is why America, Germany and Russia, the three young men, strong in their youth, are building at this moment new and beautiful institutions as residences for these artists who are to influence their native lands by giving stability and permanance to the divine gift of youth" (J. B. Carter, in *Memorandum on the American Academy in Rome* [New York, 1913], 15).

The editor of the *Memorandum* added: "It is confidently believed that no American institution has so large a responsibility and opportunity for training those who are to set the standards of our art in the future."

26. The metaphysical question surrounding the ethos of Rome as a model serving the needs of self-discovery and self-creation of a number of artists, architects, poets, even a pope, from the Renaissance through the nineteenth century is the subject of a stimulating study by Robert M. Adams. Particularly intriguing are the psychological probings of the "distance between a man's roots in nature and his redefinition of himself in Rome" (*The Roman Stamp* [Berkeley, Calif., 1974], esp. 1–29).

Chapter IV

1. These schools were Harvard University, Columbia University, Massachusetts Institute of Technology, University of Pennsylvania, George Washington University, Cornell University, University of California at Berkeley, Washington Univer-

sity, University of Illinois at Champaign, Syracuse University, University of Michigan, and Carnegie Technical Schools. Added to the list in 1919 were Yale University, Princeton University, Georgia School of Technology, University of Minnesota, Art Institute of Chicago, and Tulane University.

2. The following are known winning projects for the American Academy in Rome Prize competitions preserved in photographs or as originals:

1909 Harry E. Warren, "Establishment for State Social Functions, Washington, D.C."

1911 George Koyl, "The American Academy in Rome."

1912 Kenneth E. Carpenter, "A Navy Yard on an Island in the South Pacific Ocean."

1913 Walter L. Ward, "A Hall of Fame in Washington, D.C."

1914 William J. Hough, "A Monument to a Deceased Ruler."

1915 Philip T. Shutze, "The Decoration of an Island Commemorating Its Purchase."

1920 James K. Smith, "A Memorial to a Great Citizen."

1922 Henri Marceau, "A National Music Center."

1923 Arthur F. Deam, "A Private Chapel."

1926 C. Dale Badgeley, "Wall Treatment of Fountain."

1927 Homer F. Pfeiffer, "A Fine Arts Museum."

1930 Walter R. Reichardt, "A Church in a Small Town."

1931 Henry Mirick, "A Hotel in a Park."

1932 George Nelson, "An Auditorium."

3. C. Grant La Farge to Edward P. Mellon, 12 April 1913, Archives of American Art.

4. S. B. Trowbridge, "Report of the Committee of the School of Fine Arts on Revision of Regulations for Competitions and Course of Study," American Academy in Rome. Annual Report (1918–1919), 31.

5. Edward P. Mellon to C. Grant La Farge, 15 March 1913, Archives of American Art. Henry R. Shepley—later of Coolidge, Shepley, Bulfinch and Abott of Boston—did not win the competition but later became a trustee of the Academy and many times a juror in architecture.

6. Edward P. Mellon to R. Wolfe, 11 March 1914, Archives of American Art. Charles Henry Crocker—the millionaire president of Crocker Printing and Stationery Company of San Francisco—had been courted unsuccessfully by the Academy to be a founder. Frank Lyon Polk was an eminent lawyer and statesman; Arthur Brown, Jr., an architect; and Truxton Beale, a diplomat.

7. Responding to Mellon's inquiry about how many competitors from Paris could be admitted to the final competitions in New York as compared with those entering from the United

States, La Farge wrote: "Now, as to the number of competitors admitted to the finals; while I quite agree with the ideas expressed by both Mr. Stevens and yourself ["that the best candidates trying for the Preliminaries should be selected in the Finals irrespective of whether they are men from America or from Europe" (Edward P. Mellon to C. Grant La Farge, 11 June 1912, Archives of American Art)], I am sure that we have got to proceed very slowly. It will not do for us to let any idea get about here that it is necessary for a man to go to Paris in order to have a good chance for the Academy, or even that it is very much of an advantage to him. . . . I imagine, however, that the proportion of competitors is likely to be about three to one; that is three from the United States and one from abroad. If so, that would make the proportion in the finals a fair one. However, I think we can reserve for ourselves a little latitude here, and perhaps if the showing in architecture from the other side is very conspicuously good, we may choose more than one man [to compete in the finals in New York]. . . . Later on, when this system of holding the competitions had a chance to work itself out, we may be in a position to take in a larger number in all the finals, but it is not that time yet" (C. Grant La Farge to Edward P. Mellon, 30 July 1912, Archives of American Art).

8. The painting jurors for the same period, 1912 to 1937, were Edwin Blashfield, seventeen times; Barry Faulkner (FAAR, 1910), fifteen; Francis Coates Jones, fourteen; Douglas Volk, ten; Ezra Winter (FAAR, 1914), nine; Francis Bradford (FAAR, 1927), seven. The sculpture jurors for the same period were James Earle Fraser, twenty-six times; Herbert Adams, twenty-four; Charles Keck, seventeen; Adolph Alexander Weinman, sixteen; Daniel Chester French, fourteen. Of the twenty-eight members of the painting and sculpture juries between 1912 and 1939, twenty—twelve painting jurors and eight sculpture jurors—were fellows of the Academy. A variation in the composition of the juries became noticeable beginning in 1935, the date that coincides with the election of James Kellum Smith as the president of the Academy.

9. A. W. Lord, "The Significance of Rome to the American Architectural Student," *American Architect* 82 (1903): 44.

10. If they are used judiciously, there is more to be learned from these restoration studies than has been commonly acknowledged, and it would be desirable to see them fully published.

11. I thank David Van Zanten for the observation that the earliest measured drawings of historical buildings by Americans were archaeological and that Francis Bacon and Howard Butler Crosby were the pioneers in this effort. John Russell Pope, the first Academy fellow, may well have been the first American architect to do measured drawings of architecture proper, in Athens in 1896 (F. H. Bacon, J. T. Clarke, and R. Koldeway,

Investigations at Assos, Drawings and Photographs of the Buildings and Objects Discovered during the Excavations [Cambridge, Mass., 1902–1921]; Howard C. Butler, *Architecture and Other Arts: Publications of an American Expedition to Syria in 1899–1900, Part 2* [New York, 1903]; Butler, *Ancient Architecture in Syria, II-A. Publications of the Princeton University Archaeological Expedition to Syria, in 1904–1905* [Leyden, 1907]; Butler, *Ancient Architecture in Syria, II-B. Publications of the Princeton University Archaeological Expedition to Syria in 1905 and 1909* [Leyden, 1920]; Butler, *Sardis II. Architecture: The Temple of Artemis* [Leyden, 1925]).

12. C. G. La Farge, "Educational Plan," *History of the American Academy in Rome* (New York, 1920), 12–13.

13. Edward Lawson to James S. Pray, 12 December 1919, Archives of American Art.

14. Richard Webel to Ferruccio Vitale, 6 August 1927, Archives of American Art.

15. Richard Webel to Ferruccio Vitale, 24 November 1927, Archives of American Art. This was the year when the Academy ceased offering studios to outside grant holders in its main building but provided them with rented space in downtown Rome. Webel's "territorialism" is interesting, as is the word "corking," which he undoubtedly picked up during tennis contacts at the British School.

16. Meanwhile, Ferruccio Vitale seems to have had his own reasons to worry about his position as a trustee on the Executive Committee of the Academy and as the chairman of the landscape-architecture jury. In a note attached separately to a letter to William Boring, a trustee of and the treasurer of the American Academy and the dean of the Columbia University School of Architecture, dated May 31, 1926, Academy President Mead expressed, in bantering fashion, disapproval of Vitale for lacking Anglo-Saxon poise: "Vitale at one time thought our men ought to hobnob with the young Italian artists and dragged me through some unkempt studios where young fellows were doing what I thought was rotten work—Privately, I wish he was not on our Board—He plays too prominent a part and is not in any way identified with the old Academy" (William R. Mead to William Boring, 31 May, 1926, Archives of American Art). Mead died soon after, and Vitale's position on the board remained secure until his death in 1933.

17. In 1913, the Pittsburgh Architectural Club exhibited the drawings of the Academy's "Third Year Men" at the Carnegie Institute. The request of the Chicago Architectural Club to show the drawings had to be refused, since the show was already dismounted and dispersed, with the exception of the restoration studies of the House of the Vestal Virgins in the Forum Romanum by Edgar I. Williams (Pls. 95–99). They had been sent to the Massachusetts Institute of Technology for a special showing. Williams's work had attracted considerable attention when it was shown at the Architectural League of New York exhibition in 1912.

18. The following studies by the Academy fellows in architecture and by architects with outside fellowships but Academy affiliations were published in the *Journal of American Institute of Architects*: Richard H. Smythe (FAAR, 1911–1913), "The Stock Exchange of Ancient Rome (Basilica Julia)," 1 (1913): 342–43; Kenneth E. Carpenter (FAAR, 1913–1915), "The Entasis of the Columns of the Temple of Mars Ultor," 1 (1913): 396–97; Carpenter, "Mino da Fiesole," 2 (1914): 204–5; George S. Koyl (FAAR, 1912–1914), "A Marble Pavement from the Villa Pia, Rome," 1 (1913): 456–57; Koyl, "Roman Mosaics," 1 (1913): 560–61; W. C. Francis, "Hadrian's Villa, Tivoli," 1 (1913): 505–7, and 2 (1914): 98–99; Walter L. Ward (FAAR, 1914–1916), "The Capitoline Bisellium," 2 (1914): 156–57; Ward, "The Temple of Concord, Rome," 2 (1914): 403–4; L. G. White, "Variations in Roman Chimney-pots," 2 (1914): 262–63; J. Scarf, "The Massimi Palace," 2 (1914): 306–7; L. G. Grant, "Variations in Roman Keystones," 2 (1914): 352–54. And there was a contribution by the director, Gorham P. Stevens, "Notes on the Villa di Papa Giulio, Rome," 2 (1914): 539–40.

19. The following measured drawings and archaeological restoration projects were published by the fellows in architecture in "Recent Works of the School of Fine Arts," *Memoirs of the American Academy in Rome*. In volume 2 (1918): 11–14, pls. 1–8: Kenneth E. Carpenter, "Cortile Belvedere, Vatican"; Walter L. Ward, "Corinthian Capitals from the Temple of Mars Ultor, Rome"; William J. Hough, "Palace of Domitian, Palatine"; Hough, "Ponte Senatorio"; Hough, "Piazza San Pietro Fountain, Rome"; Philip T. Shutze, "Circular Pavilion at Hadrian's Villa, Tivoli"; Edward Lawson, "Villa Gamberaia, Settignano." In volume 3 (1919): 101, pls. 76–91: Richard H. Smythe, "Plan of the Sanctuary of Apollo, Delphi"; Raymond M. Kennedy, "Women's Baths, Tivoli"; Edgar I. Williams, "Plan of Isola Bella"; Philip T. Shutze, "Villa Lante"; William J. Hough, "Interior of the Pantheon"; Edward Lawson, "Entrance Gate, Villa Borghese, Rome"; Eric Gugler, "Model for a Scheme of Approach to St. Peter's." See also the independent studies in the *Memoirs*: James Chillman, Jr., "The Casino of the Semicircular Colonnades at Hadrian's Villa," 4 (1924): 103–20, pls. 50–56; James K. Smith, "The Temple of Zeus at Olympia," 4 (1924): 153–68, pls. 58–62; Homer F. Robert and Henri Marceau, "The Temple of Concord in the Roman Forum," 5 (1925): 53–75, pls. 44–51; Henri Marceau, "Roman Methods of Working and Handling Stone as Exemplified on the Temple of Concord," 5 (1925): 76–77, pls. 52–57; C. Dale Badgeley, "The Capitolium at Ostia," 7 (1929): 221–23, pls. 19–21; Cecil C. Briggs, "The Pantheon of Ostia," 8 (1930): 161–69, pls. 51–57; Homer

F. Pfeiffer, "The Ancient Roman Theater at Dougga," 9 (1931): 145–56, pls. 11–15; Pfeiffer, "The Roman Library at Timgad," 9 (1931): 157–65, pls. 16–19; George Fraser and Albert W. Van Buren, "Roman Baths at Leptis Magna," 10 (1932): 129–33, pls. 30–33; B. Kenneth Johnson, "The 'Terme Nuovo' at Ostia," 10 (1932): 143–44, pls. 43–47; Henry D. Mirick, "The Large Baths at Hadrian's Villa," 11 (1933): 120–26, pls. 4–12; Walter L. Reichardt, "The Vestibule Group at Hadrian's Villa," 11 (1933): 127–32, pls. 13–20; Olindo Grossi, "The Forum of Julius Caesar and the Temple of Venus Genetrix," 13 (1936): 215–20, pls. 47–53.

20. Edward Lawson, "List of English Estates" (1929, Typescript); Richard K. Webel, *A Guide to the Villas of Italy* (Rome, 1930, 1932); Webel, *A Guide to English Gardens* (Rome, 1930); Charles R. Hutton, "The Villa Marlia, Lucca" (1932, Typescript). Webel's guide was amplified by A. Aldrich and J. Walker, *A Guide to Villas and Gardens of Italy* (Florence, 1938).

21. Between 1915 and 1930, Director Stevens started a collection of "Full Size Detail" (FSD) drawings of architectural ornaments measured and rendered by the fellows in architecture. He proposed, repeatedly, a two-volume publication covering the Greek, Roman, medieval, and Renaissance periods. Two trial plates prepared in 1928 was as far as this worthy project progressed. It must have been quashed because of insufficient funds or lack of interest. The whereabouts of the collection is unknown. Another worthy architectural project that Stevens started in 1915 but never realized was a collection of marbles and building stones of Italy. Interest in marbles and building stones revived in the 1960s through the pioneering studies of John B. Ward-Perkins on the quarrying and trading of marble in classical antiquity, leading to the formation of the Comitato per lo Studio del Marmo e Pietra Antica in Rome.

22. The idea of providing an axial approach to St. Peter's in the form of a monumental avenue had been around since the seventeenth century; one project, requiring the demolition of Borgo Vecchio and Borgo Nuovo, had been proposed by Carlo Fontana in 1694. The present scheme, Via della Conciliazione (commemorating the reconciliation of the church and the state), is based on the design by the architects Marcello Piacentini and Attilio Spaccarelli; it was presented to Benito Mussolini and Pope Pius XI in 1936. The project was implemented during and after the Second World War and was finished in 1950, in time for the Jubilee Year. The most grandiose proposal for the reorganization of the approach to St. Peter's was that of the neobaroque architect Armando Brasini (1879–1965). Brasini's scheme, a gigantic colonnade conceived as a continuation of Bernini's colonnade, joined the Piazza San Pietro with the Piazza Pia by Castel Sant'Angelo and the Tiber. There is no reason to assume that Eric Gugler was aware of Brasini's grand and forceful scheme, which was probably in preparation during 1915 and 1916 while Gugler was working on his. Brasini was a well-known figure in architectural circles in Rome before and after the First World War, and his studio was regularly visited by his admirers. It is unlikely, however, that the Academy would have encouraged contact between this extravagant and dramatic neobaroque designer and its fellows in architecture (American Academy in Rome. Annual Report [1914–1915], 57; S. Kostof, *The Third Rome, 1870–1950* [Berkeley, Calif., 1973], 70–71; P. Orano, *Urbe Massima. L'Architettura e la decorazione di Armando Brasini* [Rome, 1916]; W. L. MacDonald, "Armando Brasini," in *Macmillan Encyclopedia of Architects* [New York, 1982], 1: 282–83). See also a photo-album and a typescript report on Gugler's project kept at the library of the American Academy in Rome (E. Gugler, "Accesso alla Piazza di San Pietro" [1926]).

23. American Academy in Rome. Annual Report (1922–1923), 33; "Model of St. Peter's Dome," *Pencil Points* 5 (1924): 90.

Chapter V

1. S. M. Bedford and S. M. Strauss, "History II, 1881–1912," in *The Making of an Architect, 1881–1981*, ed. R. Oliver (New York, 1981), 34–35. For the disagreement between McKim and Ware about the planning of Columbia University's Morningside Heights campus and other relevant subjects, see the excellent article by David De Long, "William R. Ware and the Pursuit of Suitability: 1881–1903," in *Making of an Architect*, 13–21, esp. 17.

2. M. N. Woods, "Charles Follen McKim and the Foundation of the American Academy in Rome," in *Light on the Eternal City. Papers in Art History form the Pennsylvania State University*, ed. H. Hager and S. S. Munshower (University, Park, Pa., 1987), 315. For the drastic stiffening of the Academy's attitude in the years immediately following the war, see pp. 60.

3. C. H. Meltzer, "Two Homes of Art in Rome, the Academies of Old France and Young America," *Arts and Decoration* 16 (1921): 15.

4. Ibid., 16.

5. L. Valentine and A. Valentine, *The American Academy in Rome, 1894–1969* (Charlottesville, Va., 1973), 142–43.

6. Jesse B. Carter to William R. Mead, 28 January 1913, Archives of American Art. Carter had been a professor of classics at Princeton from 1898 to 1907; he then served from 1907 until 1913 as the director of the School of Classical Studies in Rome. He died from heatstroke in 1917 while on his way to the front to study Red Cross conditions in Cervignano in northern Italy. His outgoing personality and flamboyant mannerisms and language exasperated some but charmed many, including J. P.

Morgan, who played an important role in Carter's becoming the Academy director in 1913. "When he offered public lectures, Roman society flocked to hear him. 'The ladies swooned over him; he was a spellbinder,' said one woman fellow who knew him well" (Valentine and Valentine, *American Academy in Rome*, 63).

7. J. McMillan, "The American Academy in Rome," *North American Review* 174 (1902): 629. A decade later, the argument for an official American style in architecture was reopened in connection with the controversial design of Henry Bacon's Lincoln Memorial. On January 27, 1913, the Wisconsin chapter of the American Institute of Architects passed a resolution supporting Bacon's design and expressed its opinion that classical architecture has "by common and long usage become world architecture" and could be accepted as the official American style until a new native expression in architecture is born; it "has gone beyond the experimental stage and has stood the test of time" (Correspondence Received, 1913, T–Z, The American Institute of Architects Archives, The Octagon, Washington, D.C.). The Wisconsin chapter's resolution reflected the sentiments of the larger section of the architectural establishment at the time and presented an artistic refutation of the traditional American political isolationism.

8. F. D. Millet, "The American Academy in Rome," *American Monthly Review of Reviews* 31 (1905): 713.

9. Quoted in C. Moore, *The Life and Times of Charles Follen McKim* (Boston, 1929), 152–53. Although he was treading the ground lightly because of Burnham's feelings, McKim was worried that the work from Chicago might turn out to be utilitarian and nonhistorical in nature, in view of the current aesthetics of Chicago skyscrapers and office blocks. To the New York–based East Coast architectural establishment and to the American Academy, Chicago was a parochial center with parochial architectural tastes. The modernist view on the subject, as expressed years later by J. Burchard and A. Bush-Brown, contended that "what McKim failed to see was . . . the Yahoos and Hottentots would exist, Academy or not, and their vigor would breed a new style capable of giving form to modern institutions" (*The Architecture of America* [Boston, 1961], 262).

10. H. Van Brunt, "Architecture at the World's Columbian Exposition," and "Historic Styles, Modern Architecture," in *Architecture and Society: Selected Essays of Henry Van Brunt*, ed. W. A. Coles (Cambridge, Mass., 1969), 133–34.

11. K. Cox, *The Classic Point of View* (New York, 1911), 28, 1–35.

12. C. H. Cheney, "The American Academy in Rome," *Architectural Record* 31 (1912): 251.

13. Quoted in Valentine and Valentine, *American Academy in Rome*, 9. The italics are McKim's.

14. Quoted in Moore, *Life and Times of Charles Follen McKim*, 166.

15. D. D. Egbert, *The Beaux-Arts Tradition in French Architecture*, ed. D. Van Zanten (Princeton, N.J., 1980), 106–8, esp. n. 21.

16. American Academy in Rome. Annual Report (1914), 49.

17. G. Gromort, *Italian Renaissance Architecture* (Paris, 1922), 146.

Chapter VI

1. Gorham P. Stevens to C. Grant La Farge, 12 December 1917, Archives of American Art.

2. William R. Mead to Gorham P. Stevens, 16 October 1918, Archives of American Art.

3. American Academy in Rome. Annual Report (1919–1920), 29.

4. Ibid., 48.

5. F. Fairbanks, "Report of the Acting Professor in Charge of the School of Fine Arts—To the Board of Trustees of the American Academy in Rome, October 1, 1921" [Frank Fairbanks's final draft of the Annual Report sent to New York], Archives of American Art.

6. Philip Trammel Shutze traveled extensively in Tuscany with the purpose of studying the Tuscan villa tradition and "filled several notebooks with valuable material." La Tana was easily accessible, and Santa Colombo and the Villa Gori, both outside Siena, were on the Academy's list of primary recommendations (a photograph of the last actually appears in his scrapbook). The Villa Gori, with its prominent central element of a two-story open loggia surmounted by an elaborately voluted *risalto*, offers a particularly close parallel to the garden façade of the ambassador's residence as well as to the garden façade the Calhoun-Thornwell House, which Shutze subsequently designed in Atlanta, Georgia (see illustrations in E. Wharton, *Italian Villas and Their Gardens* [New York, 1904], 67).

7. Shutze has been accorded considerable national recognition in the past decade or so. He has been championed as "America's greatest living classical architect" by Henry Hope Reed, Jr.; his work was featured in the exhibition "Georgian Splendor: The Work of Philip Trammel Shutze of Atlanta," held at the Low Library of Columbia University; and in 1981, the year before his death, the exhibition "The Classical Tradition: The Wave of the Future," organized by the School of Architecture of the University of Texas at Austin and *Classical America*, also highlighted his work. Shutze was definitely a gifted classicist whose long architectural career (ca. 1920–1960) also encompassed English Regency and American Georgian styles. His best and

most distinguished work, however, was in the Italian baroque manner and was produced in the 1920s, immediately following his long Italian sojourn. It was based closely on the training and methodology he acquired at the American Academy and retained, more or less, to the end of his career. In many ways, Shutze represented the ideal classically inspired architect the Academy hoped to train to carry on the classical tradition in future American architecture. Yet the emerging modernism and the changing socioeconomic order of the twentieth century threw Shutze, as well as many other Academy graduates, and his work into obscurity. Two revisionist studies are aimed to alter the score: H. H. Reed, Jr., "America's Greatest Living Classical Architect: Philip Trammel Shutze of Atlanta, Georgia," *Classical America* 4 (1977): 5–46; and, more fully, E. M. Dowling, *American Classicist: The Architecture of Philip Trammel Shutze* (New York, 1989). The latter, sponsored by the Atlanta Historical Society, is an affectionate accolade to Atlanta's "talented native son." The critical and penetrating introduction by Vincent Scully is essential.

8. "Report of the Committee of the School of Fine Arts on the Collaborative Problem of 1923," October 24, 1923; Gorham P. Stevens to William R. Mead, 9 February 1926, Archives of American Art.

9. "Report of the Committee of the School of Fine Arts on the Collaborative Competition, 1924," Archives of American Art.

10. V. L. S. Hafner, "An Entrance to a Stadium," Archives of American Art.

11. J. Esherick, "Architectural Education in the Thirties and Seventies: A Personal View," in *The Architect*, ed. S. Kostof (New York, 1977), 264.

12. Other handwritten comments on the margin of Hafner's competition statement can be deciphered with difficulty: "Received it [the fellowship] for his good work but in spite of two collaborative problems in which he produced work without merit whatsoever. And in a style and manner of who [?] the [?] contrary to the principles of the American Academy."

13. "Your Committee is reluctantly compelled to believe that the responsibility for this condition lies at the door of the Director of the Academy. It has been frequently pointed out to him that the Trustees consider the Collaborative Work to be of vital consequence to the work of the fellows of the Academy and that the fundamental idea of the American Academy in Rome is to train the fellows in the Classic and Classical Renaissance Art.

"In spite of these repeated warnings, academic works of the fellows are sent here [New York] for exhibition year after year, in direct violation of the above principles. We cannot inflict penalties upon Fellows who have had the sanctions of the Director during the progress of their work.

"Your Committee therefore requests that the Trustees, through the Secretary, shall re-state to the Director the aims and purposes of the Academy and call his attention to the fact that it is his duty to see that the Fellows and all who are entrusted with the conduct of the work of the Academy in Rome shall adhere to the principles of Classic and Classical Renaissance Art; and to again point out to the Director the vital importance of the Collaborative Problem" ("Report of the Committee of the School of Fine Arts to the Board of Trustees, 1924" [signed S. B. P. Trowbridge], Archives of American Art).

14. F. E. Schelling, *The Unity of the Arts* (Rome, 1924).

15. I gratefully include Anthony E. Hecht's (FAAR 1952, literature) observation of Professor F. E. Schelling: "It seems worth noting that this curious man was a teacher of Ezra Pound (1905–1907) and one with whom Pound continued to correspond until at least 1934." I presume that this connection corroborates my point.

16. "The American Academy in Rome is founded upon a settled belief, and since all those who go to become Fellows in the Fine Arts are required to observe certain rules which are the practical application of that belief, it is essential that they understand it.

"It is that in the arts of classic antiquity and their derivatives, down to and including the major Renaissance period, are contained the fundamental principles upon which all great art so far known and proven is based;

"That these arts are closely and inseparably interrelated and interdependent; that in the days when they attained their noblest expression this interrelation was manifested by a common understanding and practice, by collaboration, since largely vanished, which should be re-established to the greatest possible extent;

"That the greatest comprehension of these principles will again be gained by actual residence upon the very theater of their past performance, before the background against which moved the artists who established and bequeathed to us those principles, and that residence should be made the occasion for acquiring mutual sympathy and understanding, and for the tangible practice of collaboration;

"That nobody can afford to depart from tradition and the great examples who has not first learned them; that freedom can never be born of ignorance nor high performance of slovenly mind or hand;

"That the field to which the Academy limits its students is so vast, so richly fruitful, as to give all needful scope to the student in the matter of design, and that the three years of residence should be exclusively devoted to the study of that field.

"Therefore we have made rules in accordance with our belief and expressive of our policy. It is the duty of every Fellow to become fully aware of the policy and to accept it as a governing

law and without question. Guidance will be given to them, and that guidance must be accepted wholeheartedly. Then, when they have satisfactorily completed their course, and are in a position to choose their ways of expression because that choice is grounded upon essential knowledge, let them elect as they will the manner in which they shall contribute to the civilization of their country" (American Academy in Rome. Annual Report [1923–1924], 20–21).

17. Gorham P. Stevens to Samuel B. Trowbridge, 7 November, 1924, Archives of American Art.

18. Samuel B. Trowbridge to Gorham P. Stevens, 2 December 1924, Archives of American Art.

19. Among other popular "documents" were J.-A. Leveil, *Vignole, Traité élémentaire pratique d'architecture, ou étude des cinq ordres d'après Jacques Barozzide Vignole* (Paris, n.d.); C. Daly, *Motifs historiques—et décorations extérieures* (Paris, 1881); J. Guadet, *Eléments et théorie de l'architecture,* 7 vols. (Paris, 1902); H. D'Espouy, *Fragments d'architecture antique* (Paris, 1905); and G. Gromort, *L'Architecture classique—parallèle d'ordres grecs et romains* (Paris, 1927). At his death in 1982, Philip T. Shutze's architectural library contained an impressive 1,756 items. Downing's appendix, "Books on English and Italian Architecture and Landscape Architecture" (165 items), reveals a noticeable absence of works that may be called art historical, analytical and theoretical (*American Classicist,* 222–27). Vincent Scully, in his introduction to *American Classicist,* observes that Shutze did not pretend to follow theoretical interests or Big Ideas, unlike many modern architects who "*pro forma* felt it necessary to do so" (xi).

20. This observation can be applied on a broader basis to the practitioners of the profession in America in the 1920s and 1930s: "Although they may have discussed art with painters and sculptors, the American architects were not accustomed to the cross-cultural, cross-disciplinary discussions of the European intellectuals and artists. They knew nothing of science, almost nothing of literature, and the history they paraded was more often than no half-studied and ill-remembered. They were interested in the political and social climate. The 'gay' discussions between St. Gaudens [*sic*], McKim and Hunt seldom turned on the gloomy philosophical questions their friend Henry Adams was asking of the atom, or on such social puzzles as the slum. It was more pleasurable for them and more characteristic that they bandied jests about the vulgarity of Chicago, pretended to chase bulls around the amphitheater of Arles [in fact, it was in the amphitheater of Nimes], exchanged reminiscences of the boulevards" (J. Burchard and A. Bush-Brown, *The Architecture of America* [Boston, 1961], 236).

21. For the breadth of Morey's scholarship and the wide variety of subjects of his contributions (including essays in criticism, modern art, and academic art), see obituaries by Rensselaer W. Lee, in *Art Bulletin* 37 (1955): iii–vii, and Richard Stillwell, in *American Journal of Archaeology* 60 (1956): 63–64. During the Second World War, Morey was the cultural attaché at the American Embassy in Rome and served as the acting director of the Academy during the period of transition, 1945 to 1947.

22. The full text of this important letter of February 4, 1926, follows:

Dear Fairbanks,
I think that the "statement of principles" is perfectly logical, once the premise is accepted. The premise seems to be contained in the second paragraph, stating the belief on which the Academy is founded, "that in the arts of classic antiquity and their derivatives, down to and including the major Renaissance period, are contained the fundamental principles upon which all great art so far is known and proven is based."

This belief takes issue with that held by all historians of art. They would say that in the arts of classical antiquity etc. are contained the fundamental principles of what may be called the ideal and intellectual mode of artistic expression, but they would certainly not subscibe to the proposition that all great art is comprised within that mode. If leave out Asiatic art and the intrusions thereof into Europe, we certainly still have two modes of artistic expression which have developed in Europe alone, one the classic, intellectual, ideal mode mentioned above, and the other the Gothic, intuitive, realistic mode. The belief on which the Academy is founded assumes that Gothic architecture is not great art, nor the painting of the Dutch, nor what is most vital in the Italian fifteenth century. The realistic mode was doubtless influenced by the classic, as the latter was by the former, but the two are essentially independent, and derived from different racial sources. The historians of art would, I think, also hold it to be true that what is vital in modern art is derived rather from the realistic mode than from the classic.

If the "statement of principles" read thus: "that in the arts of classic antiquity and their derivatives, etc., are contained the fundamental principles upon which all effective technical education and discipline for artistic practise is based," I should cheerfully subscribe to that. However one may admire the Gothic realistic mode, its very intuitive spontaneity makes it a dangerous mode for purposes of discipline. If the Academy is conceived as a school of discipline, and not as a milieu provided for the free play of creative instinct, I think that its single-minded adherence to the classical ideal is a position well-taken. In any case, the Academy has, so long as it is a private foundation, the right to take any aesthetic position it pleases. And I take it also, in view of its years of existence, and the years of thought and effort that have gone into its foundation and development, that this position is a deliberate one, and that the "statement of

principles" was written with full knowledge that it made the Academy the expression of an aesthetic preference, and classed it in the public eye with institutions of propaganda like the Barnes Foundation, if the second paragraph is taken at its face value.

My talk with you yesterday showed me how difficult was the task the Academy was trying to do for American art, and I also feel that the problem is outside my bailiwick. But I have written out the above in order to clarify my own reaction to the "statement of principles" and thought that it might be interesting to you to get such a reaction from a layman [Signed C. R. Morey] (Archives of American Art).

23. Frank Fairbanks to William R. Mead, 11 February 1926, Archives of American Art.

24. Morey did not mention the American Academy in Rome or its "Credo" in his article specifically, but the indirect reference to both, using the French Academy as a surrogate, is too obvious to miss: "In art, the outstanding result of the academic point-of-view has been the separation of art from the public, for the single reason that its principles, so long as they were extraneous, had nothing to do in any vital sense with contemporary life. From the French Academy with its fixed *credo* has sprung the modern one in every country, and from the art-school which the French Academy established to protect its *credo*, has sprung the art school of today. The public cannot possibly have any stake in this *credo* except in so far as it can be 'educated' to accept it" ("The Academic Point of View," *Arts* 11 [1927]: 238–87; 12 [1927]: 40–44, esp. 43).

25. "It would be folly, so long as this bewilderment lasts, to give up, in training our youth either for intellectual or artistic pursuits, the clarifying factor formulated by the academic method. Organized by centuries of use in pedagogy, exact in its premises and deductions, the classic mode of conceiving truth, exotic though it may be, can still teach our youth to think robustly, and to be sound instead of sentimental in conclusions" (ibid., 44). Regarded by his colleagues as a conservative, Morey, in his own way, appears romantic and chauvinistic in trying to advocate the exclusive suitability of the realistic Anglo-Saxon vocabulary of art ("the realistic mode that thrills our race," as opposed to the "Latin vocabulary" of the French and the Italian) to those who belonged to the Anglo-Saxon race, in which he included Americans.

26. R. A. M. Stern, *George Howe: Towards a Modern American Architecture* (New Haven, Conn., 1975), 68–72.

27. F. Fairbanks, to the trustees of the American Academy in Rome, 18 March 1928, Archives of American Art.

28. Frank Fairbanks to C. Grant La Farge, 13 July 1929, Archives of American Art.

29. The classicism underlying Art Deco aesthetics and the general appeal of the new style is aptly summarized by Rosemarie

H. Bletter: "Art Deco was a style that pointed to modernity with arrows and exclamation marks, but without ever giving up the past. It was a kind of modernism, American architects, steeped up in the Beaux-Arts tradition, could feel quite comfortable with" ("Modernism Rears Its Head—The Twenties and Thirties," in *The Making of an Architect, 1881–1981*, ed. R. Oliver [New York, 1981], 107–11, esp. 109–11).

30. C. Dale Badgeley, the senior architect in 1929, had been on the winning team in each of his three years at the Academy. He seemed to epitomize the ideal Academy fellow because of his good taste and willingness to comply with the rules. He was complimented that year by Fairbanks as a model fellow: "a man of the very best type and our encouragement lies in just such material as he represents" (Fairbanks to La Farge, 13 July 1929, Archives of American Art).

31. "Report of the Committee of the School of Fine Arts on the Collaborative Competition, 1929," Archives of American Art.

32. Stern, *George Howe*, 77; S. Cheney and M. C. Cheney, *Art and the Machine* (New York, 1936), 7–8; S. Chase, *Men and Machines* (New York, 1929), 247–51; H. Lippman, "The Machine Age Exposition," *Arts* 11 (1927): 324–27; J. Heap, "Machine-Age Exposition," *Little Review* 11 (1925): 22–24. See also *Machine-Age Exposition Catalogue* (New York, 1927).

33. Despradelle's "Beacon of Progress" (or "A Monument Dedicated to the Glory of the American People"), inspired by the Columbian Exposition in Chicago, was planned to be placed on the site of the fair, facing Lake Michigan. The Piranesian design (a tower 1,500 feet tall) and its rendering took six years to complete and received the first gold medal at the Salon exhibition in Paris in 1900. The drawings were purchased by the French government. Despradelle (1862–1912) came to the United States in 1893 as a professor of architecture at the Massachusetts Institute of Technology and won national acclaim as one of the most forceful and imaginative Beaux-Arts educators in this country. His work was exhibited in Boston in 1913 (F. A. Bourne, "On the Work of the Late Désiré Despradelle," *Architectural Record* 34 [1913]: 185–89; F. S. Swales, "Master Draftsmen, XI. Désiré Despradelle," *Pencil Points* 6 [1925]: 59–70. See also J. F. Harbeson, *The Study of Architectural Design* [New York, 1927], 229ff., figs. 285–87).

34. *Bulletin of the Beaux-Arts Institute of Design* 5 (1927): 4–15; 1 (1924): 17–24. Closer comparisons can be suggested between the plan and the lower massing of the pyramidal design by the team of Johnson, Snowden, Mattison, and Rapuano (Pls. 31–34) and the first medalist in the competition for "A Masonic Temple" (Fig. 38); this project was sponsored by the Fountainebleau School of Fine Arts in 1929 (*Bulletin of the Beaux-Arts Institute of Design* 5 [1929]: 5). Also compare the buttressed, cylindrical monument proposed by the team of Briggs,

Waugh, Beck, and Sutton (Pls. 35–37) with the central round auditorium of "A Radio Broadcasting Station" (Figs. 39, 40), the winning design for the Paris Prize of 1927, published in *Bulletin of the Beaux-Arts Institute of Design* 3 (1927): 10.

35. On the picturesque and neobaroque qualities of the American Beaux-Arts design, see V. Scully, *American Architecture and Urbanism* (New York, 1969), 136–40.

36. "Report of the Committee of the School of Fine Arts on the Collaborative Competition, 1930," Archives of American Art. The necessity to stay within the boundaries of historical probability is well expressed by John F. Harbeson's admiration for the imaginative qualities of Despradelle's "Beacon of Progress": "There are echoes of what has been done before, of course, for otherwise it would be too alien to our taste to appeal to us" (*Study of Architectural Design*, 229).

37. Frank Fairbanks to Roscoe Guernsey, 1 December, 1930, Archives of American Art.

38. "American Academy in Rome. Collaborative Problem for 1931," Archives of American Art.

Chapter VII

1. Although Stevens was an architect who had started his career in the office of McKim, Mead and White, he became increasingly interested in classical archaeology and scholarship. He had been asked to do a revised edition of Anderson and Spiers's *Architecture of Greece and Rome* (1902), a highly regarded archaeological source book. During the war years, he worked on this project on and off, but could not complete it; this important book was later revised and enlarged by William B. Dinsmoor and published in 1950 as *The Architecture of Greece*. While in Rome, Stevens was more effective working on smaller and more detailed projects, such as determining entasis in Roman columns. To start an Academy excavation in a classical site in order to give the architecture fellows opportunities for field study was one of his dreams. Howard Crosby Butler, who was excavating Sardis before the war, offered the Roman sections of Sardis to the American Academy. Stevens was much interested in this offer. In the Annual Report of 1915–1916 he proposed this venture to the trustees and quoted Butler: "It would be a fine thing to have one great site excavated and set in order by American enterprise" (52). Nothing more was heard of the proposal.

2. Fairbanks also composed and painted the monumental archaeological map of Rome (5 × 7.50 m, based on Rodolfo Lanciani's *Forma Urbis Romae*) in the so-called Map Room (Lecture Room, originally the Architecture Library) of the main building. This handsome map, commissioned by the Academy Alumni Association in 1931, is in honor of Gorham

Phillips Stevens and contains a list of the fellows' names (except Hafner's) until that year.

3. Frank Fairbanks to Roscoe Guernsey, 18 March 1928, Archives of American Art.

4. American Academy in Rome. Annual Report (1931–1932), 24.

5. Ibid., 24.

6. Stevens's belief that the state should play an active role of leadership in the arts echoes the popular and idealistic sentiments of his youth when he was an architect in McKim's firm and the American Renaissance was in full swing. For the kind of architecture Stevens wanted to see, the state was, indeed, probably the last and most important patron in the 1930s. The size and scope of the federal building program, with strong neoclassical preference, during this period in Washington, D.C., alone is staggering.

7. In 1913, Stevens had recommended that the president of the United States give the awards to the fellows at a special state reception, just as the French did for their Prix de Rome winners (Annual Report [1913], 29). He also tried to arrange to show President Woodrow Wilson the Academy buildings and grounds during the president's visit to postwar Rome on January 3 to 9, 1919. According to Stevens's diary (January 9, 1919), Wilson "went especially to see [the] outside of [the] Academy" on that day, driving past it but not stopping to see the inside.

8. G. P. Stevens, "The Volute of the Capital of the Temple of Athena at Priene—A Machine for Drawing this Volute for any Column between Twenty and Sixty Feet in Height," *Memoirs of the American Academy in Rome* 24 (1956): 33–46.

9. American Academy in Rome. Annual Report (1932–1933), 19, 24.

10. American Academy in Rome. Annual Report (1933–1934), 23.

11. S. Rather, "Paul Manship and the Genesis of Archaism," in *Paul Manship: Changing Taste in America* (St. Paul, Minn., 1985), 63–89. With the exception of John Russell Pope, the Manship bibliography is the most extensive of any Academy fellow before the Second World War. See, particularly, E. Murtha, *Paul Manship* (New York, 1957), a *catalogue raisonné* of Manship's work, and H. Rand, *Paul Manship* (Washington, D.C., 1989).

12. Although the Academy's jurists were sensitive about and critical of the spirit of collaboration among the arts and the artists (the fellows participating in the Collaborative Problem), and they expected harmony between painting and sculpture, on the one hand, and architecture, on the other, ideal and harmonious relationships were rare even among the practicing artists who were the chief proponents of collaboration at the turn of

the century. Numerous technical, artistic, and personal problems arose in the collaboration on the mural paintings of the Walker Art Building, Brunswick, Maine (Bowdoin College Museum of Art). There was little communication between the architect, Charles F. McKim, who designed the building in 1892 to 1893, and the four painters—Elihu Vedder, John La Farge, Kenyon Cox, and Abbott H. Thayer—whose murals for the building's lunettes took five years to complete (1893–1898). Not only had McKim designed the building totally independently of the artists, but the program had not been properly communicated to all the artists involved, so that Vedder's already finished *Art Idea* panel had to make do as *Rome*, along with *Florence*, *Venice*, and *Athens*, the four cities "which affected profoundly the course of Western art"—the subject chosen for the final scheme. "Although all the artists suffered various problems in the execution of their commission, for the least experienced, Thayer, the project was to be a thoroughly agonizing and painful experience" (R. V. West, *The Walker Art Building Murals*, Bowdoin College Museum of Art Occasional Papers, no. 1 [Brunswick, Me., 1972], 3). For the more experienced La Farge, too, this collaboration had been a chore and definitely less than the Renaissance ideal: he added to his signature and date on the finished painting the sentiment "Enfermo e Stanco" ("Sick and Weary").

13. The sculptors were Paul Manship (FAAR, 1912) and Albin Polasek (FAAR, 1913); the painter was Eugene Francis Savage (FAAR, 1915). All three artists were fellows in Rome at the same time (D. C. Rich, ed., *Catalogue of a Century of Progress. Exhibition of Paintings and Sculpture* [Chicago, 1933], 66–77, 106–14; [1934], 72–85, 86–95). We should, however, also consider the view expressed by W. L. Vance: "Since art history of the past thirty years has been written from the viewpoint of triumphant modernism, artists who persisted in traditional representational, illustrative, and decorative tasks have largely disappeared from the record. Of the nearly eighty sculptors who had studied at the American Academy in Rome by 1976, only Paul Manship was included in the Whitney Museum's retrospective of American sculpture in that year purporting to represent two centuries of achievement. No doubt after the neoclassical sculptors of the nineteenth century . . . a certain redundancy is felt as we regard the works of their 'academic' successors" (*America's Rome* [New Haven, Conn., 1989], 1: 375).

14. H. Marceau, to Chester Aldrich, April 1935, Archives of American Art.

15. John Walker III later became the chief curator (1939–1956) and the director (1956–1969) of the National Gallery of Art in Washington, D.C.

16. American Academy in Rome. Annual Report (1935–1936), 29.

17. L. Valentine and A. Valentine, *The American Academy in Rome, 1894–1969* (Charlottesville, Va., 1973), 98.

18. A. Saint, *The Image of the Architect* (New Haven, Conn., 1983), 1–18.

19. Kendall also designed the shield over the iron grille of the main gate in 1914. In 1921, he gave the four stately cypresses in the courtyard and the umbrella pines that adorn the Academy's garden. The handsome forged-iron lantern of the main entrance was presented by E. F. Caldwell of New York in 1914, as a memorial to McKim. The billiard table ("the best available in the market") was a gift to the fellows by William R. Mead, in the same year.

20. "I thoroughly agree with you with what you write about the students studying the primitives to the exclusion of the painters of the high Renaissance. Winter [Ezra Winter, FAAR, 1914, painting] preferred the latter painters, and in some ways I think him the best painter the Academy has yet produced. I will do my best to emphasize your point of view. I keep prints of the library walls in the cupboard in my office and have tried to interest every painter as he has come along. So far Winter is the only one who has attempted a scheme" (Gorham P. Stevens to William R. Mead, 26 July 1926, Archives of American Art).

Chapter VIII

1. R. N. Murray, in R. G. Wilson, D. H. Pilgrim, and R. N. Murray, *American Renaissance, 1876–1917* (New York, 1979), 187–89.

2. L. Craig et al. *The Federal Presence* (Cambridge, Mass., 1977), 286–87.

3. The Gold Medalists for the years 1922 to 1938 were Victor Laloux (1922), Henry Bacon (1923), Sir Edward Landseer Lutyens (1924), Bertram Grosvenor Goodhue (1925), Howard Van Doren Shaw (1927), Milton Bennett Medary (1929), Ragnar Ostberg (1933), and Paul Philippe Cret (1938). The conservative attitude of American architects had not changed much by 1948. In a poll conducted among 500 AIA members, the five top-ranking buildings were (1) Folger Shakespeare Library, (2) Lincoln Memorial, (3) Rockefeller Center, (4) Nebraska State Capitol, and (5) Federal Reserve Board Building. The only building in the top ten that may be considered as truly International Style was the Philadelphia Savings Fund Society Building by George Howe and William Lescaze, occupying seventh place (R. G. Wilson, *The AIA Gold Medal* [New York, 1984], 61–62, 71; E. B. Morris, "What Buildings Give You a Thrill?" *Journal of the American Institute of Architects* 10 [1948]: 272–77).

4. E. B. Morris, "Can Modern Architecture Be Good?" *Federal Architect* (1930): 6.

5. Wilson, *AIA Gold Medal*, 61, esp. 69, 85–86; H.-R. Hitchcock, "Modern Architecture I: The Traditionalists and the New Tradition," *Architectural Record* 63 (1928): 337–49; Hitchcock, "Modern Architecture II: The New Pioneers," *Architectural Record* 63 (1928): 453–60.

6. Inez Longobardi, who came to the Academy in 1926 as a young cataloguer at the library (and who became the Academy librarian, 1961–1975), recalled the important occasion when Ragnar Östberg came to lunch at the Academy in 1929. The works of the Swedish architect were greatly admired by the fellows and their seniors. Cecil C. Briggs may have decided to include Stockholm in his travels that year (he may have even been encouraged to do so by the director) as a result of this meeting (Inez Longobardi, interview with author, Rome, 23 July 1984; see also Wilson, *AIA Gold Medal*, 53, 57, 160–61).

7. Craig et al., *Federal Presence*, 294–98; J. Burchard and A. Bush-Brown, *The Architecture of America* (Boston, 1961), 265; W. C. Kidney, *The Architecture of Choice: Eclecticism in America, 1880–1930* (New York, 1974), 63.

8. Craig et al., *Federal Presence*, 309–22, esp. 310.

9. The Federal Triangle may have had greater civic grandeur and meaning, if the scheme for the Great Plaza and the Twelfth Street Circle had been completed as originally proposed "after the arrangement of the Louvre in Paris" (which would have required the demolition of the Romanesque Old Post Office). The site plan was prepared by a committee of six architects "in the manner of the men of the Chicago fair," Henry Hope Reed, Jr., observed. Reed saw in the Federal Triangle a kind of swan song to the American Renaissance, and the City Beautiful "confined to oblivion by the secessionists." Three of the six-man architectural committee—John Russell Pope, William Adams Delano, and Louis Ayres—were on the board of directors of the American Academy (H. H. Reed, Jr., *The Golden City* [New York, 1959], 96–98, 105–7; Craig et al., *Federal Presence*, 309–10). The scheme was widely criticized in the 1930s for disregarding the needs of modern offices: "Well over $1,000,000,000 of taxpayers' money is being used, not to provide modern, efficient, stripped-for-action office buildings which every federal department has been needing badly, but to provide a parade of monumental structures that are copies of French palaces when they are not reconstructions of pagan temples" (W. H. Hale, "The Grandeur That Is Washington," *Harper's Monthly Magazine*, April 1934, 566; see also J. Hudnut, "Twilight of the Gods," *Magazine of Art* 30 [1937]: 480–81). With the hindsight of history, however, it is difficult to decide if the majority of those "stripped-for-action office buildings," which every department asked for and eventually received in Washington and elsewhere, were a major improvement over the palaces and the temples.

10. For the contemporary criticism of the National Gallery and Pope, see Burchard and Bush-Brown, *Architecture of America*, 488; J. Hudnut, *Architecture and the Spirit of Man* (Cambridge, Mass., 1949), 49–57; L. Rich, "A Study of Contrasts," *Progressive Architecture* 22 (1941): 407–516; "Flashback: Marble Marvel," *Architects' Journal* (1941): 370–75.

11. "The full size profiles were drawn with the aid of an apparatus, fashioned by Mr. Pope, that consisted of a folding drawing board and level with an extension T-square. One end was pointed to follow the actual profile of the molding, the other end of the extension pointed to register on the drawing board every quarter of an inch" (F. S. Swales, "Master Draftsmen, VIII. John Russell Pope," *Pencil Points* 5 [1924]: 65–90, esp. 65–66).

12. A number of good studies deal with the origins and development of architectural education in the United States and its relationship to the Ecole des Beaux-Arts. They include J. Draper, "The Ecole des Beaux-Arts and the Architectural Profession in the United States: The Case of John Galen Howard," in *The Architect*, ed. S. Kostof (New York, 1977), 209–35, with extensive bibliography; S. M. Strauss, "History III, 1912–1933," in *The Making of an Architect, 1881–1981*, ed. R. Oliver (New York, 1981), 94–101; J. P. Noffsinger, *The Influence of the Ecole des Beaux-Arts on the Architects of the United States* (Washington, D.C., 1955); T. C. Banister, ed., *The Architect at Mid-Century: Evolution and Achievement* (New York, 1954), 100–107; Wilson, Pilgrim, and Murray, *American Renaissance*, 92–101; A. D. F. Hamlin, "The Influence of the Ecole des Beaux-Arts on Our Architectural Education," *Architectural Record* 23 (1908): 241–47; J. S. Barney, "The Ecole des Beaux-Arts: Its Influence on Our Architecture," *Architectural Record* 22 (1907): 333–42; M. Schuyler, "Schools of Architecture and Paris School," *Scribner's Magazine* (1898): 765–66; P. P. Cret, "The Ecole des Beaux-Arts: What Its Architecture Means," *Architectural Record* 23 (1908): 367–71. Also useful are R. Chaffee, "The Teaching of Architecture at Ecole des Beaux-Arts," in *The Architecture of Ecole des Beaux-Arts*, ed. A. Drexler (New York, 1977), 61–109; E. H. Denby, "The Ecole des Beaux-Arts and Its Influence in America," *Legion D'Honneur* 3 (1933): 217–27; E. Flagg, "The Ecole des Beaux-Arts," *Architectural Record* 3 (January–March 1894): 303–13; 3 (April–June 1894): 419–28; 4 (July–September 1894): 38–43.

13. University of Pennsylvania, School of Architecture, *Bulletin* (1934–1935), 20.

14. For the mounting sense of dissatisfaction with the Beaux-Arts system in architectural education and attempts to accommodate European modernism in the 1920s and 1930s, see the three articles in *The Making of an Architect*: R. H. Bletter, "Modernism Rears Its Head—The Twenties and Thirties," 103–18; J. Oberlander, "History IV, 1933–1935," 119–26; and

K. Frampton, "Slouching Towards Modernity: Talbot Faulkner Hamlin and the Architecture of the New Deal," 149–65. See also J. Esherick, "Architectural Education in the Thirties and Seventies: A Personal View," in *The Architect*, 238–79, and the case study of George Howe's conversion to modernism in the late 1920s in R. A. M. Stern, *George Howe: Towards a Modern American Architecture* (New Haven, Conn., 1975), 55–89.

15. Ronald Bradbury, an architecture student at Columbia University in 1934, quoted in T. K. Rohdenburg, *A History of the School of Architecture. Columbia University* (New York, 1954), 89. Morris Lapidus recalled a lecture given in 1927 by William A. Boring, the dean of the School of Architecture at Columbia: "As I was completing my architectural studies in 1927 . . . we had at Columbia a sort of insulated academic background—so much so that none of the instructors or professors would even talk about the International Style, the Bauhaus, and what was going on in Europe. . . . It was only in a lecture that we were told about it. . . . We were almost taken in, as if we were going to be told some dirty stories. 'We'll tell you about it, but forget it'" (J. W. Cook and H. Klotz, *Conversations with Architects* [New York, 1973], 148; Bletter, "Modernism Rears Its Head," 103).

16. Esherick, "Architectural Education in the Thirties and Seventies," 273.

17. Bletter, "Modernism Rears Its Head," 113–15; Oberlander, "History IV, 1933–1935," 120.

18. Report of the Committee on the Columbia School of Architecture, May 1, 1934; Oberlander, "History IV, 1933–1935," 120, n. 8.

Chapter IX

1. Quoted in C. Moore, *The Life and Times of Charles Follen McKim* (Boston, 1929), 150. Walter L. Ward's (FAAR, 1914) letter of September 30, 1916, to Gorham P. Stevens is full of nostalgia for Rome and the Academy. Ward, who had just returned to New York and found a job in McKim's office, complained that work kept him from seeing other returning fellows as much as he wanted and begged Stevens to communicate "any and all Academy 'scandal'" that he could furnish.

2. L. Valentine and A. Valentine, *The American Academy in Rome, 1894–1969* (Charlottesville, Va., 1973), 55–56.

3. Kenneth E. Carpenter to C. Grant La Farge, 8 December 1912, Archives of American Art.

4. E. M. Dowling, *American Classicist: The Architecture of Philip Trammel Shutze* (New York, 1989), 220; Allyn Cox to Philip T. Shutze, 22 March 1982, P. T. Shutze Collection, Atlanta, Georgia.

5. J. Hudnut, *Architecture and the Spirit of Man* (Cambridge, Mass., 1949), 240.

6. S. Cheney, *The New World Architecture* (New York, 1930), 41, 44, 62.

7. Establishing a parallel to the American situation again, the sculptors of the British School between 1913 and 1920 are described as being fairly successful artists in England after their return home. With the growing taste in modern art, however, those "who came out to Rome between 1920 and the late 30's did not win public recognition. . . . [D]own to the Second World War and beyond, the Rome School remained firmly rooted in the tradition of classical realism" (S. Farthing, "La Scuola Britannica a Roma," in *Artisti di Quattro Accademie Straniere in Rome* [Rome, 1982], 61–84, esp. 72).

8. The following are responses to the inquiry. On juries and the jury system of the Academy: "Allow for a more representative group of non-Fellows in the juries; a little less in-breeding and more line-breeding"; "Instruct the juries that the Academy encourages creative art, not archaeology, nor imitation art in any form"; "Jury should contain more 'left-wing' artists." On the admission of women as fellows to the School of Fine Arts, opinion was divided more or less in the middle; even those who favored the admission of women insisted that "women must eat separately" or "men must have, at least, one meal together." On the director of the Academy: "He must be a man of broad sympathies and interests"; "He should not be a professional architect, painter, sculptor or landscape architect, but an administrator of considerable repute and experience"; "A man of wide culture and broad views . . . without prejudice as to expression in forms of art"; "Director should be a proficient artist in one of the Fine Arts"; "An active, creative artist . . . He should stress the cultural contacts of the Fellows rather than the social. He should arrange it so that the Fellows have a chance to meet and exchange ideas with the Fellows of the other academies in Rome . . . the important thing is that these visitors come as artists to be with artists and *not* have them come as celebrities to meet a bunch of people who happen to have fancy names and a snobbish interest in that strange specimen of humanity called an artist" (Vittorio Giannini [FAAR, 1936, musical composition], Archives of American Art).

9. Paul P. Cret to Eric Gugler, 22 March 1945, Archives of American Art.

10. Olindo Grossi to Eric Gugler, 8 January 1945, Archives of American Art.

SELECT BIBLIOGRAPHY

Adams, M. A. *The Roman Stamp.* Berkeley, Calif., 1974.

Alaux, J.-P. *Académie de France à Rome.* Vol. 2. Paris, 1933.

"The American Academy in Rome." *Nation,* 16 March 1911, 277.

Andrews, W. *Architecture, Ambition and Americans.* New York, 1955.

Bannister, T. C., ed. *The Architect at Mid-Century: Evolution and Achievement.* New York, 1954.

Bedford, S. M., and S. M. Strauss. "History II, 1881–1912." In *The Making of an Architect, 1881–1981,* edited by R. Oliver. New York, 1981.

Blashfield, E. H. "Rome as a Place of Schooling for a Decorative Painter." *American Architect* 82 (1903): 51–53.

Bletter, R. H. "Modernism Rears Its Head—The Twenties and Thirties." In *The Making of an Architect, 1881–1981,* edited by R. Oliver. New York, 1981.

Bourne, F. A. "On the Work of the Late Désiré Despradelle." *Architectural Record* 34 (1913): 185–89.

Brown, G. "McKim and the American Institute of Architects." *Architectural Record* 38 (1915): 575–82.

Burchard, J., and A. Bush-Brown. *The Architecture of America.* Boston, 1961.

Carter, J. B. In *Memorandum on the American Academy in Rome.* New York, 1913.

Cheney, C. H. "The American Academy in Rome." *Architectural Record* 31 (1912): 243–55.

Cheney, S. *The New World Architecture.* New York, 1930.

Cheney, S., and M. C. Cheney. *Art and the Machine.* New York, 1936.

Cox, K. *The Classic Point of View.* New York, 1911.

Craig, L., and the staff of the Federal Architecture Project. *The Federal Presence.* Cambridge, Mass., 1977.

De Long, D. "William R. Ware and the Pursuit of Suitability: 1881–1903." In *The Making of an Architect, 1881–1981,* edited by R. Oliver. New York, 1981.

Desmond, H. W., and H. Croly. "The Work of McKim, Mead and White." *Architectural Record* 20 (1906): 153–246.

Dowling, E. M. *American Classicist: The Architecture of Philip Trammel Shutze.* New York, 1989.

Draper, J. "The Ecole des Beaux-Arts and the Architectural Profession in the United States: The Case of John Galen Howard." In *The Architect,* edited by S. Kostof. New York, 1977.

Egbert, D. D. *The Beaux-Arts Tradition in French Architecture,* edited by D. Van Zanten. Princeton, N.J., 1980.

Esherick, J. "Architectural Education in the Thirties and Seventies: A Personal View." In *The Architect,* edited by S. Kostof. New York, 1977.

Farthing, S. "La Scuola Britannica a Roma." In *Artisti di Quattro Accademie Straniere in Roma.* Rome, 1982.

Frampton, K. "Slouching Towards Modernity: Talbot Faulkner Hamlin and the Architecture of the New Deal." In *The Making of an Architect, 1881–1981,* edited by R. Oliver. New York, 1981.

Guernsey, R. "The Competitions for the Fellowships of the American Academy in Rome." *Architectural Record* 50 (1921): 227–34.

Hale, W. H. "The Grandeur That Is Washington." *Harper's Monthly Magazine*, April 1934, 560–69.

Hamlin, A. D. F. "The Battle of Styles." *Architectural Record* 1 (1891): 265–75.

———. "The Influence of the Ecole des Beaux-Arts on Our Architectural Education." *Architectural Record* 23 (1908): 241–47.

Hastings, T. "The Influence of the Ecole des Beaux-Arts upon American Architecture." *Architectural Record* [special issue] (1901): 66–90.

Heap, J. "Machine-Age Exposition." *Little Review* 11 (1925): 22–24.

Hines, T. S. *Burnham of Chicago.* Chicago, 1979.

Hitchcock, H.-R. "Modern Architecture I: The Traditionalists and the New Tradition." *Architectural Record* 63 (1928): 337–49.

———. "Modern Architecture II: The New Pioneers." *Architectural Record* 63 (1928): 453–60.

Hoeber, A. "The Prize of Rome." *Century Magazine*, May 1905, 3–10.

Hudnut, J. "Twilight of the Gods." *Magazine of Art* 30 (1937): 480–84.

Jones, H. M. "The Renaissance and American Origins." In *Ideas in America.* Cambridge, Mass., 1945.

Kidney, W. C. *The Architecture of Choice: Eclecticism in America, 1880–1930.* New York, 1974.

Kostof, S. *The Third Rome, 1870–1950.* Berkeley, Calif., 1973.

La Farge, C. Grant. "The American Academy in Rome." *Art and Archaeology* 19 (1925): 59–61.

———. *History of the American Academy in Rome.* Rome, 1915. Reprint. New York, 1917, 1920, 1925, 1927.

La Farge, J. "The American Academy in Rome." *Scribner's Magazine*, August 1900, 253–56.

Lippman, H. "The Machine Age Exposition." *Arts* 11 (1927): 324–27.

Lord, A. W. "The Significance of Rome to the American Architectural Student." *American Architect* 82 (1903): 43–46.

Lynes, R. "A Perspective." In *Artisti di Quattro Accademie Straniere in Roma.* Rome, 1982.

McDaniel, W. B. "The American Classical Schools in Rome and Athens." *Classical Journal* 19 (1924): 438–41.

McMillan, J. "The American Academy in Rome." *North American Review* 174 (1902): 625–31.

Meltzer, C. H. "Two Homes of Art in Rome, the Academies of Old France and Young America." *Arts and Decoration* 16 (1921): 15–17.

Mereu, H. "The American Academy at Rome." *American Architect* 88 (1905): 99.

Millet, F. D. "The American Academy in Rome." *American Monthly Review of Reviews* 31 (1905): 713–15.

Moore, C. *The Life and Times of Charles Follen McKim.* Boston, 1929.

Morey, C. R. "The Academic Point of View." *Arts* 11 (1927): 283–87; 12 (1927): 40–44.

Noffsinger, J. P. *The Influence of the Ecole des Beaux-Arts on the Architects of the United States.* Washington, D.C., 1955.

Oberlander, J. "History IV, 1933–1935." In *The Making of an Architect, 1881–1981*, edited by R. Oliver. New York, 1981.

Pevsner, N. *Academies of Art, Past and Present.* 1940. Reprint. New York, 1973.

Rand, E. K. "The School of Classical Studies of the American Academy in Rome." *Art and Archaeology* 1 (1914): 13–20.

Reed, H. H., Jr. "America's Greatest Living Classical Architect: Philip Trammel Shutze of Atlanta, Georgia." *Classical America* 4 (1977): 5–46.

———. *The Golden City.* New York, 1959.

"Rome as an Art School." *American Architect* 82 (1903): 59.

Saint, A. *The Image of the Architect.* New Haven, Conn., 1983.

Satterlee, H. L. *J. Pierpont Morgan, An Intimate Portrait.* New York, 1939.

Schelling, F. E. *The Unity of the Arts.* Rome, 1924.

Scully, V. *American Architecture and Urbanism.* New York, 1969.

Showerman, G. "America in Ancient Rome." *Art and Archaeology* 19 (1925): 63–80.

Stern, R. A. M. *George Howe: Towards a Modern Architecture.* New Haven, Conn., 1975.

Stevens, G. P. "The Architect at the American Academy in Rome." *Arts and Archaeology* 19 (1925): 81–86.

———. "The Volute of the Capital of the Temple of Athena at Priene—A Machine for Drawing this Volute for any Column between Twenty and Sixty Feet in Height." *Memoirs of the American Academy in Rome* 24 (1956): 33–46.

Stillman, W. J. *The Old Rome and the New.* Boston and New York, 1898. Reprint. Freeport, N.Y., 1972.

Strauss, S. M. "History III, 1912–1933." In *The Making of an Architect, 1881–1981*, edited by R. Oliver. New York, 1981.

"Students' Works from the Roman Academy." *Nation*, 13 February 1913, 147.

Swales, F. S. "Master Draftsmen, VIII. John Russell Pope." *Pencil Points* 5 (1924): 65–90.

———. "Master Draftsmen, XI. Désireé Despradelle." *Pencil Points* 6 (1925): 59–70.

Valentine, L., and A. Valentine. *The American Academy in Rome, 1894–1969.* Charlottesville, Va., 1973.

Vance, W. L. *America's Rome.* 2 vols. New Haven, Conn., 1989.

Van Buren, A. W. "The American Academy in Rome and Classical Studies in America." *Classical Journal* 9 (1913): 73–78.

Walton, W. "The American Academy in Rome." *American Architect* 97 (1910): 201–8.

Watson, J. "News and Comment—Closed: One Road to Rome." *Magazine of Art* 34 (1941): 38.

West, R. V. *The Walker Art Building Murals.* Bowdoin College Museum of Art Occasional Papers, no. 1 Brunswick, Me., 1972.

Wilson, R. G. *The AIA Gold Medal.* New York, 1984.

Wilson, R. G., D. H. Pilgrim, and R. N. Murray. *American Renaissance, 1876–1917.* New York, 1979.

Woods, M. N. "Charles Follen McKim and the Foundation of the American Academy in Rome." In *Light on the Eternal City. Papers in Art History from the Pennsylvania State University,* edited by H. Hager and S. S. Munshower. Vol. 2. University Park, Pa., 1987.

GENERAL INDEX

INDEX OF WORKS BY FELLOWS
IN ARCHITECTURE